The Orvis Guide to Outdoor Photography

THE ORVIS GUIDE TO OUTDOOR PHOTOGRAPHY

Jim Rowinski

The Lyons Press
Guilford, Connecticut
An imprint of The Globe Pequot Press

The Lyons Press is an imprint of The Globe Pequot Press

10 9 8 7 6 5 4 3 2 1

Printed in China
Designed by Peter Holm, Sterling Hill Productions

Photographs copyright © 2004 by Jim Rowinski

ISBN 1-59228-237-7

Library of Congress Cataloging-in-Publication Data is available on file.

CONTENTS

INTRODUCTION

A lot has changed in the photographic world since I first picked up a camera and headed out to try my hand at capturing the beautiful wilderness photographs that I saw in books and magazines. Technical advances in automatic exposure and focus allow us to capture images faster and easier than ever. And digital systems open up a world of opportunity for storing and printing images that was once only the domain of professional darkroom studios.

But one thing has not changed. The world of the photographer is essentially a world of light. Light transforms the objects around us into a never-ending combination of shapes, designs, and patterns. And capturing this light is what photography is all about.

To photograph an object is to paint with light. Just as a painter has canvas and brush or the sculptor has clay and knife, we photographers have traditionally used camera and film to capture light and manipulate it to our liking.

The photographic tools available to us today allow us to do more than ever before. Digital methods are quickly surpassing film in terms of quality, ease of use, cost, and the ability to control and manipulate light. Advances in equipment and image storage are making it easier for us to capture technically correct images every time. With today's tools, what we choose to capture on film is limited only by our imaginations.

But to really transform your vision of the world into a final image takes more than a high-tech camera. The elements that make a great photograph—ideal lighting, sharp focus, pleasing composition—have not changed. The secret to creating consistently great photographs is

Our ability to capture and transform light into film or digital images is only limited by our imaginations.

to have a clear vision of what you want to achieve and a thorough understanding of the technical processes that will get you there.

This book is designed to cover all the basics—from the fundamentals of how light acts upon film to the principles of shutter speed and composition. If you are a seasoned photographer with a good grasp of these concepts, you may want to skip these chapters. But if you have been taking pictures for a while and find yourself missing more great shots than you'd like, a quick review may be useful.

Later chapters delve into the complexities of difficult lighting situations and action photography, as well as the elements of great landscape, wildlife, and people photography. A special section on digital photography may be especially useful to those who are converting their equipment from conventional cameras to a digital system.

I hope this book helps you to understand each of the elements of photography so that you can translate your creative thoughts into powerful images.

UNDERSTANDING LIGHT

One of the real joys of photography is that it gives you the opportunity to look at, *and really see,* things in your environment that the average person would never stop to examine. A dewdrop on a wildflower, frost on a crab apple, the interplay of sun and shadow in a stand of aspens—each of these images may last a mere moment. As a photographer, you have the honor of being present to record that moment.

Light is the element that makes each of these moments unique. Every hour of the day and every month of the year offers a variation on the way an object is visually perceived. And when you throw in the elements of sun angle, clouds, shadows, and mist, the results are a multiplicity of potential images.

Many of the world's most famous photographers are associated with specific places. They are not always scurrying around the world in an endless search for new locales. Instead, they find themselves returning again and again to their favorite haunts—spots where the light fascinates them, where the seasons and the days change the colors they see, where every moment directs them to a new vantage point from which to capture the essence of the place.

Before you venture out with your camera, I encourage you to stop and look at the places that are most familiar to you. Train your eye to see the subtle changes light makes on a tree that you often pass by or the way shadows falling on a building that you see every day will affect its character. What makes the tree irresistibly beautiful one day and

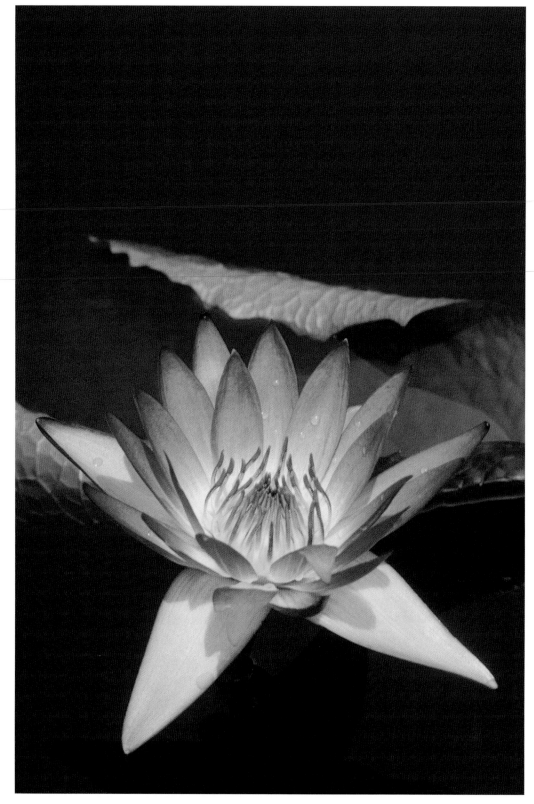

The simple elegance of dewdrops on a water lily.

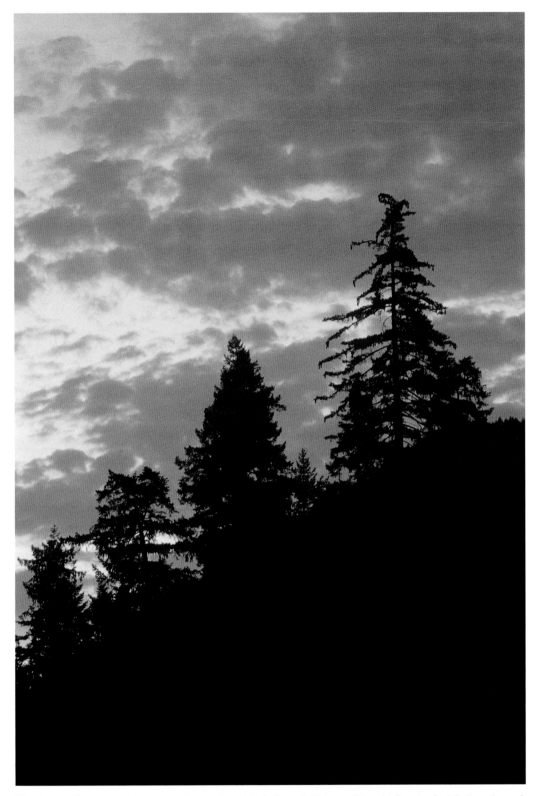

The beauty that surrounds us everyday, such as this design of silhouetted hemlocks mixed with the colors of the evening sunset, can be captured in a photograph.

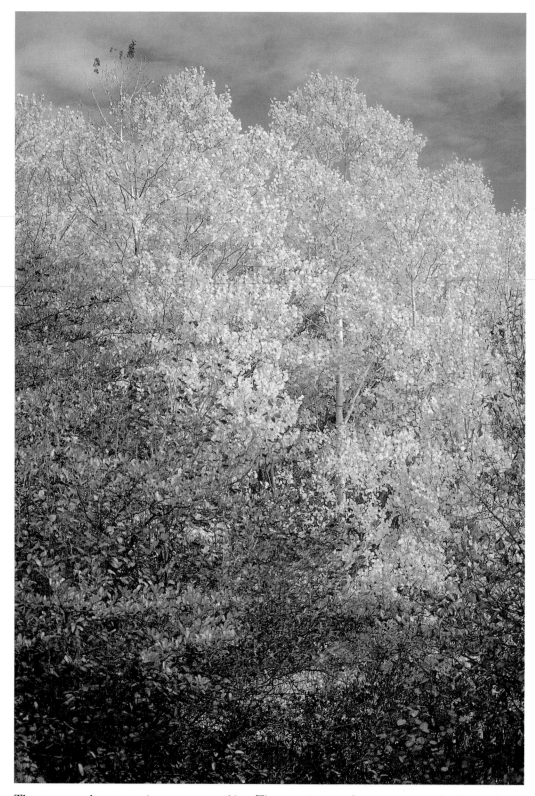

There are countless ways to interpret every subject. These two images of aspens just open the door to the unlimited possibilities.

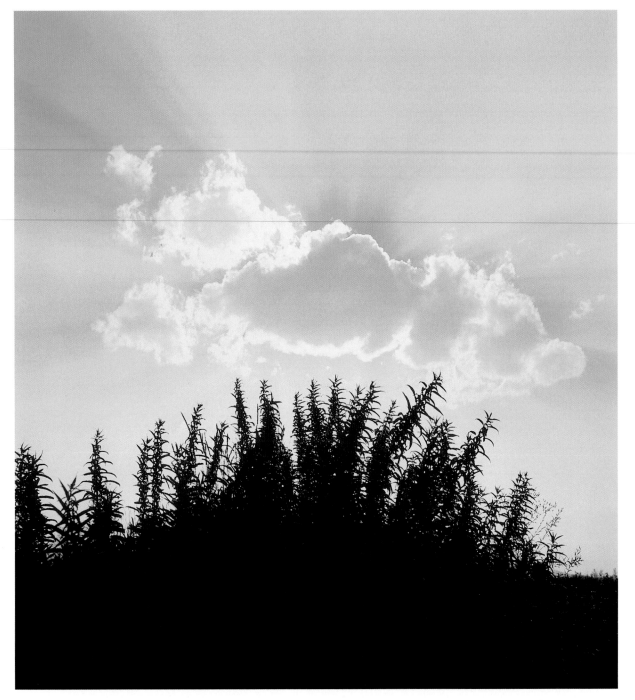

This fairly simple image is a good example of being aware of the changing dynamics of light throughout day and being ready to capture the moment.

hardly worth a notice on the next? Why does that building cast such a warm shadow one day and give you a cold shoulder on another? The successful photographer trains his or her eye to see and record the changes, and to be aware of when and how these changes occur.

Practicing this has two advantages. First, you will enjoy your commute to the office or your walk in the park a little more, knowing that you are observing things that are escaping the average eye. Second, when you do go out with your camera, you will find that you have gradually trained your eye to note the subtleties of the interaction of light and its environment. You'll become adept at finding the good shot.

Each of the following light conditions provides the photographer with a special set of problems—as well as opportunities. Understanding what to expect and how to get the most from each of them beforehand will help you to maximize your time and get the best results.

Bright Sunlight

When I first started to take photographs, I'd pray for sunny, clear weekends. I didn't want to worry about getting my camera equipment wet. I wanted to capture the brightest colors. I wanted to be able to record my outdoor activities throughout the day without fretting about exposure, low-light conditions, or the movement of subjects. Just pour light on it and I'd shoot it.

The problem with that approach? My photos were pretty mediocre. My images were flat, the high-contrast shadows that formed behind that bright light looked like big black holes, and the colors were not crisp and inviting, as I thought they would be.

As pleasant as a sunny summer day may be, bright sunlight is not flattering light. It's actually a little harsh, highly reflective, and high contrast. While it's certainly possible to take great images in bright sunlight, I now find it a little more difficult to work with than the soft, diffused light that I once avoided. I also find that a sunny day often doesn't offer up the character or moodiness of a place that other conditions can provide.

Now I no longer pray for sunny weather. I do my homework and

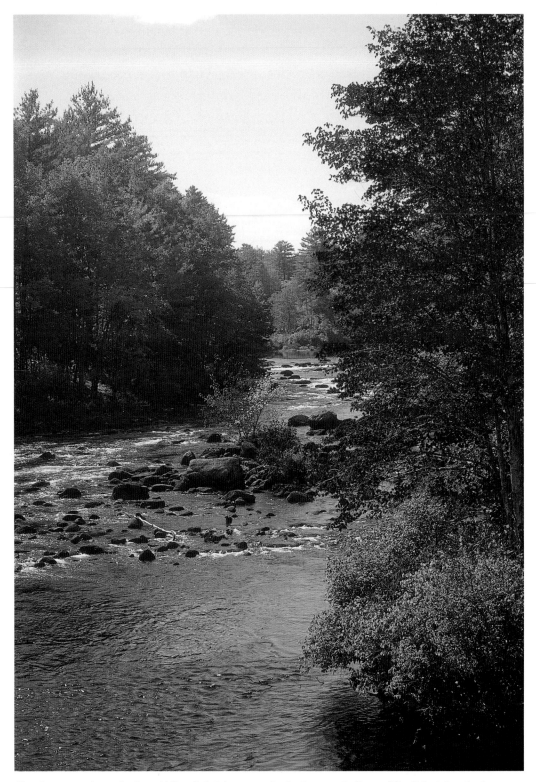

Creating great photos in the middle of a bright sunny day is always a challenge. The light is harsh, the shadows and highlights are high contrast, and often even a polarizing filter will not be able to tone down the reflections.

know what to expect in a given location so that I am prepared for whatever lighting situation that develops. A polarizing filter is indispensable on bright days. It allows me to capture my subjects to full advantage by reducing reflections and harsh glare. Normal highlights are improved and color saturation is enhanced.

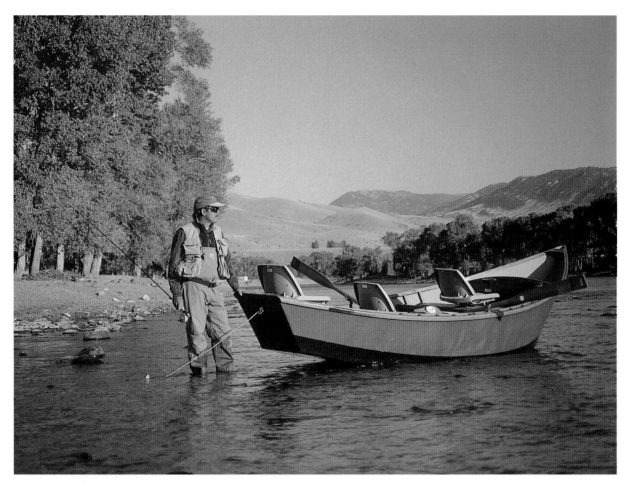

It's not impossible to get good photos in the middle of the day if you use a polarizing filter, as I did here. It will tone down the brightness a stop or two.

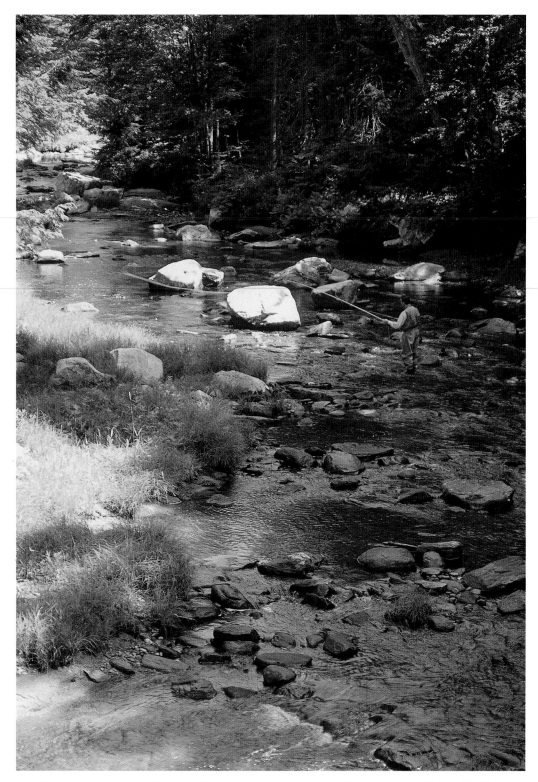

It's difficult to capture good photos in a forested environment, where deep shadows and bright highlighted areas compete with each other. There's just too much contrast between the dark and light areas for the film to record properly.

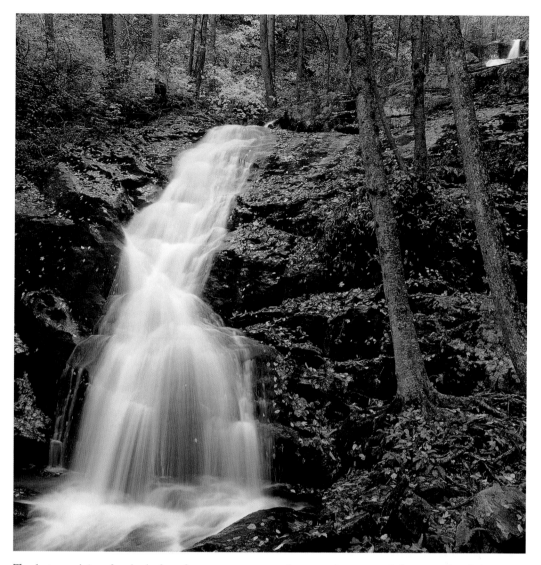

To photograph in a deeply shadowed area on an overcast day, use a shutter speed slow enough to bring everything into correct exposure. Using a tripod, I shot at 1 second at f22 on 100 ISO film.

Deep Shadow

Certain conditions, such as those found at midday in a dense forest or under a thick canopy of trees, can create very high-contrast situational lighting. A subject in deep shadow can vary by three or four stops from a background dappled in bright sunlight. This is often too much for your film to handle. If I find a subject that really wants to be photographed, chances are I will wait and try to visit it again when I think the light may be more advantageous.

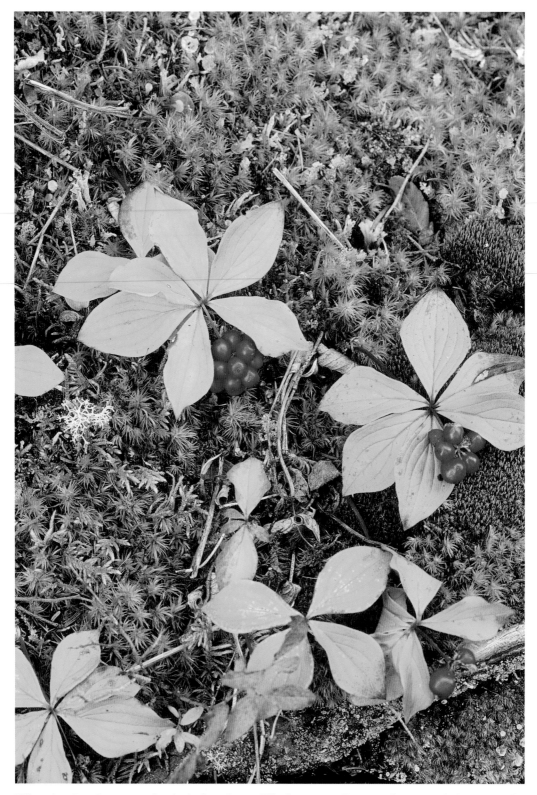

When shooting close-ups in deeply shadowed areas, I'll often use a reflector to throw extra light on my subject. This fill light is often just enough to make the image work.

But if you have just located a wildflower in perfect bloom or a frosty branch that won't be there next time you visit, there are techniques that can help you balance out the light. The trick is to minimize the contrast between light and shadow as much as possible. I carry a simple piece of white cardboard with me for times like these. Sometimes, I can bounce just enough extra light onto the subject with the help of the white card to make the shot worthwhile. Or I can use it to block just enough harsh light off the background to even things out. I will also use fill flash occasionally in these situations. Rather than just using the straight-on flash, I bounce my flash off this same white card, which will make the lighting appear more natural.

Overcast Light

As I said earlier, when I first started to take photographs, I would seldom go out if the day was overcast. On overcast days, the contrast was low and highlights were nonexistent. It wasn't until I started to study the true masters of outdoor photography that I realized that overcast lighting could be ideal lighting.

Few shadows on an overcast day give you real advantages. Everything has a similar reflectance, so it is easier to choose the correct exposure, and the results are more even. Because less light is bouncing around on the subject, the true colors are allowed to come out.

Overcast lighting with a high, bright ceiling can be great light to work with. For shooting any type of action, whether people or wildlife, the bright, high ceiling light gives you a very even, low-contrast light. Because all the subjects in the frame are similarly lit, it's easy to get a correct exposure and pleasing results. This is my favorite lighting for shooting outdoor events. It's a particularly useful type of light when shooting around water, which can create a chaos of reflected light. An overcast day takes away most of those difficulties.

Low overcast light, such as the type you experience on a particularly dreary day, or at dusk on a cloudy day, is a more difficult light to work with. You can still get great photographs, but you have to be more selective in the type you take. Broad panoramas of landscape are particularly unreceptive to this light, so it's best to focus your attention on

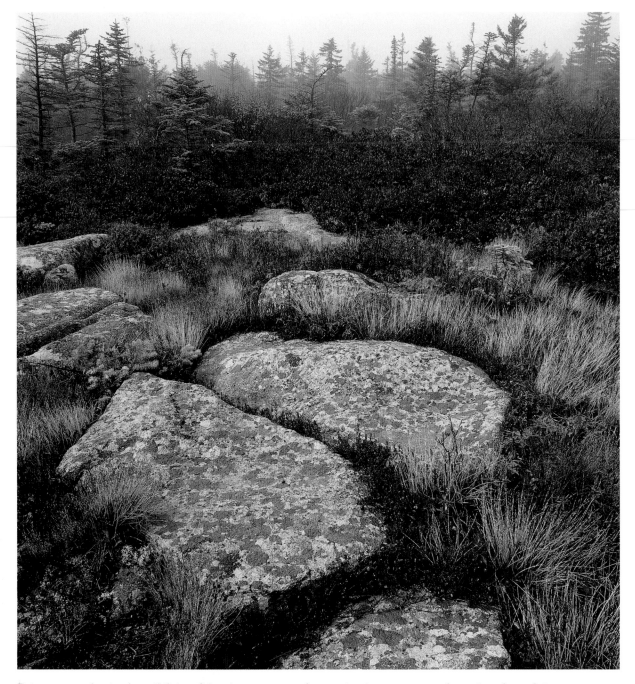

Being open to the visual possibilities of shooting on overcast days can inspire you to create dramatic and moody images.

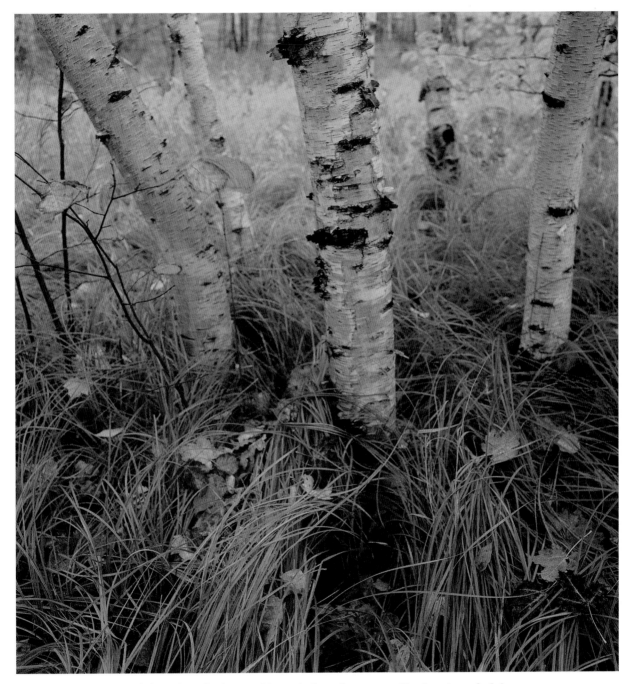

An advantage of overcast light is that it lends everything a similar reflectance, making it easier to find the correct exposure.

subjects that are closer to you. Crop as much of the sky as possible out of your shots because that bank of gray tends to be dull and boring—and usually adds nothing to your final image.

Low overcast light can have its advantages though. It can be an appropriate light for close-up work. You can also find very interesting, moody, and dramatic shots in this light. Be open to its possibilities.

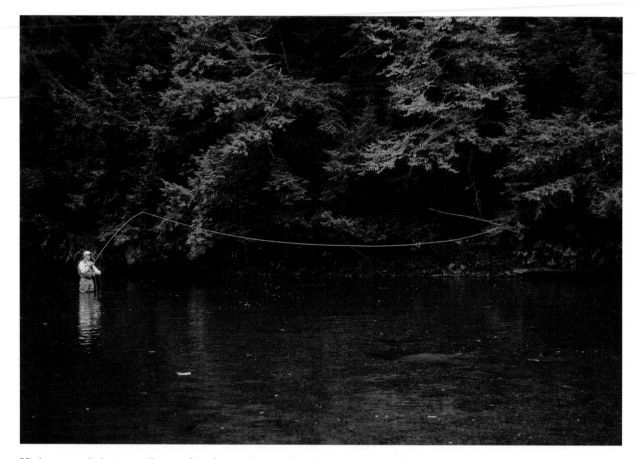

High overcast light is actually one of my favorite lighting situations. It's excellent for almost any type of outdoor activity, and also works well for more intimate landscapes, such as this New England river.

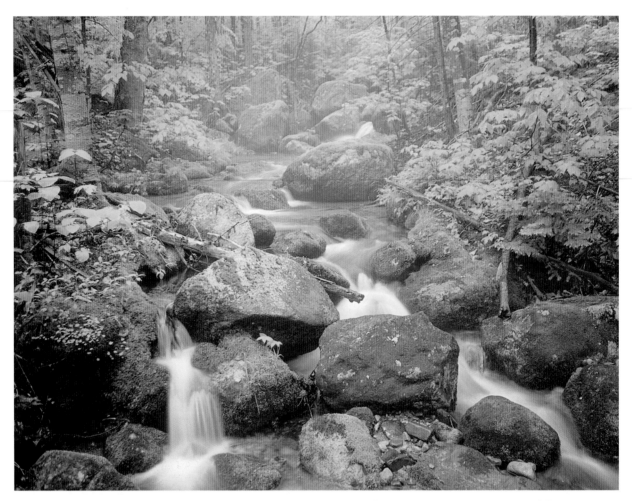

Low overcast light can be difficult for broad landscapes. I try to focus instead on scenes that are more contained. Deep lush green and mossy environments make great subjects under these conditions.

In overcast conditions, I change my objectives and look for close-ups, textures, and artistic designs in the world around me.

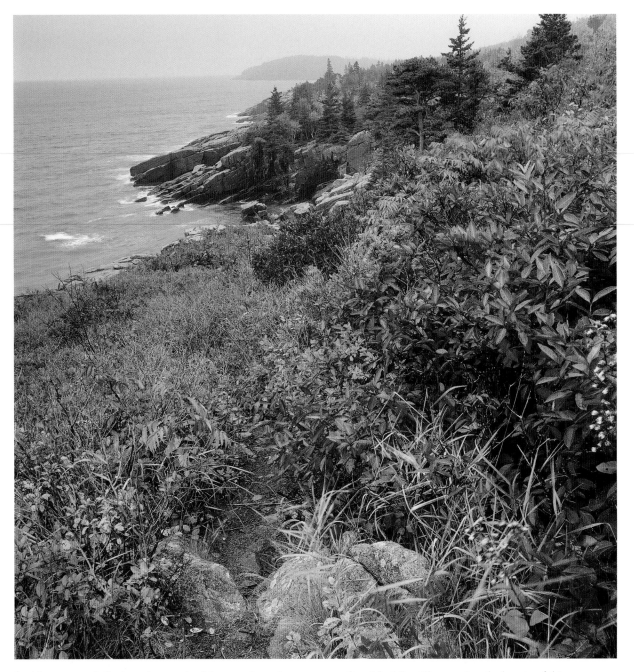

In this seascape, I eliminated as much of the gray sky and gray water as I could while still conveying the beauty of this area. Keeping your equipment dry around water or in wet weather is always a challenge, but always worth the effort.

Lighting Opportunities in Wet Weather

Many people stash away their camera equipment in soggy, uncomfortable weather, such as rain, fog, and mist. But if you are up for the challenge, these conditions can create some of the most spectacular light with which to work. The photographic possibilities under these conditions can be truly rewarding for the determined photographer.

Wet conditions bring out deep, rich colors. This is a time when you can capture a subject on intimate terms. First, look to small subjects and simple vignettes. A raindrop clinging to a brilliant green leaf. A water-laden flower drooping over a stream. A child's face peering out of a rain-splattered window. Images such as these allow us a glimpse of the world that one rarely sees.

Landscape and large-view action shots are harder to capture in this light. The exceptions, however, are often breathtaking. Some of my favorite photographs are of misty forest scenes that evoke deep, mystical emotions. Seeing a deer materializing from the mist to cross a stream or capturing a glimpse of a mountaintop emerging from fog gives you the sense that, for a fleeting moment, you've been let in on one of Nature's secrets.

Front Light

Everyone has seen the snapshot of the family group lined up, smiling into the sunshine. This directional light came from the position of the camera and, while it evenly illuminated the subjects, it produced an artificial, uninspired look.

With front lighting, your main subject will be well lit, but the loss of texture, contrast, form, and shadow flattens it out and takes away from its character. Snap a photo under these conditions and your foreground may be flooded with light, but your background will be left dark and underexposed. Highly reflective surfaces, such as the surface of a lake, skew your camera's meter reading even further, giving you a correct reading of the water, but throwing your principal subject into darkness.

As always, there are exceptions to the rule, and there may be a particular instance when front light shows off the subject to advantage. If

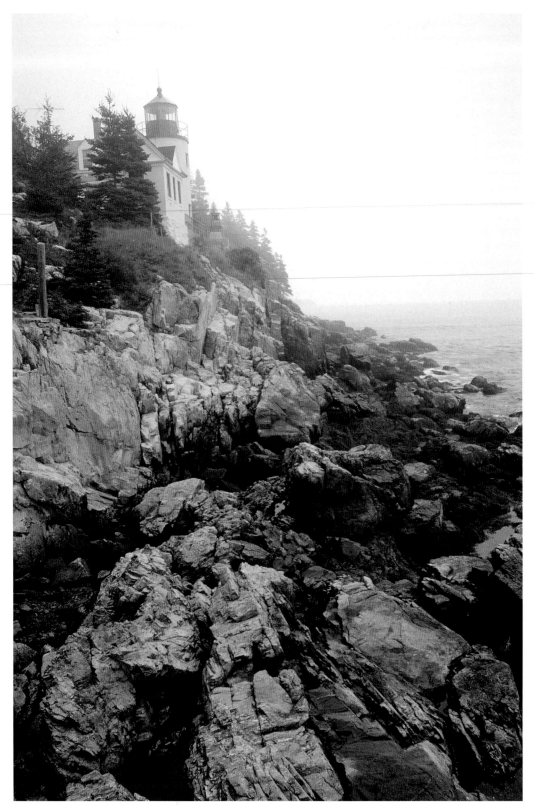

Finding interesting wet weather landscapes is difficult, but they are always intriguingly moody.

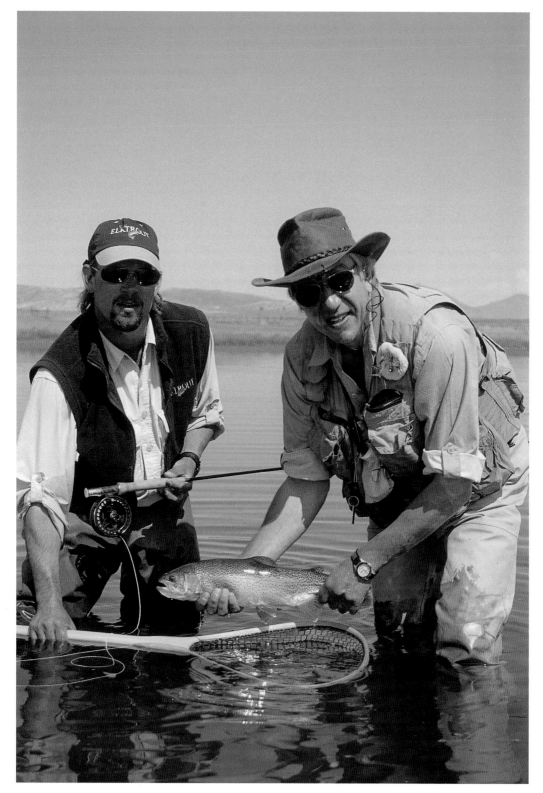

Front lighting is generally unflattering light, even though your subject is well lit. The loss of texture, contrast, shadow, and form flattens out your subject and takes away from its character.

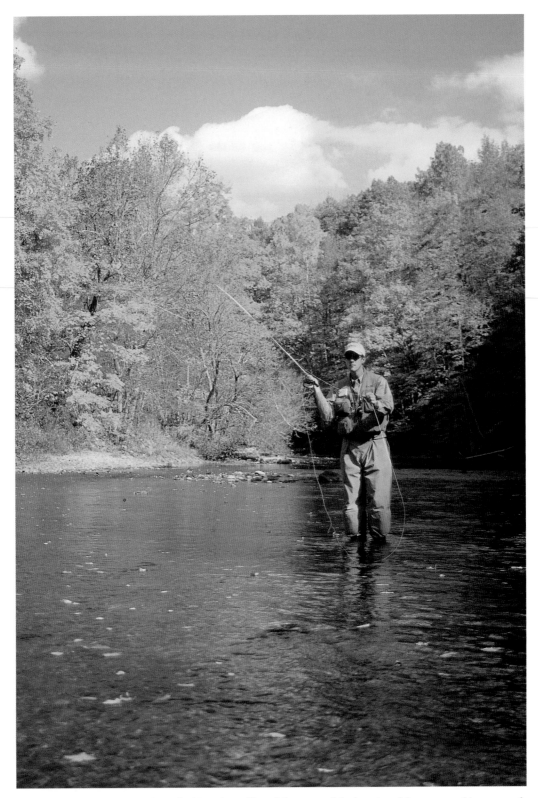

Sometimes front lighting is the only thing that will work because of the location. Move your subject around in the light to determine the most advantageous position.

shadows are unimportant or undesirable to your subject, you may find that the flat, even illumination of front lighting is ideal. Move your subject around in the available light to determine the best position.

Sidelighting

Remember that family in the last section, smiling directly into the sunshine? Turn them around so that the afternoon sun shines down on them at an angle from its two o'clock position, and you have probably turned a disastrous shot into a successful one. Light that reflects off a subject from a right angle to the camera is called "sidelighting." It highlights texture and form well. It's great lighting for faces, bringing

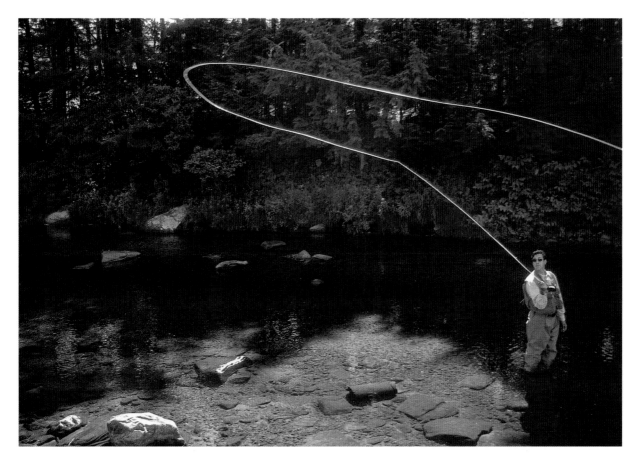

Sidelighting works best for shooting faces or, as in this situation, highlighting the bright fly line against a dark background. Shooting the fly line at 250th of a second in these conditions is the ideal way to show off the classic loop of a fly cast.

out character, and emphasizing form. In fact, it shows most subjects to advantage by creating the impression of volume and depth.

You can fully explore the potential of sidelighting by examining some of your favorite landscape subjects early in the morning or late in the evening. The light at these times of day produces long shadows that can create interesting and unusual images.

Backlighting

Backlighting is one of the most exciting types of directional light. Although it is the most difficult type of light to work with, it can also produce the most dramatic results. Taking advantage of backlighting requires a good working knowledge of metering and exposure techniques. In this type of lighting, the illumination is facing directly at the camera, but is partially blocked by the subject, creating highlights around it. The subject will almost always be one to three, sometimes up to five stops darker than the objects surrounding it. Because of the high contrast between objects in the frame and the intensity of the light, an inexperienced photographer will often be disappointed that the dramatic image he saw in his viewfinder did not translate onto the film.

Choose what is most important in your viewfinder. If you want to see your main subject in detail, take a meter reading directly off it, then step back and shoot using that setting. Crop tightly to remove extremely bright or distracting areas of contrast, such as sky or water.

A gray card, which is a piece of cardboard that is an 18-percent reflectance, middle-tone gray color, may also be helpful in ascertaining the proper exposure. Your camera's exposure meter is set to give a correct exposure with the same 18-percent reflectance tone. A gray card allows you to find the proper mid-tone reading for the light you're working with. Most photography stores and catalogs sell them.

You can achieve dramatic effects by placing your subject between your camera and the sun. Experimentation is often the most rewarding and educational way to work with backlighting. Set up your shot, and then run a range of exposure settings. Make a note of each with a shot number so you can later correspond the image with the setting. You'll find that

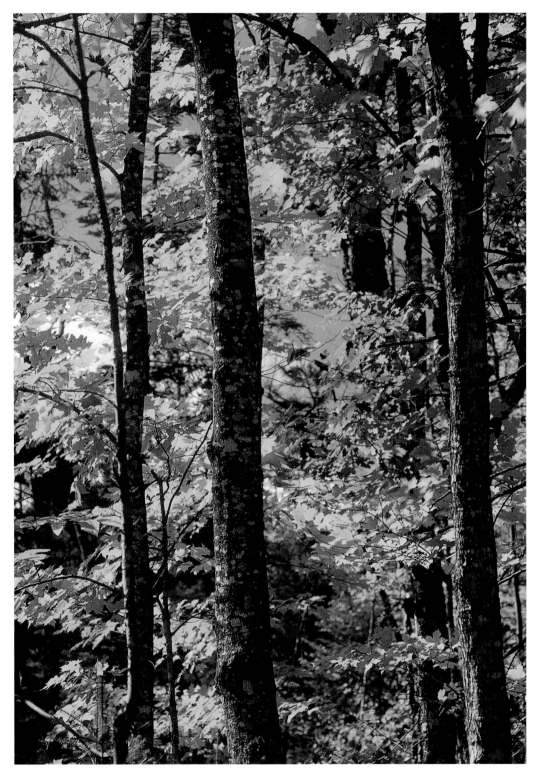

Sidelight can make humdrum shots come alive. The best times of the day to shoot are morning and late afternoon.

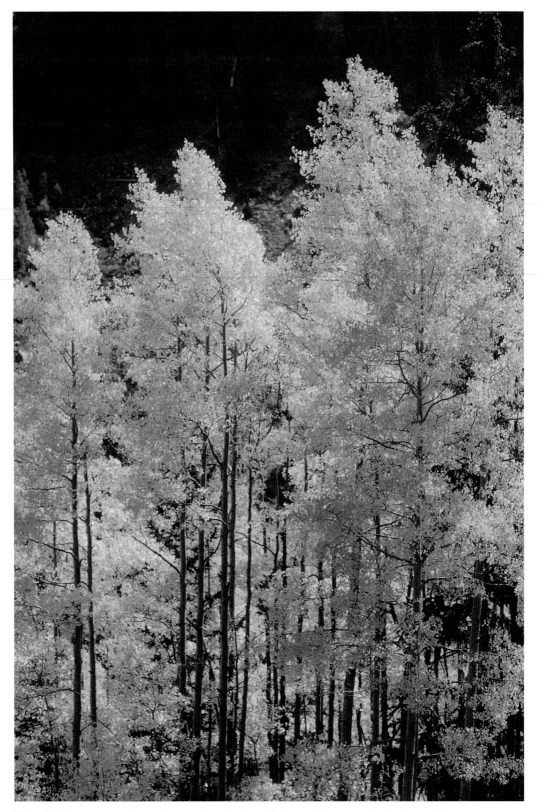

These backlit aspens really stand out against the deep shadow of the mountain background.

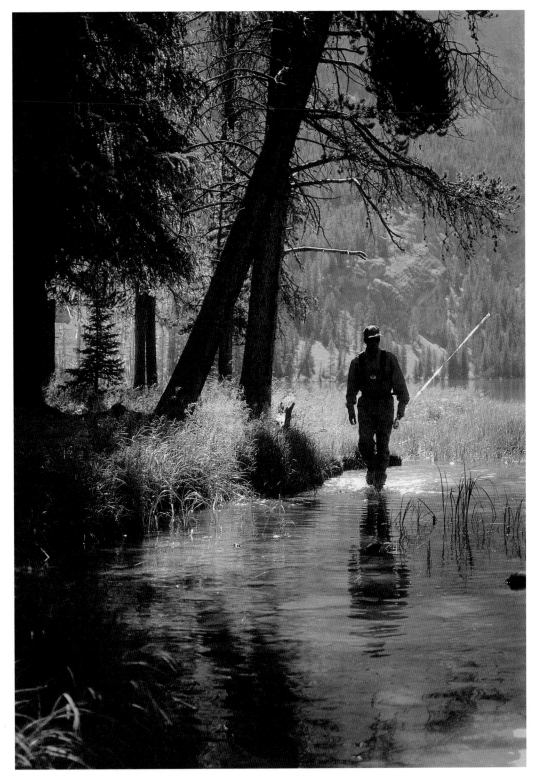

You can achieve dramatic backlighting affects by placing your subject between your camera and the sun. Set up exposures over a wide range of settings to vary your results from a completely dark subject with a bright background to one with a halo or light flare around it.

you get a wide range of effects, from a completely darkened subject with a bright background to one with a halo or light flare shooting around it.

Adjusting the amount of direct sun that is covered by your subject can give you various degrees of controlled sun stars or flare effects. Flare can cast a shimmering aura around your subject. To capture this *rim lighting*, you'll need to find an exposure that is somewhere between the bright light and the dark tones of the subject. Try to meter right to the subject, then open up one stop.

Those sun stars or flares make interesting effects, but make sure you only get them when you want them. A dirty lens often causes unintentional flare. To avoid flare, make sure the front and rear elements of your lens are clean because any type of debris on your lens can increase the chances of a flare spot.

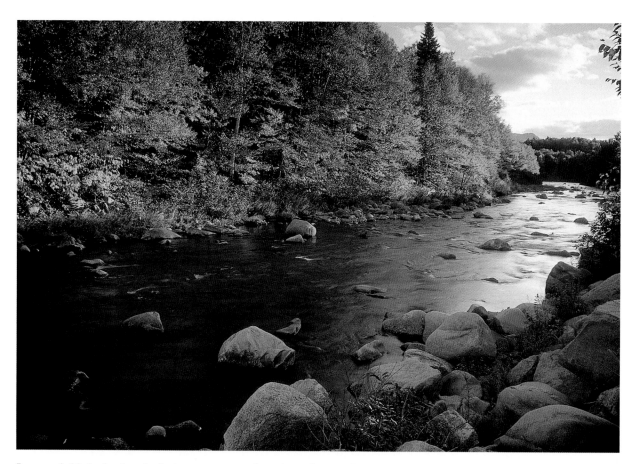

Low-angled light develops in the hour or so around sunrise and sunset. It is usually a warmer, softer, and more dramatic light to work with.

Low-Angled Light

The edge of light is the time of day when many outdoor photographers are most actively searching for that perfect shot. Low-angled light develops within an hour or so around sunrise and sunset. It is a warm and soft light. If the day isn't overcast, it can set everything aglow, and the outdoor world seems inclined to show off the best of its moods and emotions.

This ephemeral light complicates things for the photographer, however, who must keep a steady eye on exposure settings. The light at dawn and dusk shifts moment to moment. As the sun goes up or down, the light intensifies or weakens, constantly changing these settings.

To capture these many moods requires quick thinking or a lot of bracketing—or both. Check your meter reading often. Make certain that the sun is not in the viewfinder when you take your meter reading. Take your reading off the sky to either side of the sun or on grass or foliage nearby that's a middle tone compared to the surrounding colors. Then recompose with that setting and shoot.

Winter/Snow Lighting

A snowy condition can be difficult for photographers who have no experience with it. It is somewhat similar to backlighting situations— the bright reflective nature of the snow acts like a light source and skews your camera's meter toward that brightness. The snow will be one to three stops brighter than your subject, depending on how sunny it is and how much light is reflecting off the snow.

If you have a spot meter in your camera or can move close enough to your subject, take a reading directly off the subject without interference from brighter snow around it. Lock in that setting and recompose. If this is impossible, let your camera take the average meter reading and then open up your aperture one to two stops. If it's a bright day and your subject is in shadow, open up three stops. If possible, it's always best to bracket in these conditions to ensure you get the shot you want.

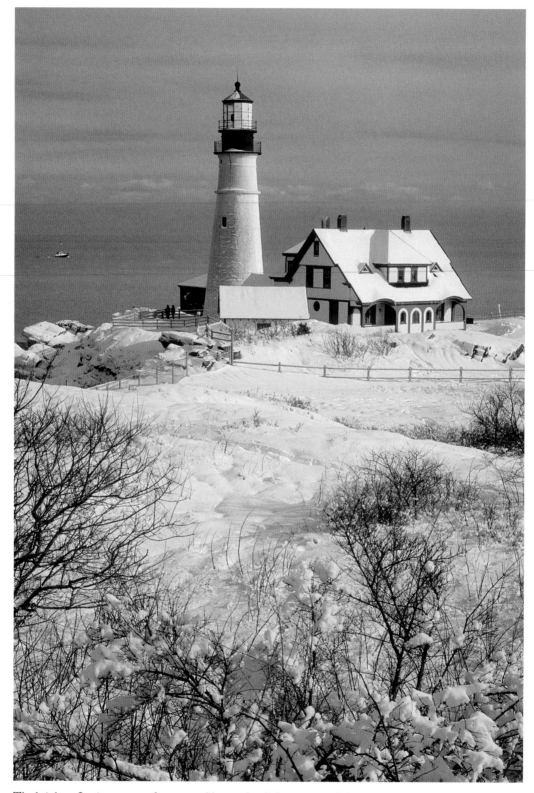

The bright reflective nature of snow acts like another light source and skews your camera meter. The snow will always be one to three stops brighter than your subject, so you need to adjust for this.

Silhouettes

A dark silhouetted tree against a blue sky. The clean outline of a mountaintop against a bank of clouds. Silhouetting your subject is one of the most dramatic techniques available to the photographer.

You can create silhouettes any time of the day by choosing an exposure setting based on the lighting behind your subject. To do this, take a meter reading of your subject and then stop down two to three stops, depending on how bright the conditions are. For example, if your average meter reading is f8 at 125, if you stop down two stops, it will be f16 at 125.

Atmospheric Lighting

Rainbows are probably the best example of atmospheric lighting, but other examples are worth noting. Smoky or dust-filled skies can render a deep, reddish cast to the sunset. The virga effect is an unusual phenomenon in which streaks of precipitation, such as rain or ice, fall from clouds but evaporate before reaching the ground. Some of the most dramatic photographs were shot during times of unusual atmospheric conditions.

Painting with Light

As a photographer, the entire world is your inspiration. Light is your paint and film your canvas. The limitless color palette, and ever-changing atmospheric conditions offer the photographic artist a constantly renewed canvas—if you are open to the possibilities.

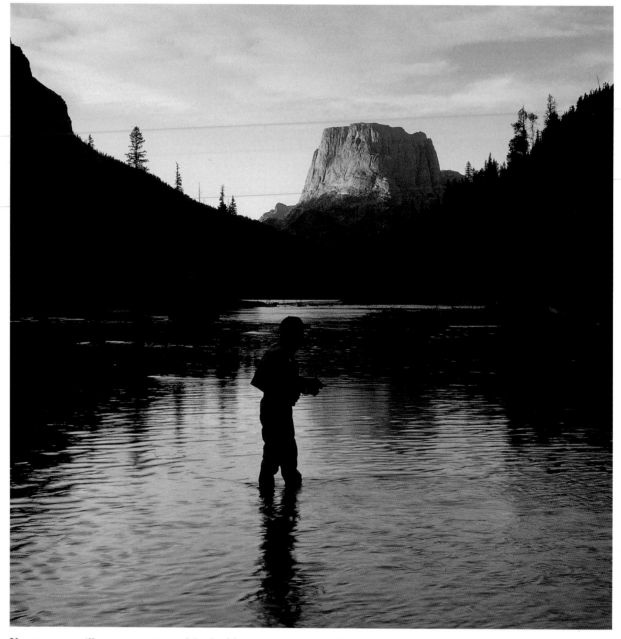

You can create silhouettes any time of the day. Take a meter reading off your subject and close down two to three stops, depending on how bright the conditions are. Each stop down will make your subject darker.

Atmospheric lighting can be powerful. The smoke-filled skies of a forest fire intensified the reddish cast of this sunset.

As a photographer, the entire world is your inspiration. The limitless color palette, and the ever-changing lighting conditions offer the photographic artist unlimited opportunities.

Exposure

What is exposure? If we follow our "painting with light" analogy, the exposure setting is like the painter's brush. It is what determines how much light will reach the film.

There are two ways to determine how much light will reach the film. The first way is to adjust its *duration*; the second is to adjust its *intensity*. Duration indicates how long the film is exposed to the light. It is controlled by the camera's shutter speed setting. How wide the lens aperture is opened controls the intensity.

Light comes into the camera through the lens. Aperture and shutter speeds are each represented in increments called "stops." Stops either double or halve the amount of light that is exposed to the film. Controlling the amount of light that reaches the film is achieved by combining the settings of these two controls to create the effect you want.

Shutter speed and aperture provide different attributes. It is imperative that you understand them *independently* so you can use them *together* to have total control over your final image. But the bottom line is that shutter speed and aperture always work together. Both are needed to control and manipulate the light reaching your film.

Shutter Speed

The shutter speed setting measures how long the shutter will be open to let light reach the film plane. This setting controls the appearance of

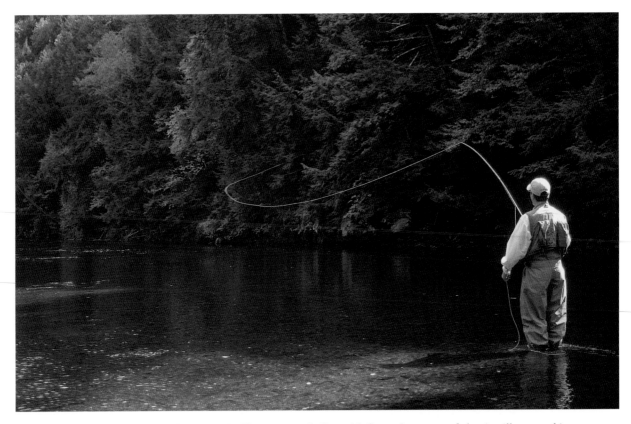

The best shutter speed to shoot a fly line is 250. You can stop the line with faster shutter speeds but it will appear thinner.

motion in your images. A faster speed generally freezes action, while a slow speed blurs it. By adjusting the shutter speed, you can arrest the action of a bird's wing or show it in a blurring flight. Shooting a running animal or human at 1/30th of a second will leave an image of blurred colors. At 1/250th, you will certainly completely freeze a human. To stop a cheetah at 70 miles per hour, however, you might need to go to as high as 1/500th.

Most camera shutter speed dials start on the low end with "B," which stands for *bulb*. When your shutter speed is set at B, the shutter will stay open for as long as you hold down the shutter release. Most cameras will allow you to set shutter speeds as slow as one to three seconds or more.

Shutter speed settings go as high as 1/1000th to 1/8000th of a second. We refer to shutter speeds using the denominator of the fraction. A speed of 1/125th of a second is called "125," which is how the shutter speed is usually designated on a camera. The higher the number, the faster the shutter speed. High numbers indicate smaller increments of time.

To capture colored reflections in moving water, experiment with different shutter speeds. The photo on the left was shot at a quarter of a second. The photo on the right at a full second. The slower the shutter speed the smoother and silkier the moving water will appear.

This sequence demonstrates how just changing the shutter speed can change the appearance of motion in a photo. Clockwise from top left: 1/30, 1/4, 1/2, and 1-second exposures.

The most common shutter speeds that you'll find and use on various cameras are 1 second, 1/2, 1/4, 1/8, 1/15, 1/30, 1/60, 1/125, 1/250, 1/500, 1/1000, 1/2000, and 1/4000.

In my introductory classes, I always ask students to open up the back of the camera without film in it. This exercise will help you to better understand how the camera shutter works.

First, take the lens off the camera or open the aperture on the lens to its widest opening. Set your shutter speed dial at B and press the shutter release. The shutter will stay open as long as you hold down the button.

Now set it at 1. A full second seems like an eternity.

Work your way through the entire set of shutter speeds on the dial and watch how quickly the shutter opens and closes. This will give you an idea of how much light reaches the film for each shutter speed.

As you work from one second up through the faster shutter speeds, the time is cut in half for each subsequent shutter speed. A 1/2 second is half the time and half the light of 1 second, 1/125 is half the time and half the light of 1/60. The faster the shutter speed, the less light that is allowed onto the film.

Aperture

Aperture is the measurement that tells you how large your lens opening is. This, along with the time the lens is opened, controls the amount of light that will reach the film. Aperture settings are known as "f-stops," and are designated by the lowercase letter "f," followed by the size of the opening. You'll find these settings on the lens itself.

Aperture controls depth of field, which is the portion of the image that will be in sharp focus. The smaller the aperture opening, the greater the depth of field. The larger the aperture opening, or f-stop, the shallower the depth of field.

Every lens has a different range of aperture settings based on the speed of the lens. Lens speed is determined by the largest aperture setting for the lens. A lens is called "fast" if it has wider aperture openings, such as f1.4 to f1.8. The largest aperture opening of a slower lens may be as high as f2.8 or f5.6.

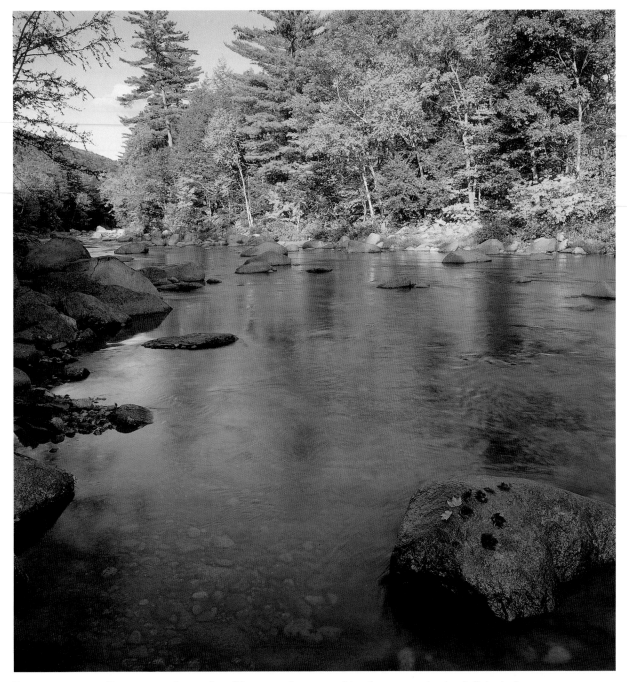

By using a very small aperture setting, such as f22, you can keep everything from your tripod to infinity in focus.

Aperture controls depth of field. In this photo, I purposely wanted to keep the depth of field shallow to draw attention to the subject within the surroundings.

The photo on the left was shot at an aperture of f8 at 60. It has a much narrower depth of field than the photo on the right, which was shot at f32 at 1/2 second to give it enough depth of field to keep all the flowers in focus.

Aperture settings range from f1.2 to f32. The smaller the number, the larger the lens opening. The higher the number, the smaller the lens opening. An f1.4 aperture creates a larger opening than f2.8. An f32 aperture creates a smaller opening than an f16.

The most common apertures are f1.4, f2, f2.8, f4, f5.6, f8, f11, f16, f22, and f32.

Each number in the series, from the largest opening of f1.4, transmits half as much light to the film as the previous number. That means that f2 transmits half as much light as f1.4 and f11 allows half as much light as f8 to reach the film.

Do the same exercise described above for shutter speeds, this time for apertures. Take the lens off the camera. Look through the rear of the lens and turn the aperture settings from largest to smallest. Setting the aperture at f22 or f32 will create a pinhole opening. Turning it to the lowest number, f1.4 or f2, will create an opening almost as large as the diameter of the lens.

Combining the Elements

Achieving control over your exposures is a combination of choosing the right aperture and shutter speeds. There are often many correct combinations that will achieve the proper exposure, but not every combination will look the same. If you choose a high shutter speed with a large aperture opening, you will capture the motion of a central subject in sharp detail, but most of the background will be in soft focus or out of focus. Choosing a low shutter speed with a small aperture will give you excellent depth of field, meaning almost everything in the frame will be in focus, although any movement may be blurred. Try shooting several exposure combinations of one subject and see the differences in sharpness or depth of field for yourself.

When using small aperture settings, such as f32, you will almost always need to use a very slow shutter speed. The lens opening is so small that in order to give the film enough light for proper exposure you will need to keep the shutter open longer to compensate. When shooting landscapes in early morning or late evening, I often use an aperture setting of f32 with a shutter speed setting of one or two sec-

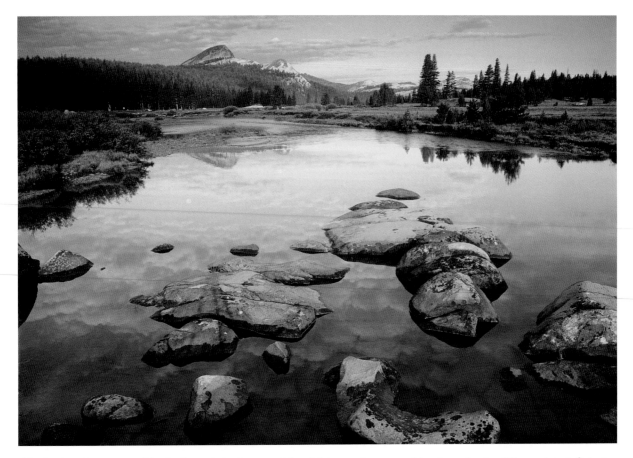

All of us have been inspired by the dynamic landscapes of Ansel Adams, where everything from the tip of his toes into infinity is in focus. To achieve this yourself, you need to use a very small aperture and usually a slow shutter speed, such as f32 at 1 second.

onds. This allows me to have virtually everything in my viewfinder in sharp focus—as long as nothing in the image is moving! The combination gives me tremendous latitude to create expansive landscapes. Of course, when shooting at these settings, I always use a tripod.

Metering Light

Virtually all cameras today offer more than one metering option. Despite the fact that most cameras have a setting that automatically takes an assessment of the subject field and renders a perfectly good exposure, it is important for you to understand how your metering systems work and how to override them. Even the most sophisticated metering systems are not right 100 percent of the time.

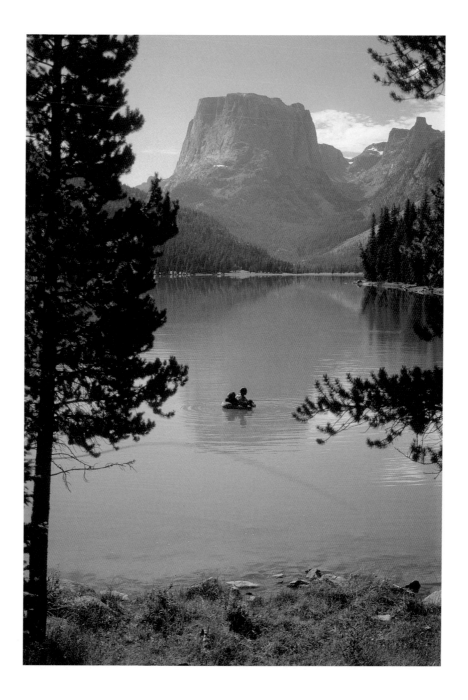

I used a center-weighted exposure metering to capture this fly fisherman in the Wind River Range because my main subject was centered in this photo.

Common metering choices are:

Center-weighted metering: Center-weighted metering measures all the light in your frame, but concentrates on the 60 to 75 percent in a circular section of the middle of the frame. This would work well if you always placed your subject in the center of a photograph. But, as you'll discover later in this book, keeping the subject in the center can be very dull after a while. You'll want the flexibility to move your meter reading to selected areas within your frame and still control your exposure to compose photographs that are more dramatic.

Matrix metering: Matrix metering takes readings from all areas of the photo frame and averages these readings to give you the most balanced metering system. In professional cameras, you can adjust the importance of various areas within the frame so that the averages are tilted

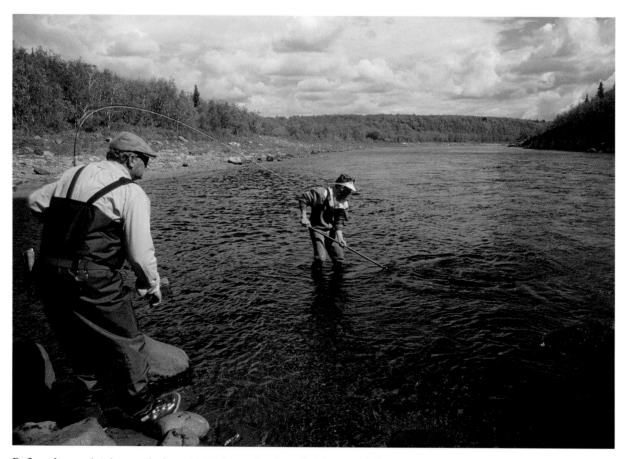

Reflected water, bright sun, shadows, highlights, and action all add up to a difficult lighting situation. Using the matrix metering system allowed the camera to evaluate all of these factors to give me the best exposure.

towards those areas. This is the most accurate metering system for automatic settings and sports action. Each camera manufacturer has its own version of matrix metering.

Spot metering: This is the most accurate metering system when you want to have total control of your exposure. Spot meters cover a circular area in the frame from 1 to 10 percent of the image, allowing you to take very specific readings off portions of the image. I use my spot meter more than 90 percent of the time when using a tripod, shooting landscapes, or snapping close-ups. Using the spot meter helps me to have precise control over my exposures.

When shooting outdoor action, I will more often use my camera's matrix metering, which can adjust faster than I can to moving subjects and changing light.

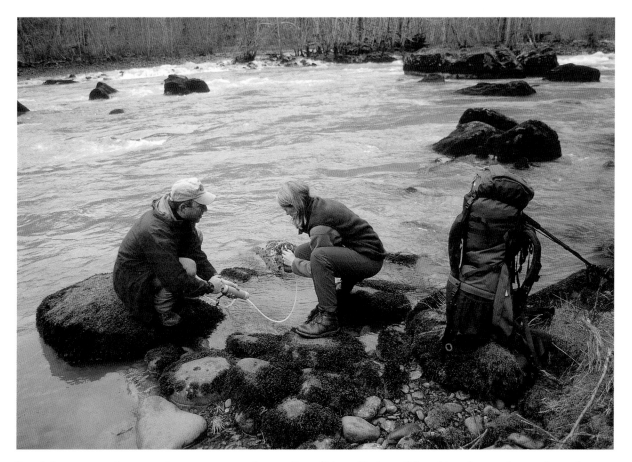

I used the spot metering system in my camera to take a reading off the red jackets of the subjects because I wanted to make sure these were bright and true colored.

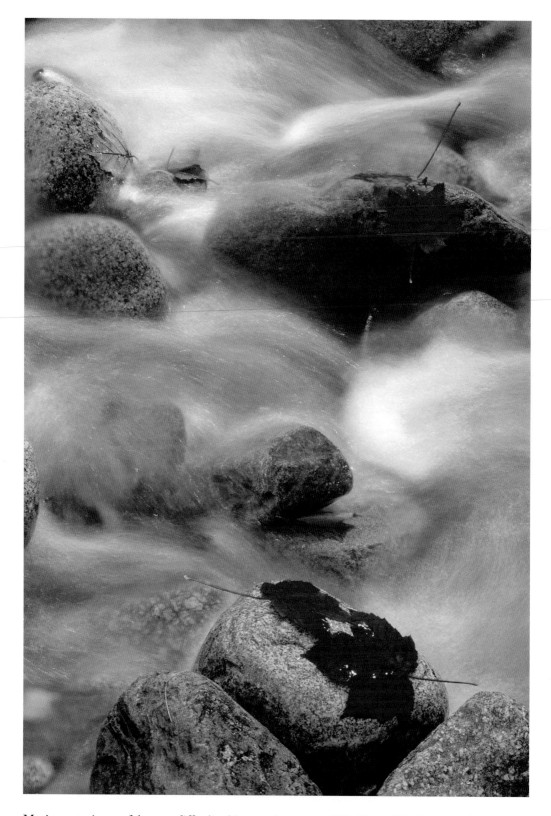

Moving water is one of the most difficult subjects to shoot successfully. Most of the time, any of your meter readings alone will be incorrect. I used a spot meter to take a reading off a nearby medium-toned green bush, and then another off the gray rocks. I averaged the two readings to give me the highlights I wanted.

Outwitting Your Light Meter

Certain lighting conditions can confuse the camera system. What you want to be well lit may not be what the camera is concentrating on. So even if your camera has automatic exposure settings, read the manual thoroughly, and learn how to override the automatic setting. Once you know how your camera works, it's usually a simple matter to adjust your meter setting to suit your needs. Having a fundamental understanding of the way light works and how your camera measures light is the key to successful photographs.

Film

What is film? Film is the photographer's canvas. The film you choose affects the type of image you eventually produce.

When I give slide shows, often members of the audience will complain that they have photographed the same area, but with different and often discouraging results. One of my first questions is always: "What type of film were you using?" They often answer that they used print film. But it is very difficult to compare results between slide film and print film. The way they interact with light is so different; one could never hope to achieve equivalent results. Therefore, it is important to know what your objectives are when choosing film.

How Film Works

Film reacts to light in two fundamental ways. The *light speed* of the film indicates how receptive it is to light. This is a carefully designated variable that is indicated by its "ISO" number (thus called because this index was adopted by the International Organization for Standardization). *Color sensitivity* refers to film's reaction to different colors. This elusive quality is not designated by any specific measurement. Rather, you will find that certain films tend to produce truer reds or blues than others. Some films produce softer, more pastel colors; others produce colors that are more vibrant.

Much of the joy of outdoor photography is in the details of light and

There are myriad film choices today in both print and slide formats. It can be a little daunting choosing the right film for the job. I chose a very saturated film slide to shoot the markets of New Orleans to bring out the wild array of colors and textures.

Each film has specific characteristics, and color sensitivity is a major factor in the differences between different types and how they interpret color hues. Here, I used a warmer-toned film to emphasize the warm orange and yellow foliage.

color. By learning what films bring out the colors you want to emphasize under certain light conditions, you will lay the foundation for all your future photographic success. Once you have a grasp of these fundamentals, the sky is the limit. These are essential tools for making your individual statement about how you see the world and you'll find dozens of ways to manipulate every scene.

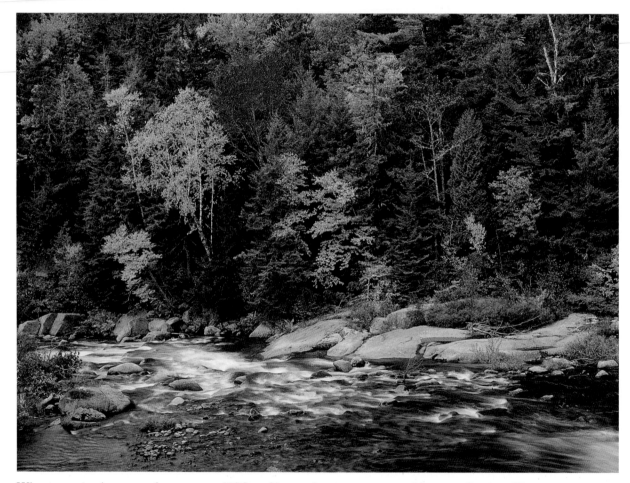

When you unite shutter speed, aperture, and ISO, or film speed settings, you get a wide range of options. How you arrange these three settings makes all the difference in the final image captured on film. Here, f16 at 1/4 second on 50 ISO Fuji Velvia smoothed the ripples of this stream and saturated the color of the autumn leaves.

Film Speed

Three factors merge to turn light into a photograph. The first two, of course, are shutter speed and aperture. The third factor in achieving correct exposure is the speed of your film. Film is rated in stops just like aperture and shutter speed. The combination of aperture, shutter speed, and film speed must always work together to achieve correct exposure.

Film speed is designated by the film's assigned ISO number. This is a measurement of the film emulsion's sensitivity to light. Each change in film speed will either double or halve the amount of light needed to properly expose the film. The lower the ISO number, the less sensitive the film is to light and the longer it will take to expose the film. Conversely, the higher the ISO, the less time or light is needed to properly expose the film.

A film with an ISO rating of 50 is a slow film. An ISO speed of 800 is a fast film. A film speed of ISO 100 is twice as fast or twice as sensitive to light as an ISO 50 speed film and a 200 speed is twice again as fast or light sensitive as 100 and four times faster or light sensitive as 50. Conversely, 200 speed film is one half as fast as 400 speed film and 100 speed film is one half as fast again as 200 ISO film or one quarter the speed of 400 speed film.

The most common film speeds are 25, 50, 64 (a one-third stop faster than 50), 100, 200, 400, and 800. Film speeds can be found up to 3200, but these ultra-fast films are generally used for special situations.

What happens when you unite film speed, shutter speed, and aperture setting? A range of options! For example: Using 100 ISO film with an f16 aperture and a 125 shutter speed will give you proper exposure in bright sunlight. If you change to a 200 film speed, you will need to adjust for a film that is twice as fast or twice as sensitive to light. You can change your aperture to f22 to reduce the amount of light entering the lens and leave your shutter speed at 125 or you can leave your aperture at f16 and change your shutter speed to 250. Either setting will decrease the amount of light by half, giving you the same exposure, but the first one, with the smaller aperture, will give you more depth of field. The second one will allow you to stop faster action. Your choice will be based on the effects you want in your final photo.

There are many different combinations of settings that we could work through in the example above, but the most important thing to

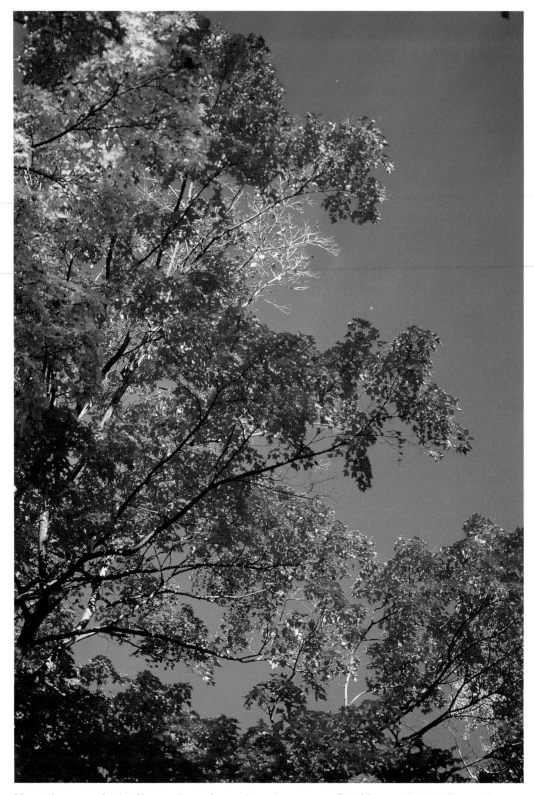

Naturally saturated color film usually needs no other enhancements. By adding a polarizing filter to the photo of brightly colored leaves on saturated film, the color is over the top and not believable.

remember is that every time you change one of the three factors, you must adjust another. They always interact.

Often, you'll need to make adjustments to aperture and shutter speed very quickly in order to capture a scene. Fumbling with settings takes up valuable time and, before you know it, that special moment is gone forever. Take the time to learn the relationship of film speed, aperture, and shutter speed. Everything else builds from these basic principles. Once you have these three elements clear in your mind and you can make adjustments quickly and on the move, you will be well on the way to becoming a successful photographer. Your properly exposed photographs will multiply tenfold.

Color Sensitivity

Film manufacturers can modify emulsion so that almost any degree of color sensitivity can be achieved. Though the differences are subtle, you may find that after you've been shooting a while, you'll develop a preference for certain types of film for certain types of shots.

Fuji films and slower-speed Kodak slide films, such as Ektachrome 100S, 100SW, and 100VS, as well as print films such as Kodak Royal Gold 25, tend to be a little "warmer" than other films. They bring out a scene's yellows and reds. Other slide films tend to be more neutral, such as Kodak Ektachrome 100 Pro and 100 Plus Pro. They're more balanced between the reds, blues, and greens.

Knowing your films and how they will render color can make a significant difference in your final photos. I learned this lesson the hard way many years ago. I did a shoot where half the film was fantastic and half was awful. I couldn't figure out why until I remembered that halfway through the shoot, I had run out of film. I'd gone into the nearest town to stock up, but the shop there didn't have my regular brand of film. I picked up what seemed like a good substitute.

The second batch of film produced very cool results compared to the first. My vivid reds and yellows were muted on the cooler film. They just didn't have the same "pop."

I now have very definite film preferences for various conditions. You will find similar differences among color print films. Read the manufacturer's literature that comes with your film, then experiment, and decide which films are right for you.

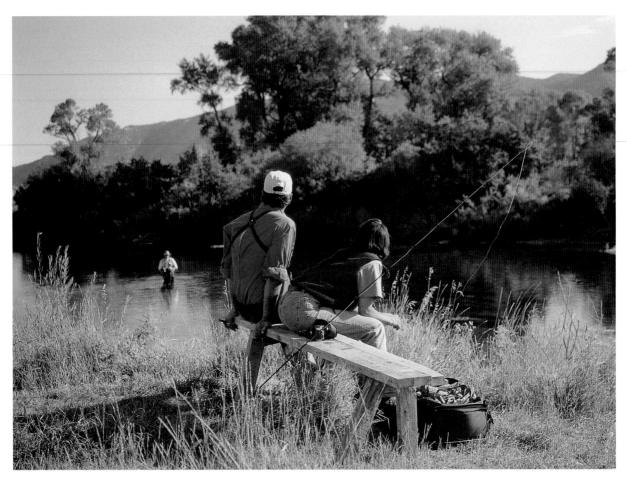

Slide films such as Fuji Velvia, Ektachrome 100SW, and 100VS are highly sensitive to color and are considered saturated or warm films. Royal Gold 25 is an example of a print film that gives very saturated colors.

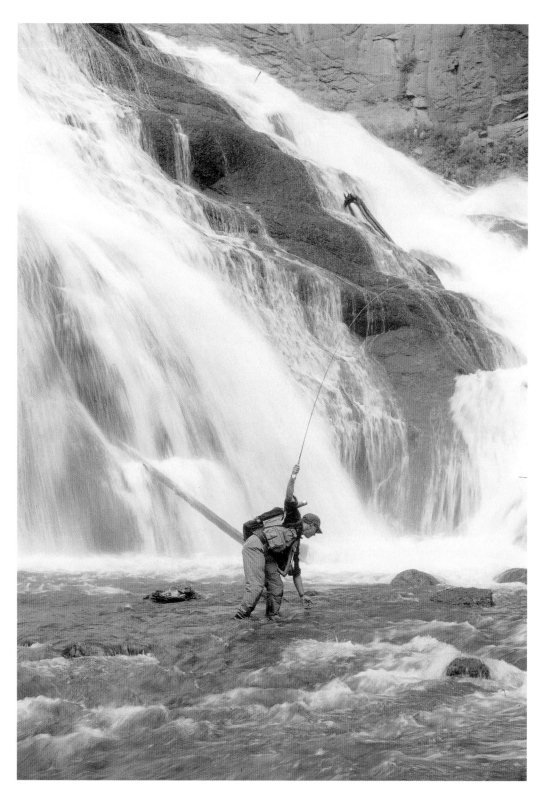

Like the film I used here, many films offer neutral tones, or even render basic colors almost pastel. Other films are designed to enhance skin tones for portrait work. Experiment with a variety so that you know what to expect from your film choice.

Choosing Film

Color prints, color slides, black-and-white prints, and digitally stored images all have distinct qualities. Each has its advantages and disadvantages. Your enjoyment of the finished photos will be greater if you take the time to match your film to your needs.

The newest cameras don't use film at all, but rather record an image digitally. There are advantages and disadvantages to these systems, too. See Chapter 12 on Digital Photography for an overview of how these images are collected and stored.

Color Print Film

Print film is the most commonly used film in the world. Almost 95 percent of all film sold is color print film. The vast majority is sold to the average amateur photographer. For that reason, there is a wider choice of print film available than any other kind of film. Processing options are also varied and available nearly everywhere.

Print film has a wider exposure latitude, or tolerance, than slide film. This is a huge advantage to the amateur photographer because it gives greater latitude for error. Color variations are subtler, so the photographer can be as much as one or two stops off from optimal exposure and still get a reasonably well-exposed shot.

Print film is also known as "negative" film. It is processed into a negative, which then must be made into a color print.

The Advantages of Color Print Film:
- It is easy to find almost anywhere you travel.
- It comes in many different varieties to cover virtually any type of lighting condition and situation for indoor and outdoor activities.
- It is easy to use and forgiving, reducing the chance of exposure errors because it offers wider latitude in contrast ranges.
- It can be easily processed in many locations.
- It can be processed relatively cheaply or made into custom enlarged prints.
- It is easy to enlarge, to share, and to file or store.

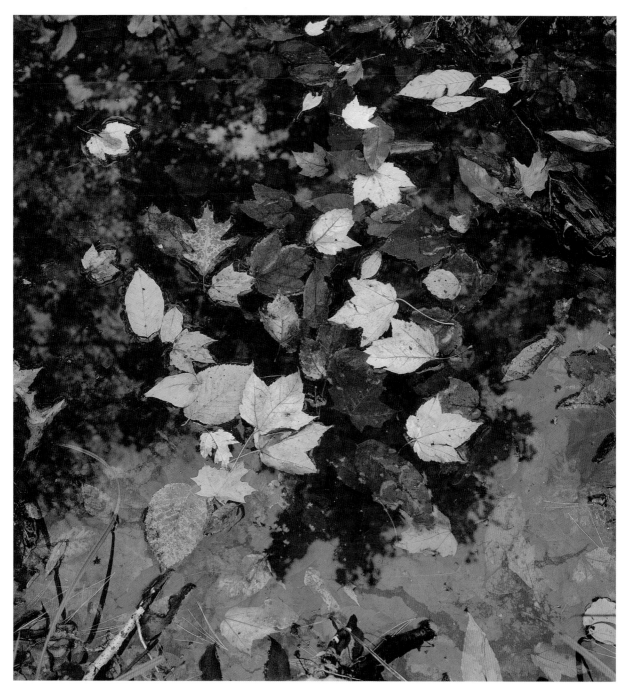

For this photograph of leaves in a small pond, I wanted true colors. I chose Fuji Provia F-100, a film that I knew would render colors very close to what I see with my own eyes.

Color Slide Film

I generally work with color slide film. Slide film has long been the preferred film choice of the majority of professional photographers. It's the film that's used in most publications and advertising. It's more difficult to use, however, because it has a narrower exposure latitude and it's a little higher contrast than print film.

Slide film is also referred to as "transparency," "reversal" film, or "positive image" film. The film images you shoot in your camera are the same images that you will get back after processing. There is no negative to be printed.

Color slides are viewed by transmitted color, rather than reflected color as with print film. That makes for brilliant intensity and color saturation. Of course, to share them with others, you need to either project the image or create an enlargement.

Color slide film tends to produce higher contrast images than print film does. This means there is less latitude for overexposure or underexposure, so there's more chance for error. I generally underexpose my slide film slightly, maybe a third stop below the meter's suggestion. I find that I can create richer, more saturated colors that way. If you decide to try this, bracket a third stop over and under so you can see the difference for yourself. This will increase the chances that you have captured the image the way you want it.

There are two types of slide processing systems. Kodak's Kodachrome films use a C41 process and must be processed by a Kodak facility, so your local film dealer may have to send your film away. This may take two to five days. Most other slide films are E-6 process, which is generally available locally. Most professional E-6 processing firms can turn film around in three to four hours.

Slides can be made into prints, but after seeing the brilliance of the original slide image on screen, a print can sometimes be a disappointment. I always work with a professional lab to convert my slides into prints. It's more expensive, but I can tell them how I want my prints to look and they will compensate to achieve that result.

Slow-speed slide films offer the finest grain and sharpest images. These are films with an ISO of around 50. Films with an ISO in the 50 to 100 range are the finest, sharpest grain color films available. They offer a full range of colors, from the most dynamic, brilliant gem tones to the subtlest shades of pastels. Higher ISO films allow you to shoot in lower light or in situations where you are capturing motion.

To compare how different films interpret a scene, note the differences in the photo above, taken with Fuji Velvia, and the photo below, taken with Agfa RSX.

Advantages of Slide Film:
- Best for publication purposes.
- Finest grain and high contrast.
- Great for slide shows and projections.
- Offers brilliant transparencies.
- Can also be made into color prints.

Black-and-White Film

Black-and-white film still has a place in the photographic world despite the constant bombardment we receive from the colorful world around us. It is still used for many forms of journalism, documentaries, and fine art. It also continues to be a favorite for individuals who love to develop their own prints in the darkroom.

Technology today offers many superb black-and-white film choices in a vast range of film speeds from ISO 25 up to 3200. Kodak's T-Max emulsion system offers some of the finest grained and versatile black-and-white films available. Ilford also offers an excellent range of black-and-white film choices.

Advantages of Black-and-White Film:
- Great for fine art photography and the home darkroom.
- Offered in a wide range of speeds and grain structures, including film for highly specialized lighting

Advanced Photo System Films (APS)

APS incorporates new technologies into a complete photo system, which includes cameras, films, and processing. It is designed to be very easy to use, so that even the less technically oriented person can get good photos.

One of the nice features of the APS system is that you can choose your print format when you take the picture, from standard to panoramic. APS uses a smaller negative format than 35mm, so it is not the best choice if you want to make prints larger than 8 x 10. But for standard prints, it is a very good choice.

This easy-to-use system gives you virtually no control of your final image, however. Exposure choices are made for you.

Advantages of APS:
- Ease of use and lowest risk for error.
- Foolproof film loading.
- Easy storage and retrieval of your pictures.

Quick Tips For Sharper Photos

- Use a tripod.

- Use the finest grain film or lowest ISO you can get away with for the lighting conditions.

- Use a cable release.

- Use the best lenses you can afford. High-quality lenses are designed for tack-sharp images.

- Use your mirror lock-up feature.

- If hand-holding, use an image stabilizer or vibration reduction lens.

- Use a monopod, a shoulder stock, or place your camera on a solid platform such as a rock or table if you don't have a tripod.

- Add weight to your tripod, especially if it's a lightweight one.

- Always work within the rule of setting a shutter speed no slower than the focal length of your lens.

- Use a fluid tripod head to dampen movement.

<div align="center">

4

</div>

Equipment

Ever-changing technology has made choosing camera equipment more bewildering than ever. First-time buyers must decide whether to purchase a conventional film camera or whether to make the plunge into the new and constantly changing world of digital.

And those of us who have complete systems are faced with similar issues. How do we upgrade the systems we have? Should we change over to digital, instead?

This chapter will take you through the choices that are available in conventional film systems. See Chapter 12 for a complete outline of digital technology.

Cameras

A vast array of cameras is on the market today, from the simplest point-and-shoot variety to the most complex large-view cameras. Following is a rundown of the basic categories of film cameras you'll find.

Disposable Cameras

Why would any self-respecting photographer even mention the category of disposable cameras (commonly called "throwaways")? Because, under certain conditions, they can be downright handy.

These are very basic, affordable, plastic-body cameras that are used

to take one roll of pictures. After you shoot the film within the camera, return the whole camera for developing and recycling.

The major camera companies have made great strides with these funny little contraptions. There are no settings to adjust, no focus to change. That means there are serious limits to the quality of the image you will produce, but, on the other hand, you can take them any-where—without having to fret about caring for them. Kodak and Fuji even offer disposable cameras for underwater photography.

I find them useful for business travel for quick journalistic shots or when scouting areas for later use. I often stash one in my fishing vest. If I unexpectedly land the fish of my dreams one day, I'll be able to record it for posterity. Or, if I like an area and want to remember to come back to it, I may quickly document it with my disposable. And, of course, they are great for vacation or party candids.

Point-and-Shoot Cameras

The typical point-and-shoot camera is a cinch to use. Many of them come as complete packages, with built-in zooms and flashes. These cameras will focus and choose your exposure automatically, allowing you to shoot quickly. APS (Advanced Photo System) cameras, based on a new film format, camera, and photofinishing technologies, are the latest versions of point-and-shoot cameras.

Of course, your ability to manipulate an image is limited with point-and-shoot cameras. There are no settings to adjust, so the camera selects exposures for both light and speed. Another thing to keep in mind: The viewfinder you look through is separate from the lens, so you don't see *exactly* what the lens sees. Occasionally, this may cause your image to be slightly cropped; you may not capture everything you saw through the viewfinder.

Choose a point-and-shoot camera that comes with a built-in zoom lens. This will allow you to shoot vistas at wide-angle ranges or bring people in closer at telephoto range. Built-in flashes are very handy too, even when working outdoors. They are smart enough to know when to fill in a little extra light, as well as how to prevent "red-eye," a condition that makes the eyes of your subjects glow red on the finished print.

For the individual who doesn't want to invest a lot of time and/or money on their photography, point-and-shoot cameras are great choices. But if you are willing to invest a little more time and money,

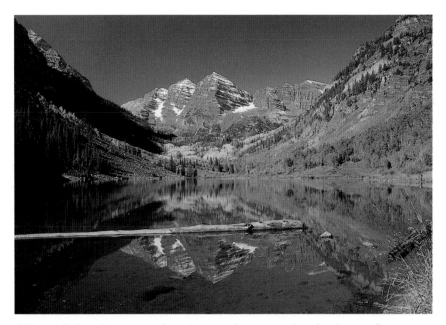

Although I shoot 90 percent of my photographs in manual mode—because I want complete control of every aspect of my images—I will use the aperture priority setting for certain landscape shots.

you can enter the world of unlimited possibilities with today's SLR and larger-format cameras.

Single-Lens Reflex Cameras (SLR)

Because you are reading this book, I assume you want to get serious about the quality and consistency of your photographs. To do this, the most versatile camera you can purchase is the single-lens reflex camera, or SLR. The SLR uses the same lens for viewing the scene as it does for recording the image on film. This gives you more control over composition and focus because the scene that is recorded on the film is exactly as you see it through the camera's viewfinder.

The other great feature of the SLR is the interchangeability of components. A variety of lenses, filters, viewing screens, flash units, motor drives, macro adapters, and many other accessories can be added to create a truly customized camera. Interchangeable lenses are available in a wide range of sizes to suit almost every need, giving you the versatility to capture your image in many different ways.

Today's SLR cameras range from the basic, manually operated types that cost a couple hundred dollars to highly sophisticated models that have electronic controls for everything from exposure and focus to built-in film advance—and come with correspondingly higher price tags.

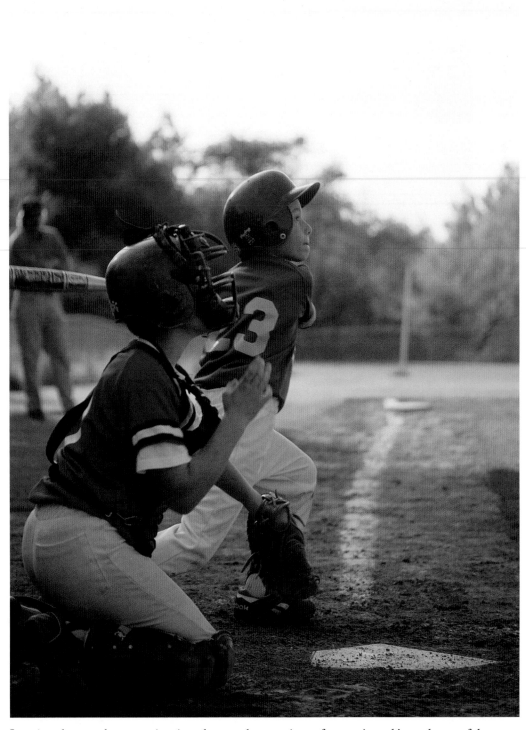

In action photography, or any situation where you have motion or fast-moving subjects, the use of shutter priority works very well.

Before you even go to the camera shop, take some time to research various camera models. Pick up one of the monthly photo magazines to get an overview of the kinds of cameras that are available in your price range. Then consider which features are most important to you.

A key decision is the level of automatic metering ability you want. Most cameras these days come with a variety of exposure options. One mode selects your aperture as well as your shutter speed. Another mode allows you to choose the desired aperture while the camera selects the appropriate shutter speed. Or you can select the shutter speed and the camera selects the aperture. If you enjoy composing and shooting, without having to fret too much over settings, you may find one of the automatic options is right for you. If you take a lot of action photographs that require speedy shooting, a fully automatic option may better suit your needs. (If you are confused about metering choices, go back and review Chapter 2. Metering options are fully described there.)

As easy as they are, automatic settings are not foolproof. Because complex lighting conditions, such as bright sunshine and deep shadows, can fool a camera's meter, automatic metering provides an accurate exposure only about 80 percent of the time. You will still need to have a good understanding of f-stops and shutter speeds in order to choose the metering mode that is right for the conditions in which you are shooting.

Automatic metering cameras generally have a manual option, so that you can have complete control over all exposure factors. For some photographers, the ability to manipulate exposure is an essential part of their work. They want to control factors such as motion, depth of field, and color. If that's want you want, make sure the camera you choose can be easily switched from automatic to a fully manual mode.

Once you have done your research, go down to your local shop and take a look at the cameras. Check how they feel in your hand. Do you like the weight? Is the handgrip comfortable? How easy is it to adjust the settings? Does the viewfinder come with a focusing screen that is easy on your eye? What about the film advance? Is it a standard single-shot advance, or does it come with an automatic motor drive that allows you to shoot several frames continuously? Let's consider these options one at a time.

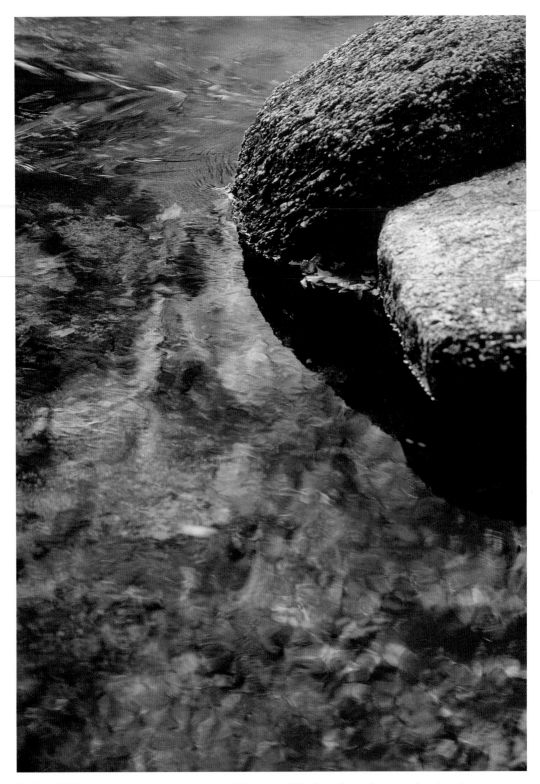

Reflected light in moving water presents one of the most difficult and complex metering situations. Knowing how to manipulate shutter speed and aperture to give you the results you want is essential. This is a classic example of when you have to have your basics down cold.

Focusing Capabilities

It's becoming ever more common for cameras to come equipped with auto-focus options. Auto-focus allows you to shoot quickly without fussing with fine focus. This is especially handy when shooting moving subjects, such as a fisherman in mid-cast or an eagle soaring overhead. I use Nikon's automatic focus tracking that automatically engages when my subject moves and locks on it—even if something else momentarily gets in the way. The auto-focus feature can give an accurate reading in low-light conditions where eyesight may fail. All auto-focus lenses give you the option of switching to manual focus for tighter control of your subject.

Focusing Screens and Viewfinder Accessories

The focusing screen is a piece of glass inside the camera upon which the image is viewed. Take a look at the screen inside the camera you're considering. Most cameras come with a split-image screen, which works by aligning the image in the center of the viewfinder as you turn the focusing ring of the lens. On many cameras, the focusing screen can't be changed, so be certain you are comfortable with it before you buy. The ability to change the screen is usually only available on the higher-priced cameras. I personally like the ability to change my focusing screen and eyepiece, because it makes it easier for me to see and focus my images.

If you choose a camera with this option, you will find more than a dozen different screen types to choose from. I like a clear matte screen because it lets me see the entire image without distraction. Other screens have grids that line up horizons and vertical lines.

As I've gotten older, I find that I need to wear glasses more often than I once did. But putting my glasses up to the viewfinder bothers me. Therefore, I use an eyepiece correction lens. This attachment screws on to my viewfinder to help me see more clearly. A few manufacturers make adapters for a wide range of eyesight requirements, so ask your camera shop what's available for your camera.

Depth-of-Field Preview

I find the camera's depth-of-field preview button a must, particularly when I am setting up a still-life shot or composing a landscape. This

I use my depth-of-field preview button to evaluate my image on every landscape photo before I shoot to ensure I have key elements in focus.

button closes the lens to the aperture setting you've chosen, so you can see exactly what elements of your image will be in sharp focus.

Motor Drives

Motor-driven film advance is built into most of today's cameras. You can buy a camera that offers a simple one-frame advance that conveniently moves your film ahead after each shot or you can choose a camera that offers a range of film advance speeds. A low-speed advance shoots two frames per second (fps)—enough to allow you to capture a sequence of normal-speed events. High-speed advance shoots four frames per second or more. These allow you to catch the action of a fighting trout or the movement of a retreating deer.

You will certainly find a fast motor drive comes in handy, particularly if you like to shoot wildlife or sporting subjects. But you may not need it if you prefer landscape and close-up photography. A fast motor drive

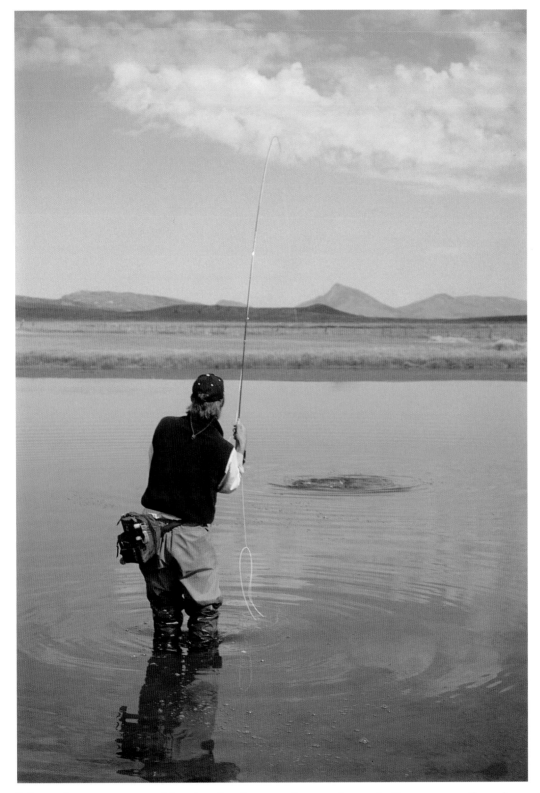

I almost always use my motor drive when shooting any action scene because it allows me to stay focused on the subject and not worry about advancing film.

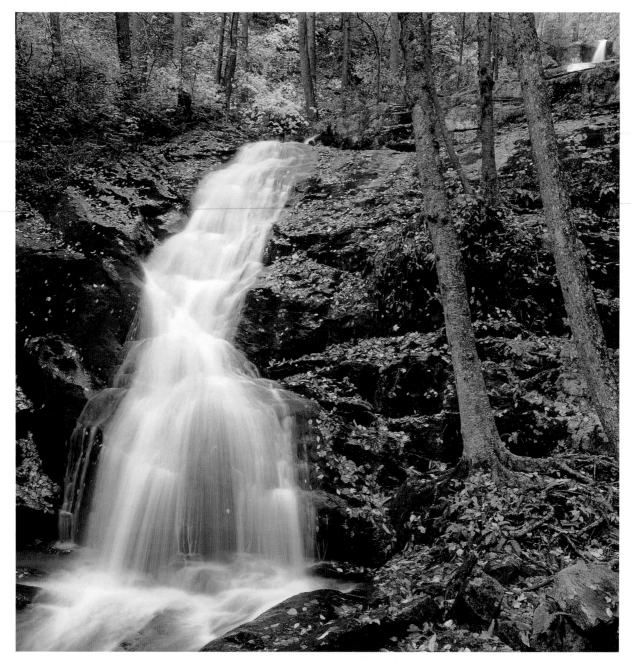

Medium-format cameras and lenses deliver larger, higher-quality images than 35mm.

makes a camera heavier. And quick film advance makes it easy to shoot a lot of film quickly.

Medium- and Large-Format Cameras

I'll quickly cover larger-format cameras. This designation refers to a wide range of cameras that shoot film that is larger than the standard 35mm film used in regular SLRs. One advantage of these larger-format cameras is obvious: You get larger film images that make it easier to produce high-quality enlargements, which is particularly important if you need to make very large prints.

Medium-Format Cameras

The most common of the medium-format class is the 645. It produces an image that is about three times larger than a 35mm image, 6 x 4.5 centimeters. Many of these cameras are only slightly larger than the more sophisticated 35mm cameras. They also offer many of the same features and accessories found on the 35mm.

A standard square format used by many professionals is the 2¼. This format produces an image that is 2¼ x 2¼ inches or 6 x 6 centimeters. There is also a slightly larger rectangular format that produces a 2¼-x-3¼-inch image, sometimes referred to as a "6 x 7." Hasselblad, Mamiya, and Pentax all offer excellent medium-format systems. Medium-format view cameras are the most common choices for working pros. They deliver larger, higher-quality images, offer most of the advanced features of the 35mm SLR cameras, and are a good compromise on weight. The larger image size is also an advantage with editors. It is just easier to see these larger images on a light box. They stand out and are often chosen over the smaller 35mm slides.

Large-Format Cameras

Large-format view cameras are used primarily in landscape and industrial photography, where depth-of-field and perspective controls are important. The most common of these is the 4-x-5-inch film size. It comes only in sheet film and each shot is a separate sheet of film.

These cameras can be very cumbersome. They tend to be large and relatively heavy. They are also more difficult to focus. Most show the image upside down; it takes practice getting used to seeing that way.

Most of them also need a dark cloth to cover the viewing area or at least a large viewing shade so you can see the image.

So why go through all this trouble?

Because the final photographs are spectacular. When a photo editor receives a set of 4-x-5 transparencies and compares them to equivalent 35mm slides, the game is over for the 35mm. It's an easy choice for the editor. The quality of the larger transparencies is so much better, and they can often be reproduced at 100 percent or at a ratio of 1 to 2 for a magazine cover.

Nonetheless, for most of us, the disadvantages of large-format cameras outweigh the advantages. They are slow, heavy, and expensive. The film is difficult to deal with and also expensive. And accessory options are limited. But, if you want to specialize in landscape, architectural, or studio photography, this may be the best format choice for you.

Lenses

A camera body cannot do anything without a lens attached. When you buy a camera with interchangeable lenses, you open up a world of possibilities. But how do you decide which lenses to include in your camera system? First, consider the types of subjects you intend to shoot. If you are going after big game, invest in the best long telephoto lens you can afford. But if you think you will do a mix of things, as most of us do, consider the better telephoto zooms that pack a range of options into one lens.

Lenses are available in a wide range of prices. Yet, it always comes down to one thing—the quality of the glass in the lens. The higher the quality of the glass and the more advanced the coatings on the glass elements in the lens, the more expensive it will be.

Is it worth the extra money for a better lens? Absolutely! You should always buy the best lens you can afford. The better the quality of your lenses, the sharper your images will be. Why are the images in *National Geographic* always so sharp and vivid? Because these pros do not compromise on lens quality! They use the very best lenses they can buy—and it makes all the difference.

The photo above was taken using a slightly wide-angle 35mm lens. The photo below was taken using a short telephoto 105mm lens.

To change the perspective of your landscape photographs, try shooting with a 400mm telephoto lens, as I did for this shot of the Maroon Bells.

Lenses are described by their focal length, or angle of view, as well as by their maximum aperture opening, also known as lens speed.

Angle of View

Lenses are designated by their angle of view. The angle of view describes how wide or narrow a view the lens takes in. A wide-angle lens, such as a 28mm, has a wide angle of view. A telephoto lens, such as a 300mm, has a narrow angle of view.

Angle of view is determined by the focal length of the lens, which is measured from its optical center to the film plane when the lens is set on infinity. This is normally measured in millimeters. Lenses are described in terms such as "50mm," "105mm," and "400mm." Lenses most commonly range in size from the ultra-wide-angle 15mm lens to the very long 600mm telephoto.

Lens Speed

The lens speed is determined by the largest size the aperture opening forms by the lens diaphragm. As I described in Chapter 2, aperture is measured in f-stops. Aperture f-stop numbers are determined by dividing the lens focal length by the diameter of the aperture. For example, a 100mm lens has an optical diameter of 25mm. 100/25 = f4. The largest aperture setting on this lens will be f4. Fine for most purposes, but if you are working in low-light or action conditions, you may feel the need for a "faster" lens, one that can bring in a greater amount of light.

In order to move to a 100mm lens with a maximum aperture of f2, the optical diameter of the lens will be 50mm. The advantage of this larger aperture is that you can shoot in lower light because you have gained two stops of light. The additional light these lenses will capture makes them ideal for low-light situations when shooting wildlife or to stop the action of a sporting event. But that increase in optical diameter means it has more optical glass and more weight, which makes it more expensive to manufacture. The most common subjects and lighting conditions you shoot will determine how much lens speed you require.

Lenses for Your Gear Bag

Every photographer's ideal field outfit is different. Many photographers advise you to have a range of lenses that are roughly double one another. Following this advice, a good all-purpose field outfit would probably include a 24mm lens, a 50mm lens, a 105mm lens, and a 200mm lens.

But only you can decide what lenses best fit your photo style. I skipped the 200mm lens in favor of a 300mm, because it's more useful for wildlife. I also enjoy having a macro lens; it's perfect for shooting close-ups of flowers and insects. Don't hurry your decisions. The more often you shoot, the better you'll understand your own needs.

Following is an overview of your lens choices.

Wide-Angle Lenses

Short focal length lenses are called "wide-angle" lenses. These lenses allow you to see more of the scene through the viewfinder than you

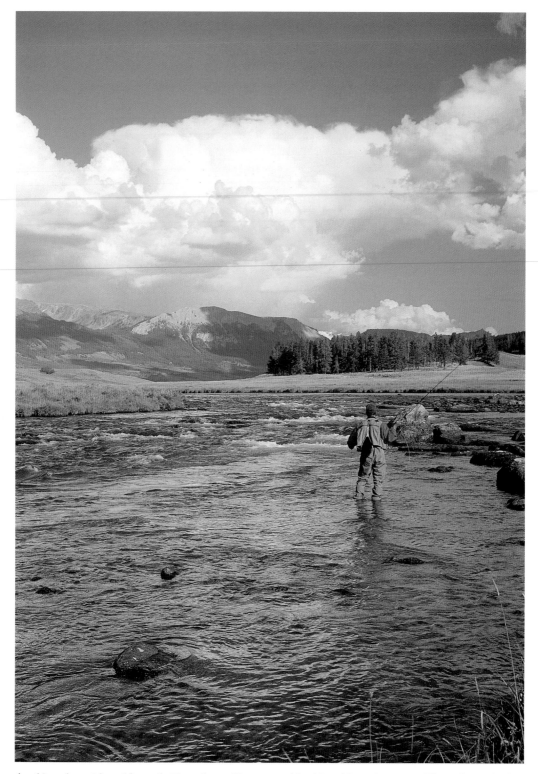

A subject shot with a wide-angle 28mm lens will appear to blend into his environment. The wide-angle also conveys a strong sense of the size of this western panorama.

would see with the naked eye. Wide-angle lenses accomplish this by bending the light that passes through them, optically shrinking everything they see, and fitting more onto the viewing screen.

The wide-angle extreme of this category is the 6mm fish-eye lens, a lens that can practically see backwards. It is capable of optically distorting an almost 220-degree angle of view and fitting it into the viewing area. Fish eyes are used primarily for scientific and architectural work.

The most common wide-angle lenses are 20mm, 21mm, 24mm, 28mm, and 35mm. A practical choice for your basic outfit would be in the range of 24mm to 35mm. I like the 28mm lens. It provides a very good angle of view, but still renders the subjects within the image a reasonable size.

The wide-angle lens is the lens of choice for landscapes. It helps capture that expansive feeling of broad sky and space. It can also give you a larger sense of space when you are shooting in tighter corners. Or use it when you're shooting on the run. Because the picture angle is large and the depth of field is wide, you can shoot quickly without a lot of worry about focus. And because it usually has a larger aperture opening than other lenses, you can shoot in a wide range of lighting conditions.

Be careful though. Because a wide-angle lens lets in more of a scene, if you're not close enough, you may lose the emphasis on your principal subject. And because a wide-angle lens distorts the image somewhat, certain features of your subject that are closer to the camera can be out of proportion. A good example of this is the "trophy fish" shot. If a fisherman holds his fish in front of a normal 50mm lens, he will bring home a photo of a nice fish. But if he takes that same photo using a 28mm lens, he appears to be holding a whopper.

50mm or Normal Lenses

Your new camera probably came with a 50mm lens, often called a "normal" lens, because it provides an angle of view that's close to that of the human eye, about 45 degrees. It's a reliable all-purpose lens and will do most of the work the hobby photographer needs.

Zoom Lenses

If I could only carry around one lens, it would be a zoom. If your camera does not come with a normal lens as part of its package, I

recommend that you purchase a 28–70 mm or a 35–105mm zoom lens as your basic lens.

Today's zoom lenses are more versatile than ever. There's a wide range of sizes on the market and they give you the convenience of many of you favorite lens sizes rolled into one lens. You have your choice of short focal length zooms such as 28mm–70mm or 35mm–105mm or mid to long focal lengths such as 70mm–200mm or 100mm–300mm.

The great advantage of a zoom lens is its versatility. You can try out various wide-angle, normal, and telephoto focal lengths on the same subject without fussing around changing lenses or changing your position.

Zoom lenses do have their disadvantages. Because they have a greater amount of glass than a regular lens, they are a little heavier than fixed-focal-length lenses, so you may need to use a tripod more often. And they generally have larger minimum apertures than you could get with a fixed-length lens, which means you will not get as much light into the camera.

Short Telephoto Lenses

Lenses in the category called "short telephoto" range in size from 85mm to 200mm. Focal lengths of 85mm, 105mm, and 135mm make excellent lenses for people or pet portraiture photos. They allow you to crop in a little tighter in the field, yet when shooting wildlife they render animals in the proper proportion to their natural environments.

I have a 105mm macro lens that is one of my favorites because of its versatility. It is the first lens I reach for on overcast or wet days. I can crop out the dull overcast skies, zero in tight for macro shots, and capture fleeting wildlife. It's also a great lens on those overcast days when I choose to shoot portraiture outside because the lighting is very even and shadows are soft.

Long Telephoto Lenses

If you are interested in tracking wildlife or capturing sports action, you'll definitely need to include a long telephoto lens as part of your gear. These lenses range from 300mm to 600mm or higher. They are designed to reach out and pull in distant subjects. Since it is generally not practical to be close enough to your subject to fill the frame, one of these lenses is essential for tracking wild animals in the field.

Telephoto lenses magnify the subject and narrow the angle of view.

This allows you to work farther from your subject, and eliminates perspective distortions that can happen when using a wide-angle lens up close to your subject.

Because they record less depth of field, you will find that the background and objects surrounding the main subject are often soft or out of focus. This can actually be an advantage, as it helps to highlight the main subject even further, removing the clutter around it in the frame.

When shopping for a long telephoto lens, you'll find that prices vary a great deal. One of the most important features to check for is the aperture opening. Lenses that open one or two stops wider are definitely more expensive. But for wildlife, you may want to spend the extra money. Many of the best wildlife shots are done at dusk and dawn, when available light is low. That larger aperture opening may mean the difference between getting the shot and missing it.

A 300mm lens is about the longest lens you can hand-hold. Anything over this requires tripod support.

Macro Lenses

A macro lens is a regular lens that has a built-in extension tube that allows you to bring a small subject into close focus. Where a 50mm lens would normally allow you to shoot a subject at about half its size, a macro lens lets you capture it at "life-size." Read more about close-up photography and equipment options in Chapter 10.

Filters

There is an enormous selection of filters on the market that are designed to help correct any number of lighting conditions and special circumstances. But I have found that there are only three filters that are necessary for the photographer who works outdoors. These correct the light so that the film sees what you see. They bring out rich colors and eliminate the glare of bright, reflected sunlight.

These three filters will help control your lighting under almost any situation. I suggest you always carry a polarizing filter, 81B (amber cast), and a graduated split neutral density filter.

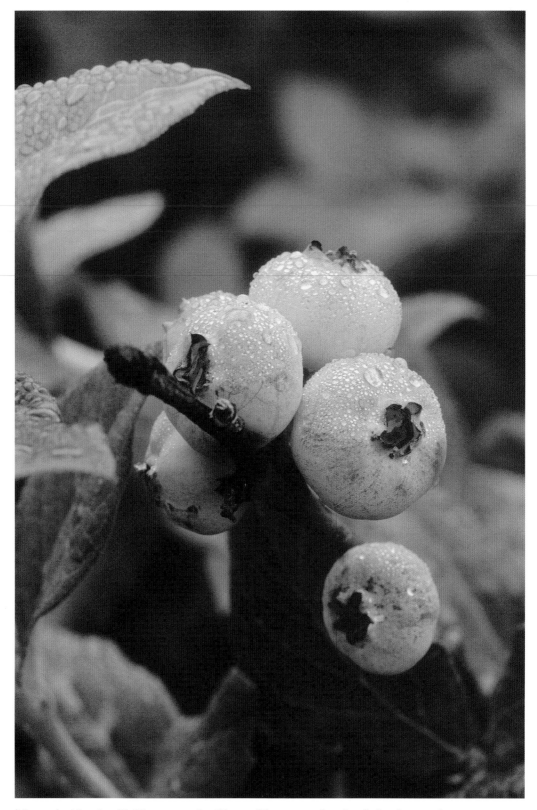

My standard lens is a 28–70mm zoom, but I keep a 55mm macro lens handy for close-up shots.

Polarizing Filters

Polarizing filters are designed to cut glare from reflective surfaces. They are essential if you often shoot around water. See the differences in the photos shown here with and without a polarizing filter. It is like day and night. Polarizing filters work best at a 45-degree angle to the sun. They do not work well shooting directly into or away from it. They help bring out the true colors of fall foliage because most leaves have a smooth surface that reflects a greater amount of light than is perceived with the naked eye.

The photo on the left was shot without a polarizing filter; the shot on the right with one. The filter removed most of the glare from the underlying water and allowed the real warmth of the leaves to come out.

81B Filters

A member of the group of filters known as "warming" filters, an 81B filter has a slight amber cast. This is a great filter to take out on overcast days, in shady areas, or at high altitudes where more blue light is present. It works by neutralizing the coolest blue cast that can throw off the balance of your photo. It can also slightly exaggerate the warmest tone of a subject that is already a warm tone. For instance, the color of fall leaves or a sunset sky can be enhanced by the slightly warm tone of this filter.

Neutral Density Filters

Neutral density filters are a neutral gray tone. They are used primarily to allow the use of a slower shutter speed on a very bright day or under bright lighting conditions.

A graduated split neutral density filter changes from clear on the bottom to light gray near the middle to a darker tone of gray at the top. These filters are often used when you have a bright sky that is one to three stops brighter than your foreground subject. It tones down the bright sky and leaves the foreground in natural light, so you can beautifully record an image that might have been ruined by too much variance between sky and foreground.

Tripods

My number one piece of advice to students in my classes: Never leave home without your tripod!

A tripod is your most important accessory. My tripod is only slightly less important than my camera and lenses. In many situations, I simply couldn't achieve my objectives without it. Whether I'm shooting landscapes, close-ups, wildlife, or in low light, a tripod is the only way to get tack-sharp images. You can hand-hold a camera if the shutter speed is at least as high as the length of the lens you are using. In other words, you can hand-hold a 125mm lens if you're shooting at least 125 or faster. But if you have to shoot with that same lens at 60, you'll want to use a tripod to keep your image sharp.

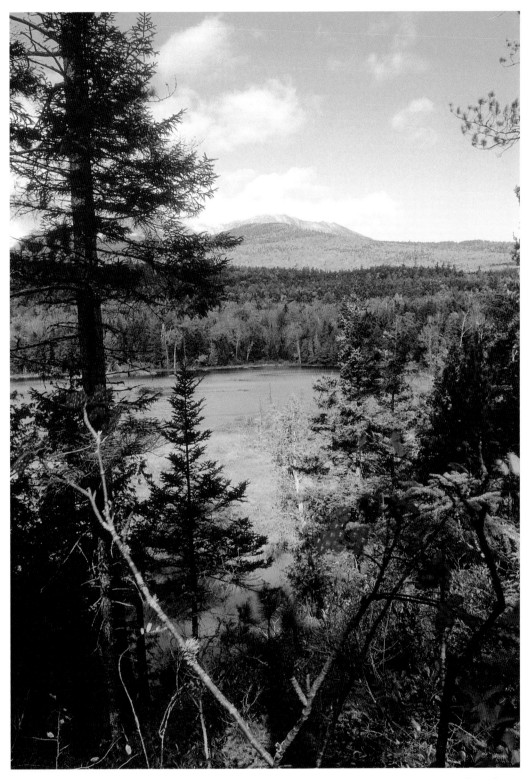

The 81B filter, which lends a slight amber tint to film, is one of three filters I use on a consistent basis. It works well in shady areas, on overcast days, and in high altitudes to counteract the cooler blue color tones found in these situations.

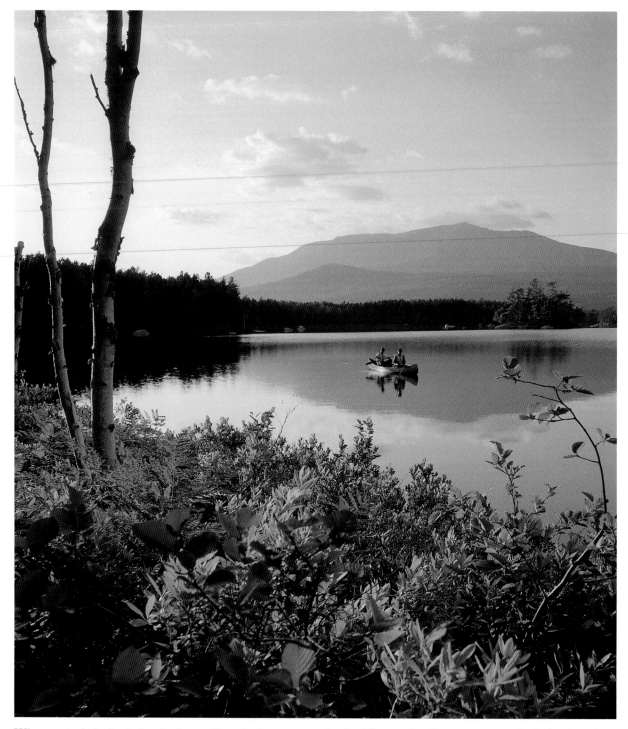

When you include the sky in a landscape, if you don't compensate for the difference, it will be one to three shades brighter than the foreground. A split neutral density filter will allow you to bring the sky closer to the same tonal range as the foreground.

My photography improved so dramatically after I purchased my first tripod that my wife and friends thought I had purchased a new camera or had started using a new film. I think that the reason for the improvement in my images is that mounting the camera on the tripod forces me to take my time. I have to set up the shot more thoughtfully, and compose and focus more carefully. I'm probably more careful with the exposure, too. And I'm more likely to bracket questionable lighting situations, since I've spent more time setting things up.

Buy the very best tripod you can afford. I have a carbon fiber tripod that is very lightweight, folds down to about 24 inches in length, and has legs that can be adjusted up and down easily with one hand. The legs are designed to be adjusted to virtually any angle, allowing me to work in difficult areas where nothing is square or straight. It also has a very short middle section that can be taken off to allow the tripod to be folded nearly flat to the ground for close-up work or at extreme angles for landscape work.

You have two choices when it comes to tripod heads: pan/tilt heads or ball and socket heads. Pan/tilt heads have separate handles for every direction of control. They provide precise movement of every camera direction, but tend to be heavier and more time-consuming to use. They're useful when you want to lock in one axis of adjustment while still being free to move the others.

I prefer to use a ball and socket head to hold my camera on the tripod. A ball and socket head is the easiest to use to, significantly lighter than pan/tilt heads, and much more packable. The great thing about a ball and socket head is that you only have to adjust one knob to get any position you want.

Also, make sure the tripod you buy is very sturdy. Don't buy a tripod just because it's lightweight. Very often, the lightest tripod is too flimsy to hold your camera in difficult situations or tips when using a tele-photo lens. My carbon fiber tripod is lightweight, but it is extremely sturdy and rock solid anywhere I use it. It is designed for use with a 35mm or a medium-format camera.

For many years, I used an aluminum Bogen tripod that weighed about eight pounds. It was very sturdy and well designed, but if I had to pack in any distance for landscape or wildlife photography, it got very heavy. I still use it when I am not traveling far from my car.

Wireless Remote Control

I shoot most of my landscape photography alone. No one wants to get up with me at 3:30 or 4:00 a.m. to hike a mile or two to catch the first rays of light reflecting off a pristine high mountain lake. I don't understand why. It's a great way to start a day.

Often when on these solo shoots, I find potential images that really need a person in them to work, or by adding a person they will make a great cover shot for a certain magazine. This is where a remote control device can pay for itself over and over again. First, I set up my shot on the tripod. Next, I establish my exposure settings and position myself in the precise area of my frame. Then I use my remote to shoot me in the landscape.

Cable Release

You can also use an inexpensive cable release that screws into your shutter release and allows you to squeeze off a shot without touching the camera. This prevents you from causing any accidental camera shake. They're very handy, particularly in close-up or low-light conditions.

Accessories for Manipulating the Light

This category includes flash units, as well as reflectors, umbrellas, and sun shields. I don't use artificial light outdoors unless it is absolutely necessary. I prefer to take advantage of what nature is offering at that moment. But I do keep a variety of lighting "helpers" with me for difficult lighting moments.

A small flash always comes along in my gear bag, just in case I need a little burst of light. I occasionally use it to fill in a dark area or balance out a foreground. But if I can, I prefer to bounce a little reflected light toward my subject. This creates a more natural effect. I always carry a little set of reflectors and diffusers.

You will find a number of lightweight folding options available. Bright, shiny silver will kick a lot of light onto your subject; shiny gold will reflect a warmer light. Soft white diffusers will soften glare and a

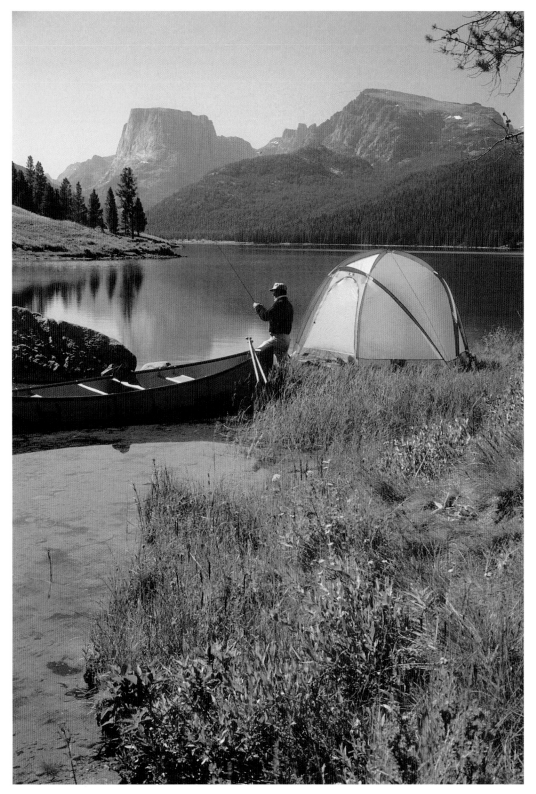

Wandering in the wilderness alone, I often come across a potential image that is crying to have a person in it. My remote control works wonders in these situations, as it allows me to place myself in my own photographs.

piece of plain cardboard can be used to block heavy shadows. Play around with these accessories. They are fairly inexpensive, but can be very effective in the field.

Other Accessories

Of course, I never leave the house without lens cleaners and dust removers. You might as well stay home rather than shoot with a dirty lens. Also, remember to carry spare batteries or rechargeable units. Most cameras run on some sort of battery, and there's nothing worse than having to pack it all in because a battery failed!

Out in the Field

My camera has taken me places I would never have dreamed of going otherwise. And I find that the more I shoot, the greater my wanderlust grows.

Weather and field conditions can make outdoor photography a challenge. If you're planning a trip to an area you've never been, look up the weather patterns before you get there. Having the right gear and accessories for coping with them will help you have a productive and enjoyable photo excursion.

Camera Bags

Your choice of camera bags and packs is enormous, and the one you choose can make a big difference out in the field. Think about how you use your equipment before you decide on the bag that's right for you.

If you travel by car most of the time, then a hard-sided case with foam compartments that keeps everything safely in place and readily accessible may be a good choice. The foam compartments can usually be configured in many ways, so you can set them up in a way that works best for you.

If you travel by air, make sure your bag passes the airline's carry-on size guidelines. I never check my camera equipment. I always carry it on the plane, even my tripod, so it's important that it's efficiently packed. Keep your film in a separate bag (preferably an insulated one) so that you can easily hand it to the inspector at the security check-

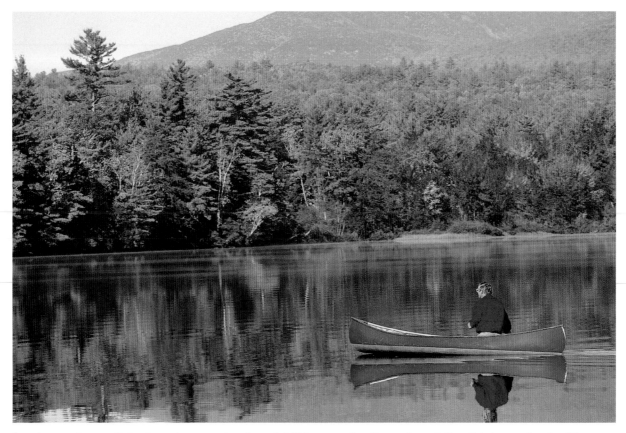

I work around water all the time—in canoes, kayaks, and drift boats, and wading and snorkeling. It is imperative that I have sturdy waterproof bags for my camera gear.

point. Never let your film go through the screening machines, because x-ray machines can damage film.

Many airports still tell you that their x-ray machines won't affect slower-speed films, such as 100 ISO, but with all the new safety regulations, many x-ray machines around the world are more powerful than ever. It's not worth the risk of putting any film—especially high speed films of 400 ISO or faster—through them. Inspectors are also taking more time to examine luggage, so your equipment is exposed to this light longer. Always pack film out of their canisters in a large, clear, zip-lock freezer bag. It makes it much easier for the inspector to review it. Less hassle for them—and for you.

There are some very advanced backpacks designed specifically for camera equipment. The Trekking series by Lowepro has almost any configuration you could want. I use the Super Trekker AW, which comfortably carries up to 50 pounds of gear and has all the features you'd look for in a conventional backpack. I always take along a padded

fanny pack that holds a camera with lens, one additional lens, and film. I also have a padded case for my tripod. Check with your airport before you travel to make sure you can check your tripod through the gate. Some will allow it and others won't, so be prepared to check it at the baggage counter if they won't let you check it through.

Coping with Weather

As an outdoor photographer, you need to be aware of weather and how it affects your shots, your equipment, and yourself. Taking certain precautions will go a long way in making sure you get the perfect photo—whether you shoot in chilly New England or the balmy Caribbean or anywhere in the world.

Cold

Today's camera equipment is better able to tolerate temperature extremes than cameras of the past, and modern lubricants make it unnecessary to winterize a camera. Still, there are a couple of important steps to take in extremely cold conditions.

Make sure that your camera and lenses have had a good cleaning and test your equipment thoroughly to avoid surprises in the field. And always keep spare batteries on hand; cold weather puts a huge drain on batteries. When I'm shooting in winter, I always start with fresh ones and bring backups. A weak battery can cause inaccurate meter readings and a dead battery prevents you from releasing the shutter. In general, alkaline batteries perform better than zinc, lithium a little better than alkaline, and silver oxide or manganese batteries better than lithium. Nickel cadmium batteries are impractical in extreme cold: They operate at only about 60-percent capacity in temperatures below 0 °F and must be recharged at temperatures of 50 °F or higher to prevent damage.

Motor drives drain a lot of power, so keep reserve batteries warm in a nearby pocket. Static electricity can be a bigger problem in cold weather, so use the drive in slow mode to avoid streaks on your film and rewind manually, if possible.

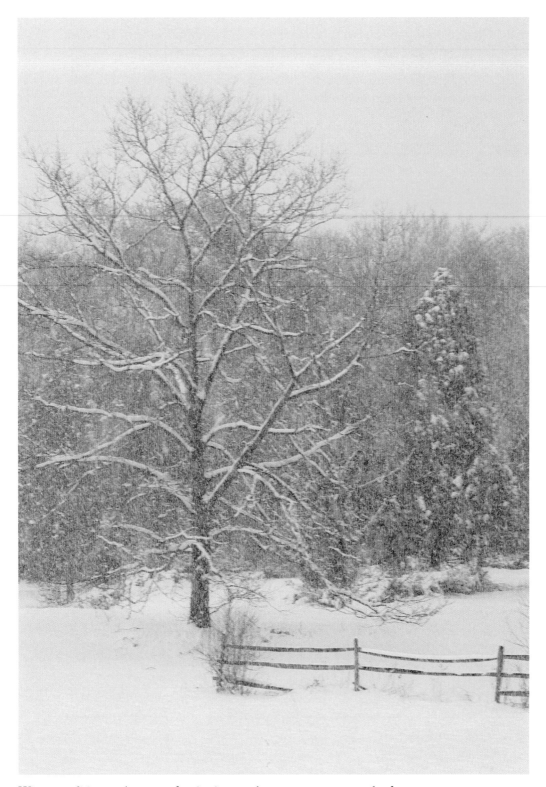

Wintry conditions such as snow, freezing ice, or sub-zero temperatures are hard on your camera gear. Prepare for the extra drain on batteries and the dangers of condensation before you shoot in the winter.

A camera body with a black finish will absorb some heat when the sun is shining. This might not seem like a big deal, but in very cold weather, it can benefit both camera and film. Some cameras are now made of polycarbonate, which is more comfortable to handle than metal. If your camera has a metal body, be careful when placing it against your face; it can cling to your skin. To avoid this, cover the parts that will come into skin contact with duct tape.

Plastic and rubber parts and accessories may stiffen. A plastic carrying strap can become brittle and break, so consider using a leather strap. Cable releases with metal sleeves are more reliable than those with plastic sleeves.

Bring along a lens shade to reduce glare from bright snow. Because these are usually rubber or plastic, treat them carefully to avoid cracking.

Gelatin filters will not work in extremely cold conditions; therefore, you'll need to use solid glass filters, instead. Keep a UV filter on lenses at all times; this will reduce ultraviolet light and prevent damage from wind or blowing snow.

If you usually use slide film, consider switching to color print film for extreme cold-weather shooting. While the temperature does not adversely impact the film's emulsions, there's a certain amount of color shift that takes place due to the low angle of the sun. In some arctic regions, the sun never gets high enough to create true daylight conditions. Print film is easier to correct for this color shift.

In conditions with temperatures below 0 °F, film becomes brittle and the emulsion may crack or the film itself may break. Take extreme care when loading and unloading film, which is when most film is broken. Advance film slowly to avoid damage and to reduce the chance of static charges that are common in cold conditions. Static charges show up on developed film as marks resembling lightning streaks, beads, or dark rings. I always stop shooting a frame or two before the final exposure to avoid ripping the film as it reaches the end of the roll.

Be careful not to breathe on any part of your camera equipment, and when preparing to shoot, try to hold your breath. The condensation from breath that forms on your lens or viewfinder will fog and freeze. Be careful not to breathe on the film back when loading film.

Condensation in your equipment can cause as much damage to your equipment as dropping it into a lake. Generally, condensation occurs in

the transition from outdoors to indoors. Moisture in the warm air causes water to form on the camera, inside and outside. In very cold weather, you need to take precautions. Seal your camera in a resealable plastic bag before entering a warm room, and enclose a few packets of silica gel (usually available at camera shops or drug stores). Warm up your equipment slowly. Store it in a cool area when you first bring it inside. Leave it on the porch, in the car under a blanket, or even on the floor in a cold corner. Gradually bring it back to room temperature. Check the camera body and lenses for any signs of moisture. If you keep your camera in the airtight resealable plastic bag while it is warming up, the condensation will form on the outside of the bag.

If your equipment is wet, take immediate action. A hair dryer set on low will complete the drying process. If you are in a tent or cabin, use the finest cotton cloth you have and hold it near a heat source to dry it.

Make sure your camera is completely dry before taking it out again. Even tiny droplets of moisture can freeze inside and jam your mechanism.

Protecting your hands is one of the most critical aspects of dressing for winter photography, but anything that reduces your sensitivity to the camera will feel somewhat clumsy. I have a pair of thin leather Gore-Tex golf gloves that fit snugly. They aren't waterproof, but they are windproof and breathable. I also have a pair of insulated leather mittens that I attach to my sleeves so that I can get in and out of them quickly and easily without ever taking off the tight-fitting gloves. The thin leather gloves allow me to use all my camera controls without exposing my fingers directly to the elements. I like the thin leather better than thin silk or polypro gloves because they give me better grip. I also wear gloves with pullback tips or with the fingertips cut off when conditions aren't too cold. Keep in mind that it's sometimes hard to know just how cold you're getting until it is too late. Skin reacts badly to cold metal too, so keep covered!

Wear roomy clothing with large pockets. Store batteries in a pocket where your body heat will keep them warm. Keep your camera on a neck strap and tuck it inside your jacket to keep it warm when you're carrying it. Try a fanny pack, worn in front, for easy access to accessories. If you're carrying a separate bag, make sure it's insulated and that the material has been treated for weather resistance. Throw in a couple of hand-warmer packets to maintain some heat inside the bag.

Heat

Conditions that are hot enough to cause problems for the outdoor photographer are not limited to desert photo shoots or hot summer days. Even in normal weather, ordinary car travel can generate heat higher than the average film can tolerate, so be prepared.

Camera equipment itself can tolerate heat pretty well, but if you're going to store cameras in hot conditions for an extended period of time, lubricants will eventually thin and run. Cements used to hold lens elements together can soften, so that a sudden jolt may cause separation. Telephoto lenses can expand a little if they are exposed to the hot sun. Even a little expansion could cause trouble focusing to infinity. Most lenses are black, so they may even get too hot to handle.

The easiest remedy for most of these problems is to keep your equipment shaded. I carry a lightweight space blanket to shield mine. It weighs almost nothing and folds down compactly.

Heat shortens battery life, so keep an extra supply on hand. Hot weather can even cause batteries to break down and leak, so I store spares in the cooler with my film.

Maintaining the quality of film is your greatest challenge in hot conditions. Almost every aspect of a film's properties is affected by heat. Heat can soften the emulsion, causing images to lose definition. Film can fade before you get it to the processor, causing poor color resolution. If you normally prefer professional film, consider switching to the amateur type; the difference in heat tolerance is about twenty degrees.

Even if I don't expect hot weather, I always store film to maximize coolness. Storing equipment in aluminum cases is a good idea because they reflect the heat away. I always bring along a cooler with a tight-fitting lid, lined on the bottom with reusable freezer bottles. Soft zippered lunch-type insulating coolers are okay for short trips. I transfer the day's film into one of these, again with a small freezer pack, for carrying in my camera bags. If not traveling through airports, I always keep my film in their canisters and pack 10 to 20 rolls in a large ziplock freezer storage bag. On location, I pick up inexpensive Styrofoam coolers, and then leave them behind for others to use. These work in a pinch, but be careful to weight the lid down for a tight fit, especially if it's very humid. If you are in the backcountry, you can keep film cool by burying a sealed bag in a shallow pit.

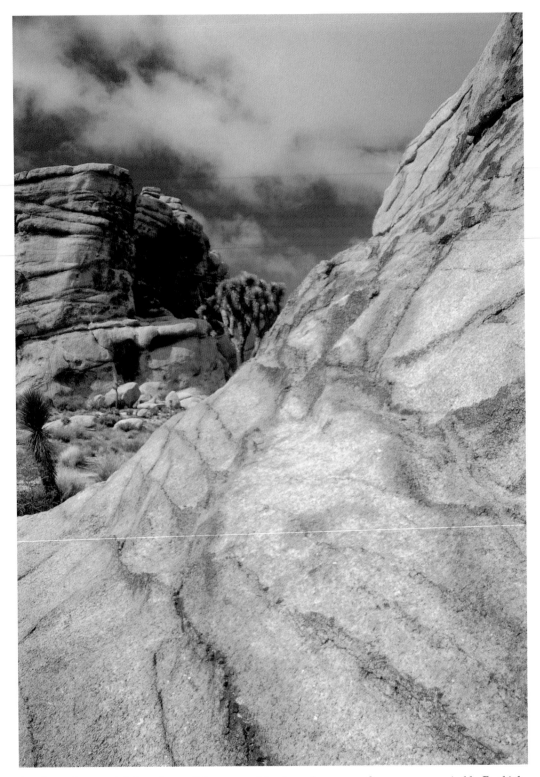

I prefer to photograph in hot, dry conditions over cold and wet, because my fingers are more nimble. But high temperatures play havoc on film, sand can easily ruin expensive lenses, and extreme heat shortens battery life.

If you can, take along only the film you'll need for the day's shoot. But don't be so conservative that you end up the day with no film. You can bet that that's when you'll see the most breathtaking sunset of your life.

Always warm up film gradually before opening the factory-sealed package or you may wind up with condensation. It takes at least an hour to raise a roll of film's temperature by thirty degrees. When you return from the day's shoot, store exposed rolls in a sealed bag with silica gel packets until you can get it to the processor.

When I travel, I often process film along the way, being careful to always use a professional E-6 lab. If I am not completely confident that a lab will process my film correctly, however, I'll hold off getting it developed. But, developed transparencies are much more stable, and once I have them in hand, I can leave an area assured that I got the shots I wanted.

Humidity

Regardless of the temperature, prolonged humidity of 60 percent or higher can inflict a great deal of damage upon cameras and film. A variety of fungi thrive in moist environments. Mold and mildew can ruin camera bodies and make moving mechanisms sluggish. Zoom lenses are especially vulnerable because they pull in more damp air than fixed lenses. If you're traveling in extremely humid conditions, consider carrying a waterproof camera or using an underwater housing.

Keep your storage cases as dry as possible. Leather bags are especially prone to attack by molds, so choose one made from another material. Wrap regular cases in double-layered plastic bags when not in use. Use resealable plastic bags for storing film, filters, and other small items.

Purchase desiccant in bulk from a camera store or pharmacy. The most common type is silica gel. Get the largest crystals available so you don't run the risk of particles getting into equipment. Keep tins in your film cooler, camera bags, and small plastic bags.

When you're out, set your equipment in direct sunlight once in a while. This can help keep it dry. But remember—only once in a while! Be careful not to overheat the camera. During the day, fresh air is better for your equipment than closed bags that absorb moisture and stay damp.

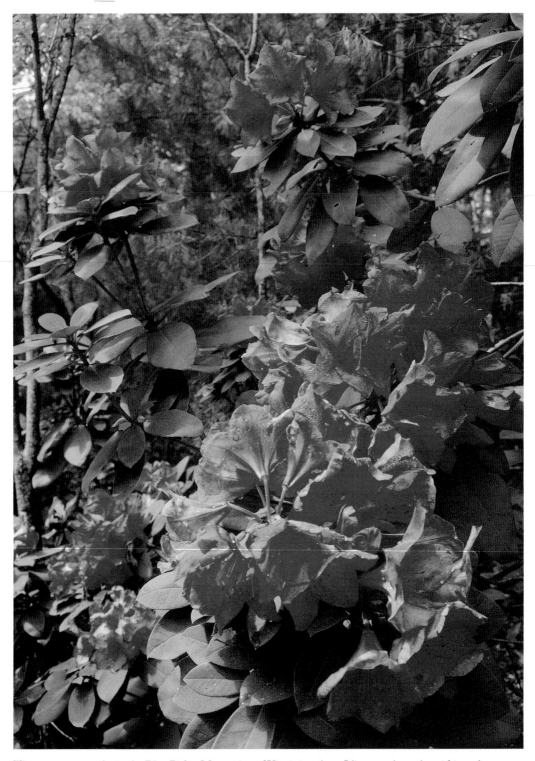

The summer months in the Blue Ridge Mountains of Virginia, where I live, can be so humid it makes you feel like you are working in water. It's important to keep cameras and lenses dry. Mildew and fungi can ruin camera bodies, camera bags, and straps if left unused in moist, humid conditions over a period of time.

When you return home from a hot, humid place, open up everything and dry it thoroughly. If you have been away a while, it may be a good idea to send all your equipment out for a thorough cleaning. Moisture is insidious. If you put away damp equipment, you may later find that leftover traces of dampness have caused corrosion, which is expensive to repair.

The best protection for your unexposed film is its factory-sealed packaging. Inside the foil wrapping, humidity is stable, so don't open any film until you need it. Once you do open film, use it as quickly as possible, and try not to leave a roll in the camera for more than a day.

If you can, process exposed film right away. If you have to store it, do not return it to its film canister. It has absorbed extra moisture while it was out, and if you trap it in that tight little space, the emulsion could be damaged. Instead, place it in a resealable plastic bag with silica gel until you can get it to the processor.

It's easy to keep yourself dry and comfortable with all the new lightweight apparel fabrics. Many are designed especially for tropical conditions. You can find cargo shirts that protect from the sun; others with mesh openings for catching a breeze. And many of them have mesh pockets for carrying your accessories.

Dust and Sand

Grit is one of your camera's worst enemies. If you're in sandy or dusty conditions, it seems like your camera equipment acts like a magnet for the stuff. A few well-placed grains of grit can gum up mechanisms and jam shutters very quickly. While you are shooting, be aware of blowing sand that can damage lenses. Light sand coming off a beach may be hardly noticeable, but it can scratch fine marks on lenses or filters. If I know I am going to be in sandy or dusty places, I always make sure my cases are tightly sealed. Even when I am in the middle of a shoot, I never leave a bag or case even slightly open.

Before you put your camera away, brush off the exterior thoroughly. I use an air can to blow away all the grit and sand I can reach, and then use a toothbrush to remove sand from around the exterior mechanisms. Open your camera back and remove the lens to air-spray your mirror and shutter mechanisms.

Sand and fine grit act like sandpaper, so never wipe away thin layers on lenses or filters. Once the majority of it has been blown off, finish cleaning with lens tissue and cleaning fluid. Clean tripod legs thoroughly after use to avoid damage to connecting joints.

Water

When it comes to water, it really is true that an ounce of prevention is worth a pound of cure. If you're going to shoot around bodies of water, make sure your camera strap is in good condition. Keep your camera strap slung loosely around your neck, even when the camera is on a tripod. Always use a waterproof case when around water. Just remember to keep it completely closed if you are on the water; an open

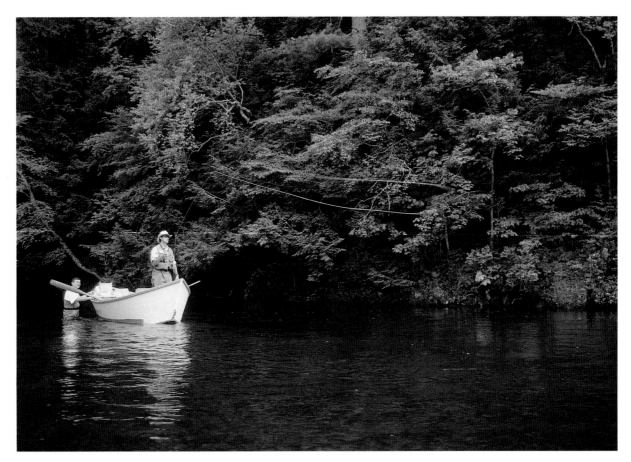

I am especially careful with my gear around water, but accidents will and do happen. Up until a couple of years ago, I'd never dropped a camera or lens into water; then, in one 24-hour period, I dropped two of them. Both times, they would have been saved—had I used a camera strap, even though they were on tripods.

waterproof case might protect from a splash here and there, but it won't help at all if the case goes overboard. A sealed waterproof case, on the other hand, should bob safely on the surface.

Only shoot in the rain if you can protect your equipment at all times. You can make a simple covering for your camera by cutting a hole in a plastic bag that's just big enough for the lens to extend through. Tie the bag around the camera body to seal out water. Shoot under an umbrella if you can. Keep your camera tucked inside your poncho or rainwear when you're carrying it. Be very careful around spray. Waterfalls throw a lot of water, even when you think you're far enough away. Salt spray is even more harmful.

I often shoot around water, so I am especially careful with my gear. But accidents do happen. Until recently, I had been very proud of the fact that I had never dunked a camera. Then last year, in spite of all precautions, two of them fell into streams within 24 hours. Ouch!

Water will ruin your camera unless you take swift action. Get the batteries out of the camera immediately! They will cause irreparable damage if left inside. Then get it to the repair shop as soon as possible. It will need to be taken apart and dried thoroughly.

If you simply splashed the camera or lens, you may be able to dry it yourself. Open up the body and use a blow dryer for everything you can reach. Or heat the oven at a very low setting, so plastic parts won't melt, then turn it off and place the camera inside. Saltwater is particularly harmful. If your camera is completely immersed in saltwater, you may not be able to save it.

Film dropped in water causes the emulsion to soften and come apart; however, you may be able to salvage it. Take it to a processor. It will only cost you ten dollars to see how it comes out, and you may be lucky. I have a friend who had an important roll of film washed and dried with his laundry. He assumed it was destroyed but sent it through anyway. It wasn't perfect, but he was able to salvage a few images, so you never know.

The Outdoor Photographer's Survival Kit

The key to being comfortable and productive in the field is preparation. If you carry the following items in your gear bag at all times, you should be able to handle almost any situation.

- Resealable plastic bags. I keep a couple of small ones for storing film, and a couple of large ones in case I need to seal equipment away from the elements.

- Lens brush, toothbrush, spray can of air, and soft cloth for cleaning equipment.

- Small insulated bag for storing film.

- Ice pack for keeping film cool.

- Hand warming packs for warming up frozen equipment and chilled hands.

- Duct tape. (You never know! I have kept broken camera backs closed with it, repaired a tripod, and used it to hold light reflectors in place.)

- Small folding umbrella for protection from sun and rain.

- Lightweight space blanket.

- Fingerless gloves. (I keep these in my bag all year; even early summer mornings can be chilly!)

- Silica gel for keeping out moisture.

- Spare batteries.

Fundamentals of Composition

The first few chapters of this book are very technically oriented—and for good reason. You must first become totally proficient in the technical aspects of photography before you can truly have the power to control every lighting and compositional situation that you encounter.

Today's cameras are engineering marvels. They can give you automatic exposure, auto focus, and through-the-lens flash metering that is nearly foolproof. Yet, they still need an operator. They are amazing mechanical and electronic wonders; but they are only as good as your ability to control their capabilities.

The bottom line? These amazing new cameras, both film and digital, are only tools. Powerful images come from you and how you interpret the world around you. A camera is like a computer or musical instrument. They're all just lifeless objects until you bring them to life. I'll bet that a competent technician with an artistic eye using an entirely manual camera will take better photographs than the artistic individual who has the latest and greatest high-tech professional camera, but doesn't have total command of how to use it.

Becoming technically proficient as a photographer is not easy. Most of us start out wanting very much to capture the fascinating images we see with our eyes. We purchase the best camera we can afford. We try to read through the manual to learn how everything works. Most of the time, we don't really grasp the basics or even finish the manual before we pick up the camera and start snapping away.

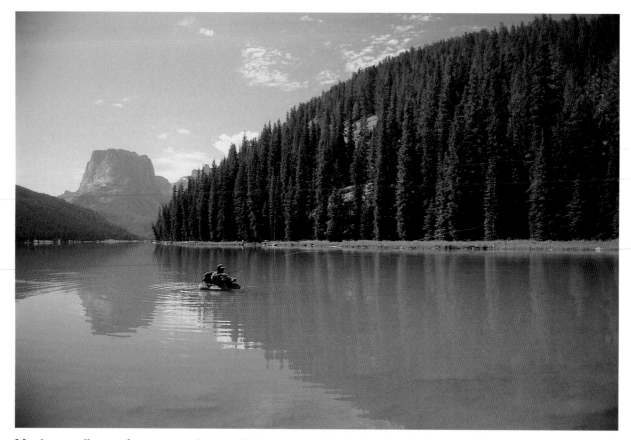

My photos really started to come together once I had command of the basic technical elements of photography. At that point, I started concentrating on the composition and design of my images, rather than on just trying to figure out how shutter speeds and aperture worked.

We shoot a few rolls of film, have them developed, and find that most of the photographs are just not very exciting. We set the camera down, but a month later, we pick it up again and take it with us on a weekend getaway. We are confident that we now have this thing under control. Yet, when we get the weekend photos developed, we find that they are actually *worse* than the first few rolls. How frustrating. And they said this camera could do everything!

Photography, as with anything else that we really want to master, demands consistent hard work and training. You can be self taught, trained by professionals, or, like most of us, be a combination of both. But, no matter how you go about learning the media, you need to practice, practice, practice until you've mastered its technical aspects. Then you need to use them often enough to retain what you have learned until shooting great photos becomes second nature.

So you finally come to some sort of agreement with this fantastic

electronic marvel you call your camera. You have developed a solid understanding of exposure, aperture, shutter speed, film speed, and how they all work together. You know all of the controls on your model and its various special features. This is only step one. The next step is to train your eye.

What attracted me to photography in the first place were the amazing images all around me. When I first began to get serious about it, I was constantly looking for images that I could capture on film. I was more alive and more aware of my surroundings than ever before in my life. I didn't really know it at the time, but I was training my eye and developing my photographic vision.

I was starting to understand lighting, composition, and perspective. I became more aware of the slightest nuances in lighting, angles of light, the way light changed during the day and throughout the seasons. I constantly composed photos while driving, walking in the city, or just going about my daily routine. I spent countless hours studying my bad photos and great photos from others who motivated me. I studied which compositions worked and which perspectives worked in certain situations. I began to understand what subjects motivated me—and why. The "why" part took a little longer, but once I knew why I was excited about a subject or composition, I was able to focus and become more creative in my own work.

I learned that I had to control every facet of the photograph I was making. I found what I included and excluded in my photographs were equally important. It was totally up to me to determine what was essential in my images, what I wanted to express in a given photo. It was my vision, based on the way I saw a subject and how I wanted to portray it. The most advanced camera in the world has nothing to do with my vision. The camera is only a tool to allow me to capture this vision on film or digital.

Understanding Your Subject

No matter what you are shooting, the better you understand your subject, the better your final images will be. Knowing what you want to capture or how you want to portray a subject will help you to focus on

the details that will make your photographs more compelling. It will also allow you to open up creatively. This is when your photography becomes alive and exciting. It is also when you'll start getting results that will grab other people's attention.

Let's say you want to photograph the first light on the towering peaks of the Cathedral Group in Grand Teton National Park. There are dozens of vantage points where you can capture this magnificent range. By studying other photos of the area, talking to park naturalists, and doing your homework beforehand, you can narrow down the possibilities to the very best places, times of day, and seasons of the year to capture this unique mountain setting in its finest light. It will also give you the best chance to create an image that is your own personal vision.

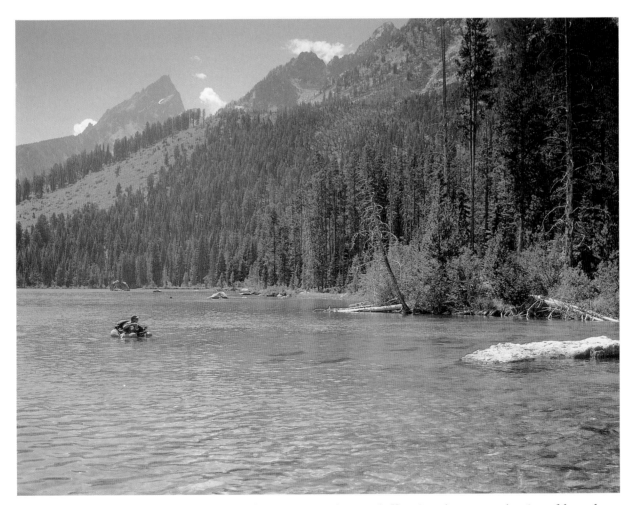

Know your subjects—you'll have a better chance of getting a great photograph. Knowing where to go, what time of day and season, and what to expect will improve your photography. Tetons, first light.

Focus on End Results

Talk to professional photographers and most of them will tell you that the majority of the time they have a focused plan of what they want to capture for any photo shoot. They'll have specific images they want or need to illustrate. The shoot will be set up to accomplish these specific shots. Yet, while in the process of getting these images, they may find other great shots. That will be a bonus.

Preplanning a shoot usually entails scouting the area beforehand. You'll analyze when the lighting will give you the best opportunity to capture the specific image you want. You'll study the weather to make sure you don't waste time if it's not correct for the photographs you're after. You'll figure in the right film choice. If you have to drive any distance to the location, you'll be there and set up on time, ready for the

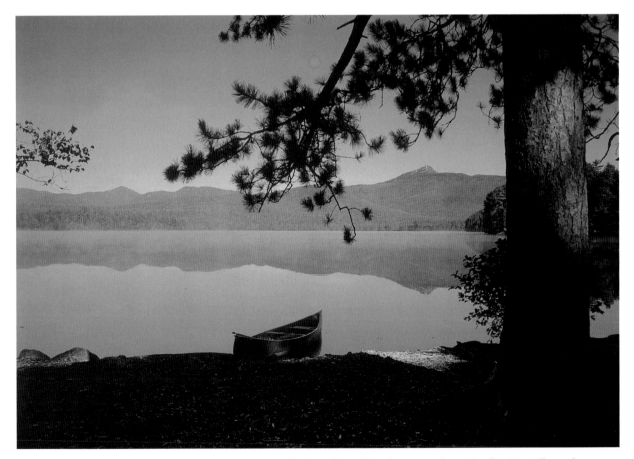

Focus on end results. Know beforehand your goals for each photo shoot. Pre-planning and pre-visualization will greatly improve your chances of getting the photos you want.

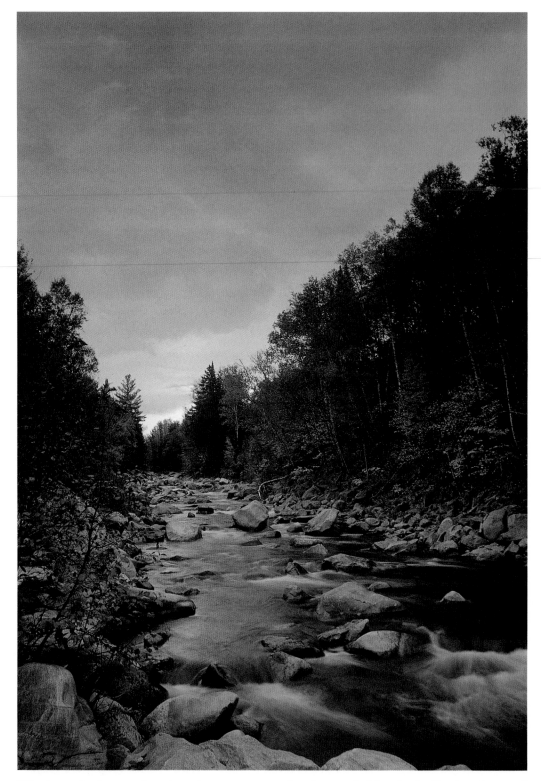

Why do certain photographers always have so many amazing photographs? Are they luckier than the rest of us? Not hardly! They preplan and have specific goals that put them in a position to capture those special moments when they occur.

light. These are the little things that separate the pros from amateurs. They add up to give you the best opportunity to capture the moment and to give you the control to get the shots you want.

Capturing the Moment

Capturing the moment is more than just being prepared. It's more than focusing on end results. It's also knowing your equipment, the limitations of your film, and the nuances of the season and the area. It's being mentally open to the possibilities around you as they develop. Dynamic lighting is seldom something you can control or predict. You always need to be aware and be ready to take advantage when those unpredictable two minutes of special lighting surround you with the opportunity to make miracle images happen.

Most of the dramatic photographs you see or have seen were not planned. They were recorded because the photographer was *there*. They were not sitting on their couch wondering if they should go out in the unpredictable weather. They made the effort to put themselves in a position to have the chance to capture that illusive and dynamic moment in time. They were also prepared to take advantage of a situation as it developed. Some of these great shots were taken by chance, but again, the vast majority was taken by very talented photographers who anticipated the moment and knew how to capture it.

Often, these magical lighting dramas take place during or after a storm. They may last only seconds. The best, most experienced outdoor photographers seem to have a sixth sense when these opportunities might develop. In reality, that sixth sense is based on experience from being in these situations many times over years of fieldwork.

Perspective

Strong photographic design in the natural environment comes from studying your subject carefully from different angles of view and then sieving out all the extra material until you have only a golden nugget

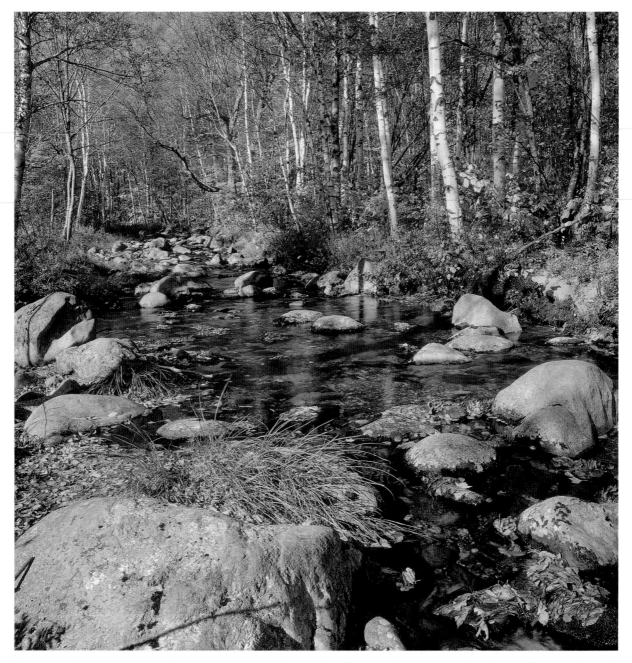

Perspective plays an important role in composing great photographs. Always work an area or subject from different angles and perspectives. Try lower angles, high angles, and different lenses, until you find the best perspective to show off your subject.

of what is important to you left in the rectangular viewfinder of the camera.

But how do you sift down to find those nuggets that make strong images? First, break out of the habits of how you look at a potential photograph. Change your perspective; get down below your subject or climb to a higher vantage point. Look for patterns, repetitions, or reflections that may not be immediately visible from a normal straight-on viewpoint. If you are using a zoom lens, look at your subject with all the different focal lengths and also from different vantage points.

Once you have found the image you want to shoot, stop and frame your shot. Take the time to identify what it is you want to portray, what is important to you, and where you will place the main subject in your rectangular frame. Then, simplify the photograph. Take out anything that's clutter or unneeded. Check your corners and edges. Do you see branches, out-of-focus flowers, bright spots, or dark shadows that are distracting from your main subject? If so, get rid of them. Crisp, clean, simplified photographs are almost always the best.

Rule of Thirds

A key photographic principle is that the main subject should occupy a strong position in the frame. There are many different ways to do this, but one of the first rules, and the easiest to grasp, is called the "rule of thirds."

Divide up your frame into thirds both vertically and horizontally. Position your main subject on the intersection of two of these lines. These intersections are the strongest points of interest in the frame. Using this simple framing rule as a starting point will immediately improve your photographs.

But this it is just a starting point. Study photographs that strike you or grab your attention right away. What is it about these images that make them work, that make them so strong and compelling to you? Often you will find the main subject is positioned within one of these quadrants or at one of these intersections. Some subjects do actually work best centered in the middle of the frame, but this is usually not the case. Just as you should view your subject from different perspectives

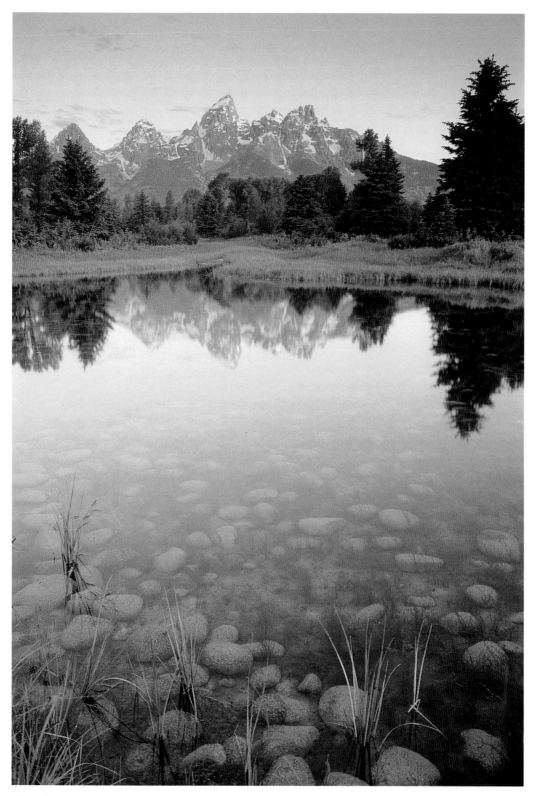

The rule of thirds is just a rule, but a very effective one. This photo of the Tetons illustrates it. I placed the horizon line in the upper third of the photograph to give it the most visual impact.

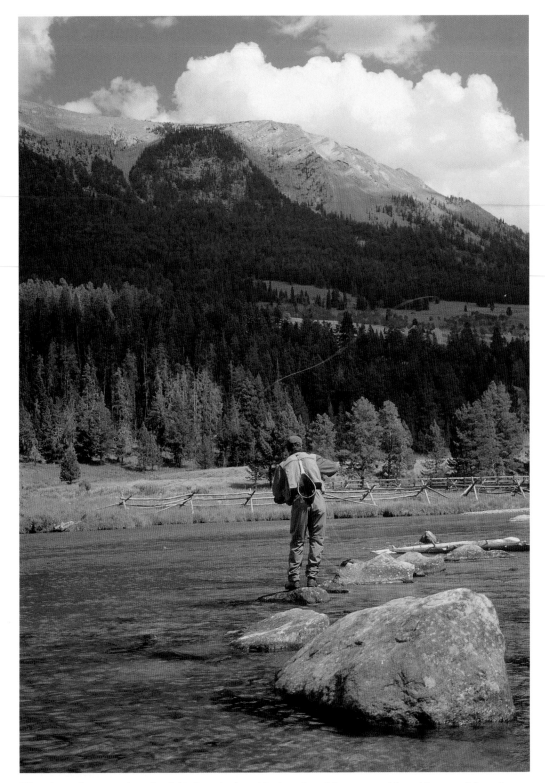

This photo illustrates the rule of thirds again, but this time the subject was positioned in one of the points within the image where horizontal and vertical lines cross casting into the photograph. This helps pull the viewers into the image.

or angles of view, you should experiment positioning your subject in various areas of your viewing frame to come up with a composition that has the greatest visual appeal to you.

When you are working with people, always position them so they are moving or looking *into* the frame. This is a more natural perception. It also pulls the viewer into the photograph. If the subject is looking or moving out of the photograph, you will wonder what they are looking at or where they are going, and lose the power of perspective within the photo.

These are the same rules you should start with when photographing animals. When doing portrait work, try to put the person's face or the animal's head in the upper third of the frame. Avoid placing the face or head dead in the center. This is one of the primary reasons most amateur photos of people and animals are so dreadfully boring and unappealing. Amateurs just usually "point and shoot," never thinking about how the final image will work in a rectangular format once it is developed.

The Power of Perspective: Lines, Texture, and Repetition

I love to wander in the outdoors looking for abstract images. The world around us is naturally chaotic, but we have the ultimate power with our camera to choose any or all parts of this wild, chaotic visual world, and organize it into our own vision. I am always amazed when teaching photography classes how an entire group of people can photograph the very same scene and all come up with a different image or point of view. What is even more amazing is the fact that that same scene will virtually never be the same twice. Day evolves to night; the weather, temperature, and seasons change, and so will this scene. When we create a photograph, we capture a unique moment in time.

One of the lessons I have learned many times the hard way always starts the same way. I see a potentially great image. For some reason, I am too busy, too lazy, or too distracted, but nonetheless I know it is a great image. I say to myself, "No big deal, I can capture that tomorrow or next week at the same time of day." Well, I couldn't. Too many times, I have gone back to a place to try to recapture a moment I missed, never to duplicate that lighting.

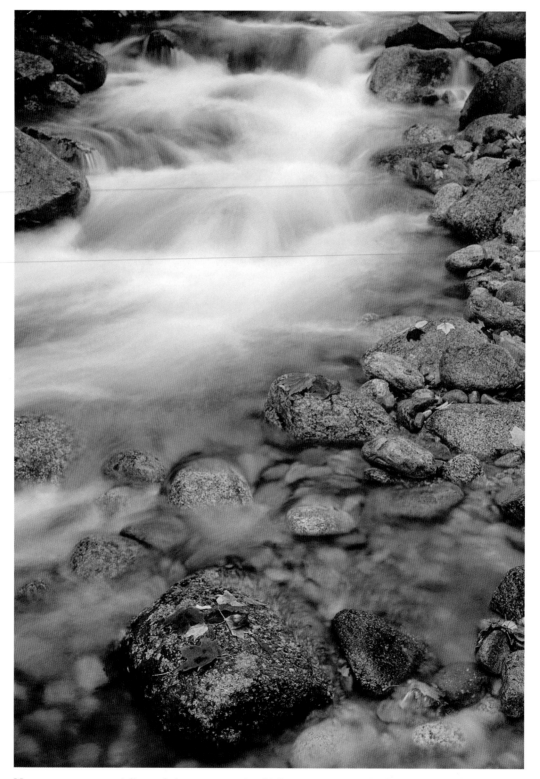

Never pass up a potentially good photo opportunity thinking you can come back another time. This little stream caught the corner of my eye one day as I drove by. It was an effort to stop and go back, but I ended up getting several very nice images from it.

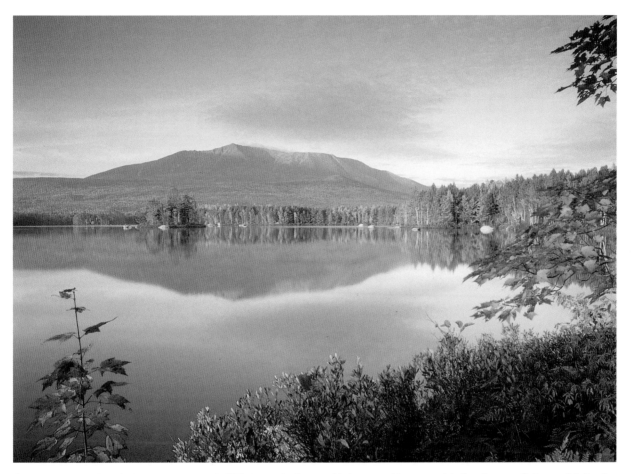

Our world around us is changing constantly. When you find yourself photographing a special place in great light, work it hard and take several in-camera dupes because you may never have the same opportunity again.

A favorite spot I like to shoot is in Baxter State Park in Maine. There, a beautiful lake reflects Mount Katahdin at first light—if there is no wind. In the fall, there are red maples that you can use to frame the summit as the sun emerges and the sweet morning light begins to sing its song.

I've shot several cover photos in this area. Along the way, a publisher lost one of my favorites. It was never found. I went back the following year at the exact time to recapture the photo. No big deal, I thought. I'll just shoot it again. Wrong! The maples had died during the summer from a drought and that day's sun never gave me the range of color it had in that old photo. High winds kept the lake from clearly reflecting the mountain. I didn't give up right away, however. I tried every fall for three years until I finally admitted to myself that it was impossible to ever duplicate that one magic moment. It happened once. I was lucky enough to be there and to capture it. But I never captured it again.

I have a good friend who often photographs with me in Baxter. He also tried to capture that same image many times while on his own shoots. He also gave up after several years. Both of us were able to get some very good photos while attempting to recapture that image, so it wasn't all in vain. But the lesson is, when you see a great image, go after it immediately. It may never appear again!

Vertical versus Horizontal

The vast majority of the photographs you see by nonprofessional photographers are horizontal. This is natural. Most point-and-shoot or automatic cameras are designed to shoot horizontal pictures very easily.

Now look at most publications. Virtually all covers are vertical. Interior images are either square in format or vertical, too. Take the time to analyze the magazines that you read for the next week and make a mental calculation how many of the photographs you see are vertical and how many are horizontal. Not only will you be surprised, you will also learn to see a little differently. You'll also begin to understand the type and style of photographs that a particular publication uses and how they are used within the magazine or article. If you have

hopes of getting your photos published, you need to go through this exercise for every publication you submit images to.

I am always looking for images that will work in a particular publication. I shoot nearly everything in a vertical format first and than look for horizontal opportunities. Landscapes, of course, lend themselves to a horizontal format, and horizontal panoramic landscapes are some of the most dramatic images you will ever see. Use the power of the format to bring out the best of your subject matter. Verticals are used more often in portraits, as it eliminates the clutter surrounding the main subject and focuses your eye on the person in the image. The fence line leading you into the horizon is much more powerful and natural in a horizontal format. Shoot your subjects both vertically and horizontally. It will improve your perspective greatly.

The photo on the left is horizontal and the right, vertical. Both are compelling. Shoot both verticals and horizontals of a subject whenever you can. It will open up more opportunities for sales if you are shooting for publication.

Another key is the levelness of your horizon. I often see what could have been a very good photo become essentially a throwaway because the horizon is crooked. This usually happens when you're in a hurry and don't pay attention to the small details within the frame. (I find myself guilty of this even today, when I'm photographing action that involves moving people or animals.) The moment is developing and changing so quickly, you're focused only on your main subject. This leaves you open to simple mistakes such as crooked horizons or floors, branches that appear to be sticking out of your subject's head, or bright highlighted spots you never saw in the viewfinder that distract from your main subject.

Depth of Field

Creating an image that has great depth of field, where everything is in focus near to far, adds dimensionality and a compelling perspective. One of the best ways to add depth and dimension to a landscape shot is to use a wide-angle lens and to add a strong foreground feature.

Move in close with your wide-angle lens. Set your aperture to a small setting from f16 to f32. Use your preview button (if you have one on your camera), to see what is in focus from foreground to distant horizon. If you cannot set your aperture small enough to bring everything into focus, keep the foreground sharp and let the distant horizon go slightly out of focus. A sharp foreground subject seems more natural to our eyes; it will also grab our attention and pull us into the photograph.

Experiment with the distance between your camera position and your foreground subject and move your subject around in the frame to see how this changes the tension and perspective of your photographs. The closer you are to the foreground subject the greater difference the camera position will make in the final image. You will find that the closer you are to your foreground subject and the more interesting it is, the more dynamic your photograph will turn out.

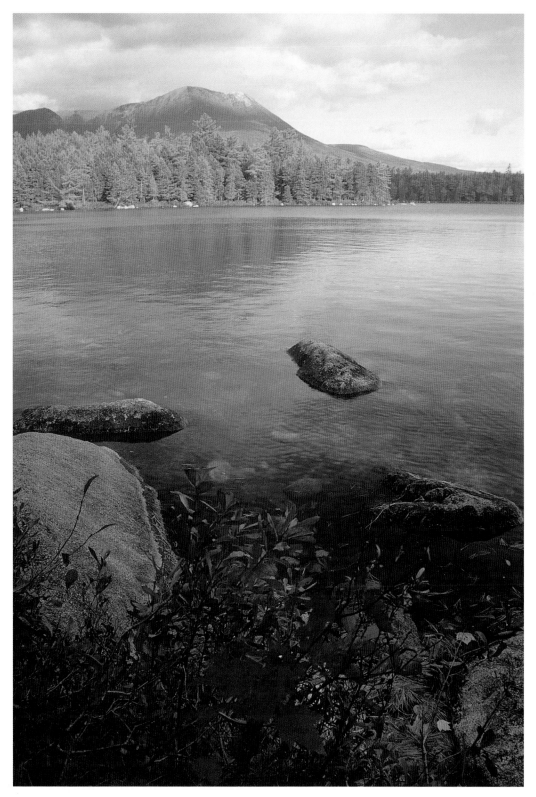

Depth of field in landscape photographs adds a three-dimensional perspective. I used a 28mm lens set at f22 at 1/2 second to keep everything in focus.

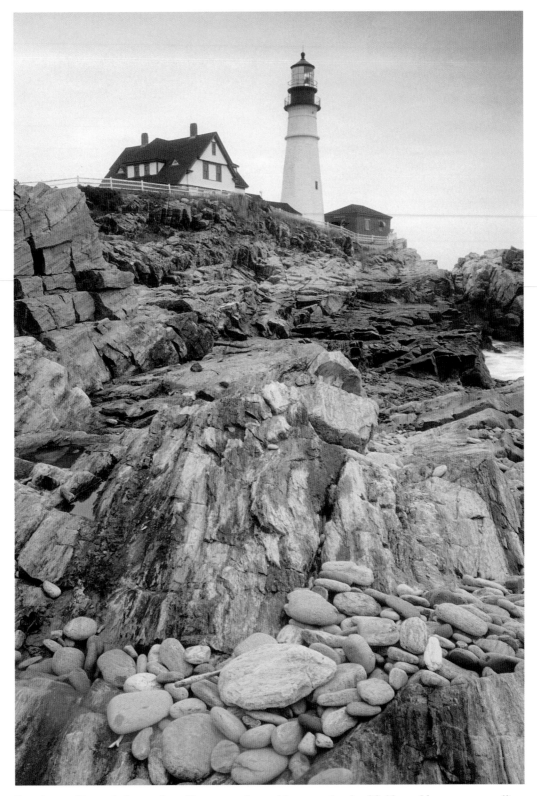

By using a wide-angle lens and small aperture, I was able to use depth of field to add a more compelling perspective to this subject.

By combining lines, color, and an unusual perspective, we can take a fairly simple subject, such as a rock wall, and make it visually pleasing.

Form and Light

Light, shadow, and form are the tools we use to design our photographs. Of course, light is always the main component of any photograph, but a graphically strong image balances these three elements. By adding shadow, we can change the form of our subject. The angle of light will also change the form and texture.

Practice finding ways to add form, line, texture, shapes, and color elements to your photocompositions. Even a simple photograph of your family can be improved by taking the time to analyze how to graphically position each person to take advantage of the angle of lighting, shadows, color, lines, and the power in the rule-of-thirds perspective. By going through this exercise, you will not only improve your photographs but will also add a whole new level of creativeness to your photographic process.

Light, shadow, and form are tools we use to design our photographs. Look for strong graphic structures to pull your audience into your images.

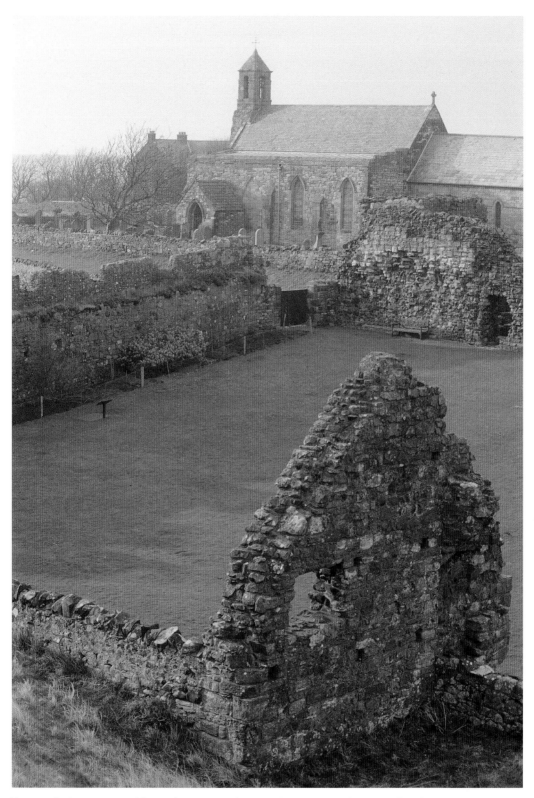

Practice finding ways to add varied textures and strong shapes to your shots. It will make your images more interesting and thought-provoking.

7

The Landscape

There are very few outdoor photography opportunities that get a photographer's creative juices flowing like a landscape. It can be at once awe-inspiring and threatening. It brings out the artistic creativity in all of us. Landscape photography is where I most feel that I am painting with light. Capturing the ever-evolving movement of light and shadow as it moves across the panorama of our natural world brings out my passion. It recharges me like nothing else does. I can go days without eating when I am lost in the trance of landscape photography. Nothing else matters. I don't even think about how cold it is or the cramps in my leg muscles. It all seems trivial when I'm enraptured by the magical world I am immersed in. These are the times when great photographs seem to be everywhere. I am so tuned in visually that I can find beauty and poetry in almost anything. But with so much stimulation surrounding us all the time, it can also be a little intimidating for someone just getting started.

At first glance, photographing the landscape seems easy. Just go to your favorite park and start shooting. The scenery is beautiful no matter where you point your camera. So why are you often disappointed when you get your photos back? Getting a great photo is not as easy as it looks, even for the pros. Many elements go into making one. Even though there is a basic formula to follow, the natural world just throws us too many variables to make it, in reality, easy.

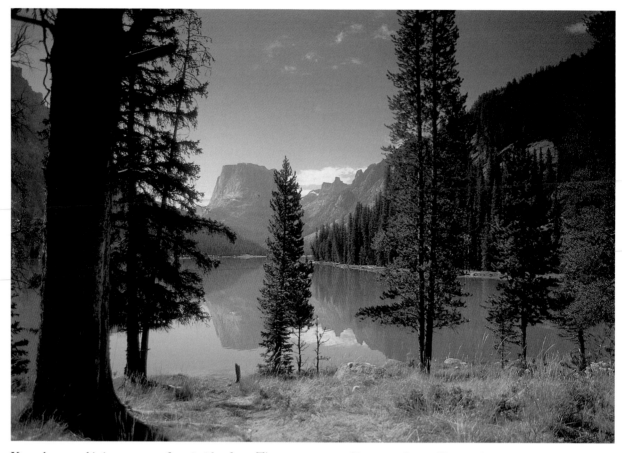

Your photographic images come from inside of you. The way you see and interpret the world around you is your vision. Satisfy your own inner passions first and others will also connect with your photographs.

Study the Best Professionals

Since childhood, I've wanted to photograph the landscape and scenery around me. Exquisite light has always inspired me. It's the primary motivating factor in my photography. But my first several years photographing the natural world were very frustrating. I would see beautiful scenes. I would carefully compose images I saw in the camera frame, do my best to get the proper exposure, and shoot. As an eternal optimist, I was always sure I'd captured the moment as I saw it.

Unfortunately, out of thirty-six shots on a roll of film, I might get one or two shots that were good. Maybe one out of two hundred would be very good. And now when I go back over those old slides and prints, I recognize that I never once got a great shot. How can that be? I was very passionate about what I was doing. I studied my manuals. I took classes and read books on the subjects I wanted to photograph so I

knew many of the best places to go. Yet, I was, in reality, just a frustrated, and mediocre, photographer.

My wife was frustrated in a different way. She knew how much I loved photography, but early in our marriage, we didn't have a lot of discretionary income. We were saving for a house, a new car, and we had young children. If I'd been coming home with gorgeous photographs, she would have been okay with this hobby. But, when I came back from the developer with boxes of slides that were mostly throwaways, it seemed like I was wasting money that we needed for real life things, not crazy dreams of being a landscape photographer.

One Christmas, she gave me a large-format coffee table book of landscape photography by David Muench. That book changed my life. I studied David's photographs intently. What was it about his work that was so magical, so inspiring, so amazing? I'd been to many of these same places and my photographs weren't anything like his.

David's compositions were often magnificent. How could he fill an entire book with such superb images? In fact, he had several books out and all of them were filled with one great photograph after another. Obviously there were some secrets I needed to learn.

From that time on, I studied the work of other photographers. And my own photography began to improve. One of the secrets was learning to see how the camera and film interpret the scene in the rectangular, two-dimensional frame of the camera format, which differs from how my eyes see the scene in three dimensions. This was an important lesson to learn and it is one that I really stress in my classes.

Many of the images I interpreted with my mind's eye did not translate into a flat rectangular format, or a two-dimensional one. Once I understood this limitation, I started to think about how my film would record the image. The way film reacts to light is very straightforward; it doesn't have any ability to interpret images like our mind does. It simply reacts to light striking a chemical formula in the flat rectangular format of a camera. After I started to see images as I perceived the film would see it, my compositions and color accuracy notably improved.

Film has significant limitations when compared to the human eye. We see things three-dimensionally. Film cannot match our ability to adjust to the huge range of contrasts, subtle lighting nuances, and the tremendous color range we see. Once I began to understand film's limitations, I was able to predict how a particular kind of film would react

Finding exquisite light is an effort. It means getting out of bed by 4:00 a.m. many mornings and shooting well after sunset—when others have gone off to find a warm meal. But when you are there for those few moments of fantastic light it is worth it!

Study the landscape masters to better understand the techniques they use to make great images anywhere they photograph. A strong, in-focus foreground is a vital component of a good landscape photo.

Experiment with many different films so you can choose the one that will help you best interpret a particular scene. There are so many great films available today it is like an artist's color palette to choose from.

to the light exposed to it. This also helped to improve my images. I was no longer guessing how a particular film would render certain colors, or if it would pick up subtle color nuances I could see with my eyes. I knew which films would give higher contrast, which ones would saturate colors, which films were better for portraits. Now I had an entire palette of films to work with that would allow me to take advantage of the numerous lighting situations or assignments.

Simplify!

The most important thing I learned from the masters was to simplify. To strip my photographs down to the very essence of what I saw and wanted to express from my subjects. Now I was getting somewhere. People

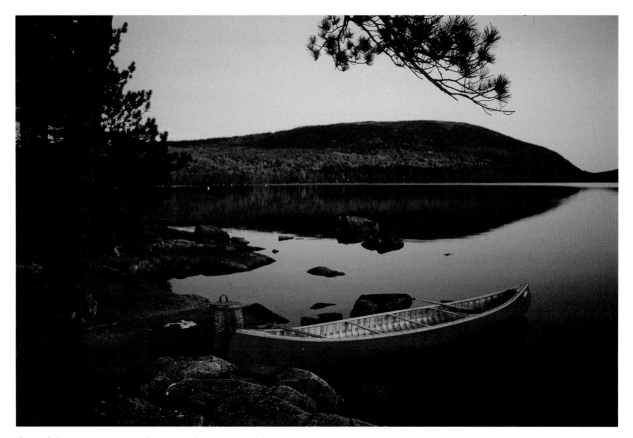

One of the most important lessons to learn that will help improve your photos is to eliminate anything that is not adding to the final image. Simplify wherever possible. Less is almost always more in a photo.

started to notice my photographs. My good shot count grew to fifteen per roll of thirty-six. My wife actually started to encourage my habit.

One of the first and most important things I teach in my photography classes is to simplify your photographs. This is easier said than done. It takes practice and discipline. As I described earlier, when studying the artistic masters, one of the things that makes their images work—photographs or paintings—is the simplicity of the final image.

Take out anything that is not contributing in a positive way to the image. Make sure there are no out-of-focus branches anywhere on the edges, top, or bottom. Look at your corners. Are there distracting highlights, shadows, or bright colors that pull you away from or fight for attention with the main subject?

Do you have too many objects included in your frame? Does your eye constantly move from one thing to another, never able to find a single focal point? Know your subject and what you want to say with the picture before you press the shutter release. Take the extra time to evaluate the entire image area. Take out the clutter and focus on what you really want to portray in the final photograph. Less is almost always more in landscape photography and, for that matter, any subject. By simplifying your images, you will actually make photographs that are more dynamic.

Follow Your Mind's Eye

What separates master landscape and outdoor photographers like Ansel Adams, David Muench, Freeman Patterson, and others from the average outdoor photography enthusiast? I think that it is simply that they have successfully expressed their inner emotions and passions on film. They each developed a style and fine-tuned it. They were each blessed with a creative eye that lets them interpret the world around them. We react to their artistry because we also feel the emotions they felt, the passions they were able to weave into their photographic vision.

The ability to interpret your passions through the photographic process takes time and patience. Become self-critical and disciplined. This will help you to focus and develop your style. As you develop your

The ability to interpret your passions through the photographic process takes time, patience, and practice. But eventually you will start to see images that were never there before that you will turn into your own "paintings."

own style, you will begin to understand more clearly what motivates you and how to bring your emotions into your photographs. When you are able to consistently bring out your passions, the way you see and interpret light into your images, others will also be motivated by your photographic vision.

Illustrating Depth

One of the first things that caught my eye when I first started shooting photos was how the great landscape masters used depth of field to bring everything in focus, from the tiny flowers at their feet to the top of a distant mountain peak. As I described earlier, depth of field is the area in the photograph nearest to you to the most distant feature that is in sharp focus. This is achieved by using very small apertures from f16 to f32. This also often means shooting at low shutter speeds of 1/2 to 1 second.

To create a sense of depth in landscape photographs, you will need a wide-angle lens, a small aperture, usually a slow shutter speed, and a sturdy tripod.

There are a few other factors that come into play to create depth of field across the entire image. The length of the lens is also important. A wide-angle lens takes in more of the subject field. The wider the lens, the greater the depth of field you will be able to achieve from the same spot. The longer the lens and more magnification, the less depth of field can be achieved even with the same small aperture settings.

I use the preview button on my camera to check the actual depth of field before I shoot. This is one of the most important features on my camera. Without it, I have to rely on charts that give me depth-of-field readings based on the focal length of my lens and the aperture size I am using.

Shooting at slow shutter speeds also means using a tripod. Sounds simple enough—but there is always the little matter of wind to deal with. Even a slight breeze at these slow shutter speeds will create blur in your photograph. Patience becomes an essential part of your makeup as you develop into a good landscape photographer. Sometimes you

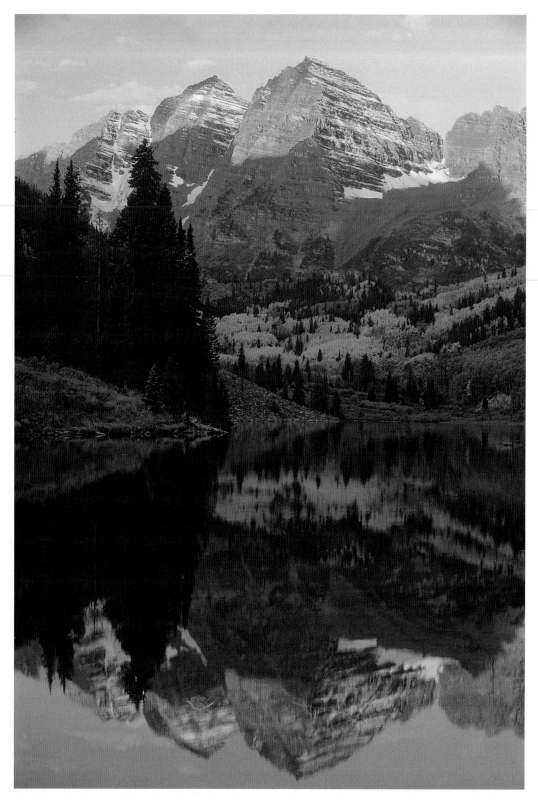

Traditionally when we think of landscape photographs we think of wide-angle lenses. Don't overlook the perspective of telephoto lenses, however; they allow you to crop in tightly to compose very dramatic images, too.

will spend long periods of time waiting for that short window when the wind stops, hoping that the perfect light won't fade.

Wind is only one of the obstacles to overcome. If you're using a telephoto lens and slow shutter speeds, this longer lens must be kept absolutely still. This can be difficult when using long telephoto lenses from 400mm to 600mm. On occasion, you will need to use a second tripod to hold the lens or an extension leg coming off your tripod. Using some sort of weight to hang from the bottom of your tripod can also help dampen potential vibration. There are beanbags made especially for hanging from tripods. You can also wrap a large rock in a shirt or towel and tie that to your tripod. In these situations, I often use a cable release to ensure there is no camera vibration. When shooting super slow shutter speeds longer than one second in length, it is also a good idea to lock your mirror up after focusing, as the mirror slap can cause a slight vibration in long shutter speed situations.

Panoramic Images

Landscape panoramic photography has really come into its own over the past few years. There are more panoramic camera styles available than ever before, in virtually all price ranges. In the past, there were a few special and expensive panoramic cameras on the market, which were used primarily by professionals. This has changed, and today even ten-dollar throwaway cameras have panoramic formats.

When setting up a panoramic shot, you have to be more aware than ever of what is happening at the edges of your frame. Generally, the final print will be about three times longer than a standard frame. Because of this, it is often more difficult to draw your viewer into a main subject in the frame. You just have to be more aware of your composition.

Many of the same principles apply to panoramic photographs that apply to wide-angle lenses. You want to evoke the broad expanse of the landscape. You want to emphasize the horizon and pull your viewer into the frame. This means keeping everything in sharp focus, near to far and side to side. Again, to accomplish this, you will generally need to use slow shutter speeds and small apertures.

Try to define the main subject in the photo, something that will grab

the viewer's attention, but don't put it right in the middle of the shot. Use the rule of thirds as a starting point and find ways to add a strong dimensionality to the image.

All Light is Good Light

One thing I have learned over the years is that you have to find ways to make great photographs in whatever weather conditions are presented to you. I believe all light is good light. Some light is better to photograph in than others, but no matter what the conditions, you can find great images if you are open-minded.

I've come to enjoy shooting on moody, damp, foggy days. I'm sure this is true partly because I often have these conditions in the forests around my home in Virginia. The Blue Ridge is only minutes from my house and the Great Smokies are just a few hours away. They are often shrouded in mist, an atmosphere that is brooding and subdued. The forest's trees are dark and solemn. But when you explore closely, many wonderful possibilities present themselves. The colors for close-up photographs are saturated; the light is even and without shadow. I've shot some of my best close-ups in this seemingly dreary light. This also presents opportunities to find and design bold, brooding abstracts. Generally, this type of lighting is not appropriate for panoramic landscapes, but it can offer very interesting cloud-shrouded mountain scenes as temperatures change along the mountain front.

Rainy days can be frustrating because it is difficult to deal with the constant moisture. Keeping your equipment and yourself dry can be a battle. You can work fairly easily in a constant drizzle or misty rain, and some of the images you find will be similar to the misty, foggy photo opportunities described above. But, when it's raining hard, I usually bag it, since it's very difficult to get great images in these conditions—and it's hard on the equipment.

Bright, clear blue, cloudless sunny days are actually some of the most difficult ones in which to get great photos. There are hard reflections on surfaces. The bald blue, cloudless sky is very bland and lifeless in the final image. If I am shooting in these conditions, I try hard to keep the sky to a minimum in my photos. I also use a polarizing filter to reduce

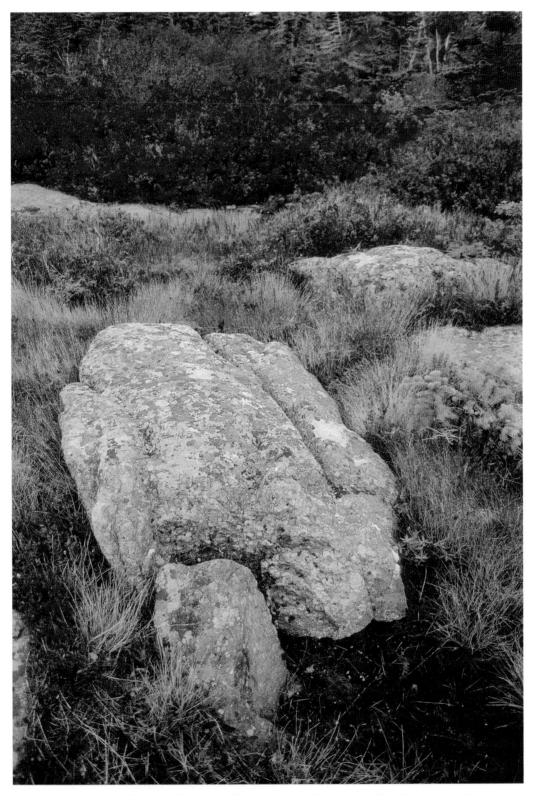

I used to avoid overcast, foggy conditions until I realized they offered some of the best opportunities to create unique photos with saturated colors and rich textures.

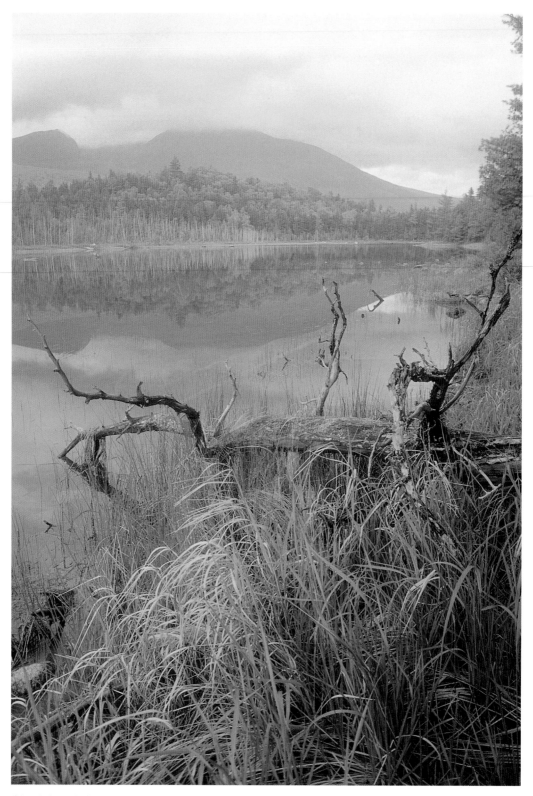

Cloud-shrouded atmospheric conditions are usually not the best for panoramic landscapes, but don't automatically write them off. They can often be very compelling.

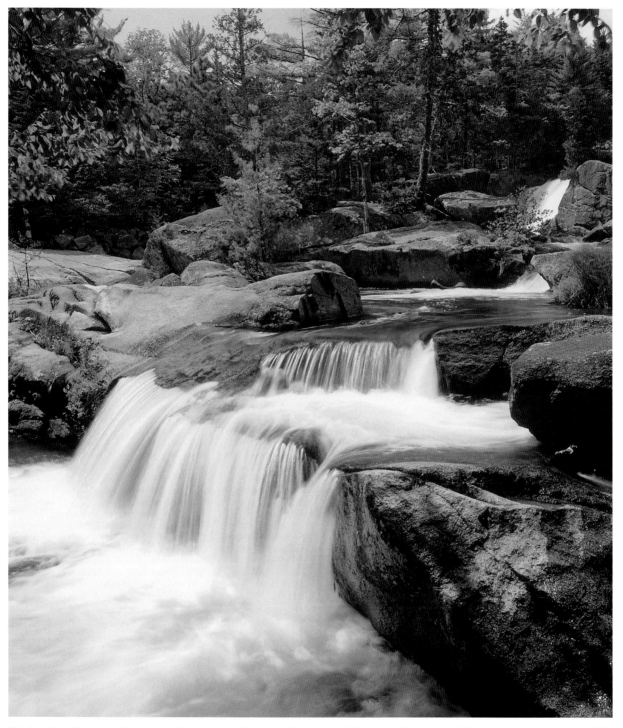

Bright, clear blue, cloudless, sunny days are actually some of the most difficult conditions in which to capture great images. I'll often use these days to scout out new locations and record places to study for future photographs.

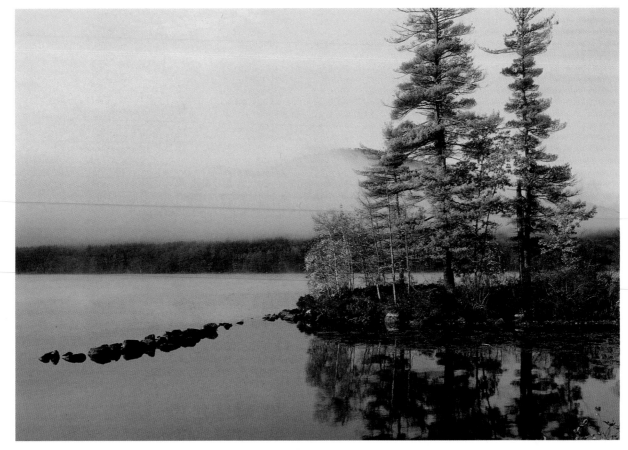

As a landscape photographer, I love the first and last light of the day. This is when magic happens. The warm, low-angled light lends everything an exquisite glow.

the reflections and glare. The polarizing filter heightens the colors and makes the pale blue sky darker blue. If shooting a sporting event or outdoor activity in these conditions, I always look around for the best perspective to take advantage of the light and lessen the harshness of this bright, direct, shadowless light.

The best light for most outdoor and landscape photography is early morning and early evening. At these times of the day, the light develops a warmth and glow that is not present other times. The low light angle creates interesting shadows and gives texture. Sunrise and sunset colors can be spectacular. But, if you restrict yourself to just those times to photograph you will find yourself sitting idle much of the time. There are great opportunities in any light, throughout the year, if you understand the techniques that will allow you to take advantage of the light and weather conditions that you are given.

Put Yourself in Position to Capture Special Moments

The slogan of *Group f64*, formed by a number of photographers in California in the 1930s, including Ansel Adams and Edward Weston, was: "f64 and Be There." The f64 is a tiny aperture, which is only found on lenses for 4-x-5 view cameras and larger. But, in a very meaningful way, it says it all. *Being there* is the first and most important element in getting great photographs. "Time on point" is another one I hear often, especially from my wildlife photographer friends. There is simply no substitute for being out in the field, camera ready, subconsciously analyzing the potential lighting opportunities and being open-minded.

Environmental Elements

Shooting in different environments, such as in a forest or at the seashore, or shooting during different seasons, such as during the fall or the spring, call for different techniques. Being prepared, having a focus on what you want to find, knowing the area, and understanding your subject are the building blocks that put you in the position to capture the great lighting moment—wherever and whenever you shoot.

The Forest
Photographing in the forest presents greater challenges than you might expect. I am always scouting for locations that will give me good compositional elements to work with. I know that on bright sunny mornings, there are often beautiful scenes where beams of sunlight filter through the forest canopy. I try to anticipate the angle of the morning light that will filter onto an interesting subject so I can be there at just the right time. Being out early in the day, ready to meet the first light, is always the best way to capture these moments.

As the sun rises, it becomes increasingly difficult to work under deep forest canopy. You have too much contrast between shadow and bright areas of light. It is very difficult for the film to record the high and low light differences. Our eyes adjust to the contrast of dappled dark and bright light, but the film cannot adjust. Certain films, such as Fuji

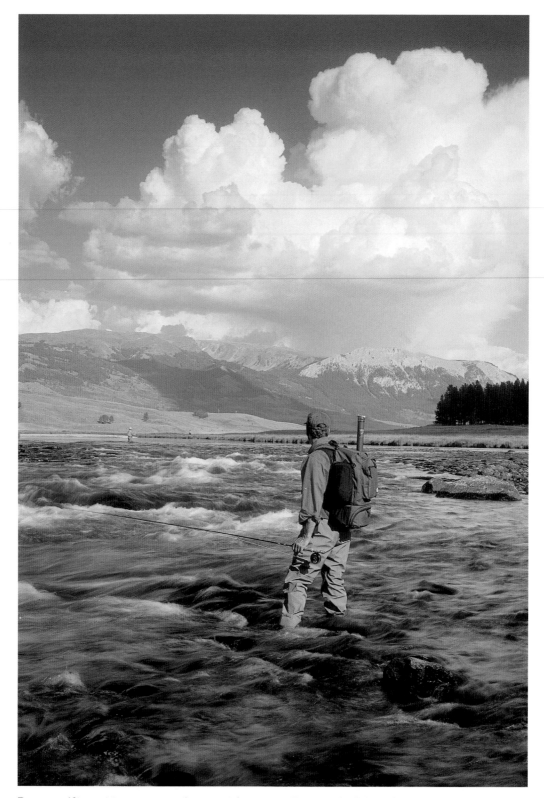

Put yourself in position to capture those special moments. Being in the field is almost always the most important element in capturing fantastic photos.

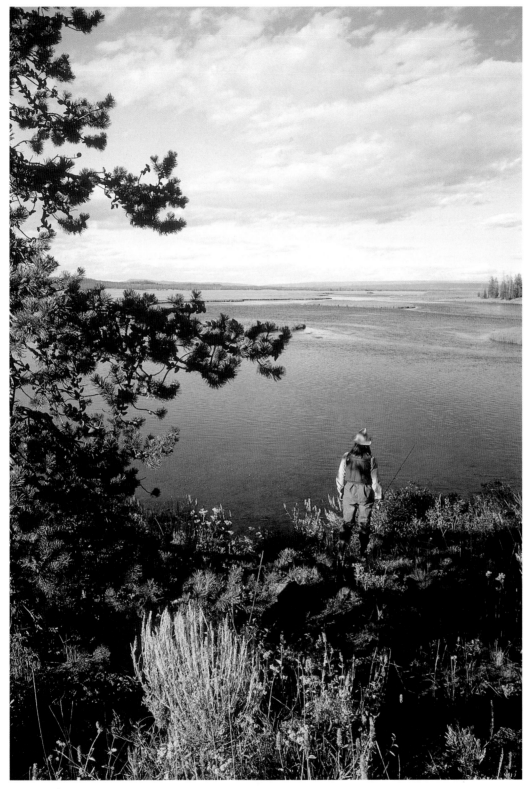

The dappled light of a bright day in a shadowed setting is almost impossible to capture correctly on film because the strong highlights and deep shadows are outside the film's range of exposure.

Velvia, which offer great saturated colors in most lighting situations, don't work well in these conditions because the contrasts are too stark.

Working in the forest on overcast, foggy, misty, or wet days offers numerous opportunities. As I mentioned earlier, these conditions lend themselves to very moody images. Using the fog or mist to frame tree trunks or branches can be very effective. Colors are more saturated and isolated. There are virtually no shadows or reflections, so true colors come through.

It is often difficult to photograph in these conditions without a tripod. There is always less light to work with, so you need to shoot at slow shutter speeds. To achieve good depth of field, you'll also need to use a small aperture, no matter what lens you use. This means it will be difficult to hand-hold any lens.

Water

Moving water is my favorite subject. It's also one of the most difficult to capture and to meter properly. Water is always reflecting light from its surroundings. This is constantly changing throughout the day and the seasons. Therefore, it is difficult to duplicate the conditions you find on any given day.

I usually use zoom lenses when photographing moving water. This gives me the freedom and flexibility to quickly select specific areas to compose with a variety of focal lengths, shutter speeds, and aperture settings. If I want to give moving water a soft look, I will shoot at 1/4. For a silkier look, but still one with texture, I use a half to one second. Beyond a second, the water will appear smoother, but will loose a greater amount of texture the longer the exposure.

You can also shoot water with fast shutter speeds to freeze its motion completely. I shoot between 125 and 250 to achieve this result. But explore a range of shutter speeds when shooting moving water. It produces an endless variety of results.

Reflections in the water bring it to life. I prefer bright, blue-sky days to capture reflected fall foliage. You must shoot at an angle from the sun that gives you the most saturated color reflections. Low early-morning and late-afternoon light and evening sun provide better angles for reflections. Overcast days can also provide opportunities for great water shots, but I use a polarizing filter to cut down on any reflected light that dampens the reflected colors in the water.

I use a zoom lens for most photos of moving water reflections. It allows me to evaluate a variety of different perspectives and images. From these different perspectives, I can adjust aperture and shutter speed to best accomplish the final look I want for the photograph.

Getting proper exposure in moving water is always difficult. It takes time and practice to gain control. I always use a spot meter to get very precise meter readings. I often use a medium-tone subject away from the water to give me a sense of range for the lighting conditions. Then I meter off any middle-tone colors in the water and adjust up or down, depending on how I want to render the total scene.

In this situation, you must be very aware of each element you include in the final photo. Depending on the lighting conditions, the water can be lighter or darker than the surrounding trees and rocks. You want to make sure that the other elements you include are in balance with your water exposure. It's very easy to get the water properly exposed, but the rocks may be three or four shades too bright and the surrounding trees in dark shadow without texture. If this is the case, eliminate those components of the photograph that are out of the range of the film to capture with proper exposure. Train your eyes to see how your film sees the scene, not how your mind's eye adjusts to these extremes.

Still water reflections are certainly easier to work with than moving water, but they can also be difficult at times. I love to capture the first

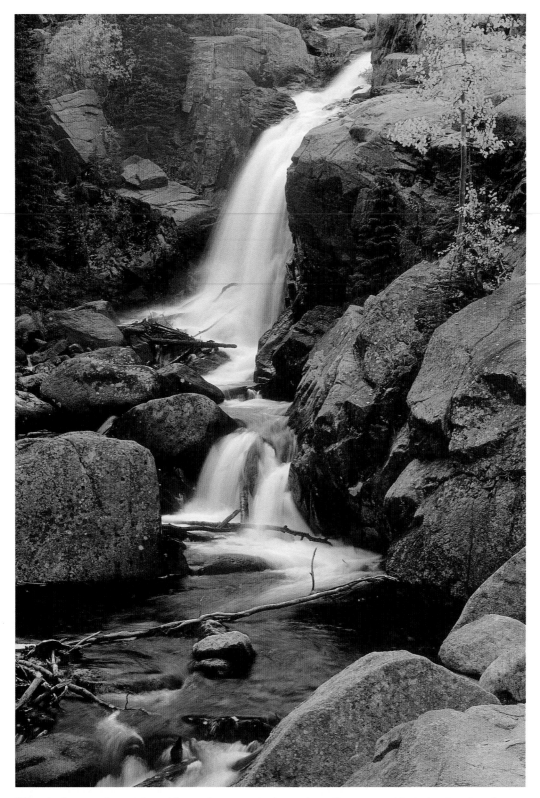

Water is always an interesting subject and you can give it a variety of textures and looks by changing shutter speeds. This waterfall was shot at f22 for 1 second to make it appear silky smooth.

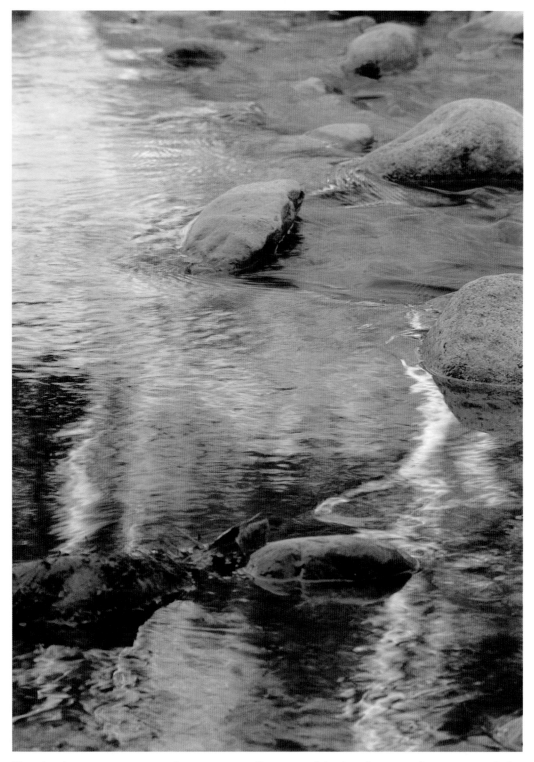

If you just let you camera meter take an average reading, most of the time the water will come out too dark. I use a spot meter to take very precise readings. First, I'll take a reading from a medium-toned subject away from the water, such as leaves, grass, or a gray rock. I will then take another reading off a section of the water and average out the two.

and last light of the day along a placid body of water reflecting a mountain scene or abstract landscape. I often start shooting a half hour before the sun rises. In the evening, I will continue to shoot a half hour after the sun sets. This is when you find the best reflected light. It will only last a few minutes, sometimes, just seconds, so be prepared. Move quickly to adjust for exposure. Bracket your shots a third stop over and under for each shot. If your exposure is correct to begin with all three will be acceptable, but you—or an editor—will prefer one over the other two.

Set your exposure in this situation the same way as when exposing for moving water. Use a medium-toned subject away from the water to take a reading from, and then take another from a medium-tone color in your reflected scene. Make sure they are close in balance. Then take another reading off the distant mountain.

Almost always, there will be too much of a contrast between the reflection, the top of the mountain, and the colored sky above or around the mountain. I use a split neutral density filter in this situation to keep the sky and the foreground reflection in a reasonable balance with each other. This means they will be within one and a half to two stops of each other at maximum. I try to stay within one stop for the best balance.

The first light of the day is a great time to capture still water reflections. Water is usually calm just before sunrise and the light is warm and enticing. I try to scout out potential first-light shots a day or two in advanced to know what to expect. I shot this at f22 at 1/2 second using a tripod.

Often, early-morning light around ponds, lakes, and rivers will be filtered through low-lying fog banks, which add drama and texture to an otherwise ordinary photo.

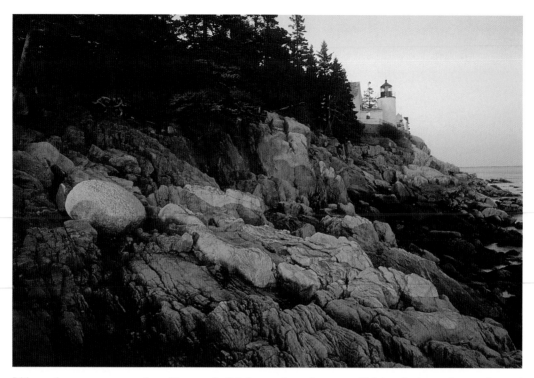

I like to shoot seascapes, such as this one of a lighthouse along the coast of Maine, during early morning and late evening light because the lower angle of the light is warmer, which counteracts the overall bluish cast from the water and sky.

Seascapes

Photographing seascapes or ocean vistas demands a different eye than what we normally use for a landscape scene. It took me a number of years to develop a set of rules and procedures that worked for my creative style. I had always looked at my landscape work from the land perspective.

The first rule is to shoot early or late in the day. This makes sense, as the sun angle is lower, the light is usually better, and there is more saturated color to the sky and the water. Sky and water can make up a large portion of a seascape. If they are devoid of color and texture, they can be overwhelmingly boring in a final photograph. The rule of thirds is especially useful here. Keep your sky at a minimum if it's blue and cloudless or overcast and gray. The same rule applies to the water. A large expanse of water of any color makes a pretty ho-hum image.

So, how do we get around these issues?

Again, shoot early or late in the day. Place attention-grabbing land features in the foreground to pull your viewer into your image. Sometimes I concentrate on the land feature and bring in just a slice of the ocean and sky to let the viewer know this is an ocean setting.

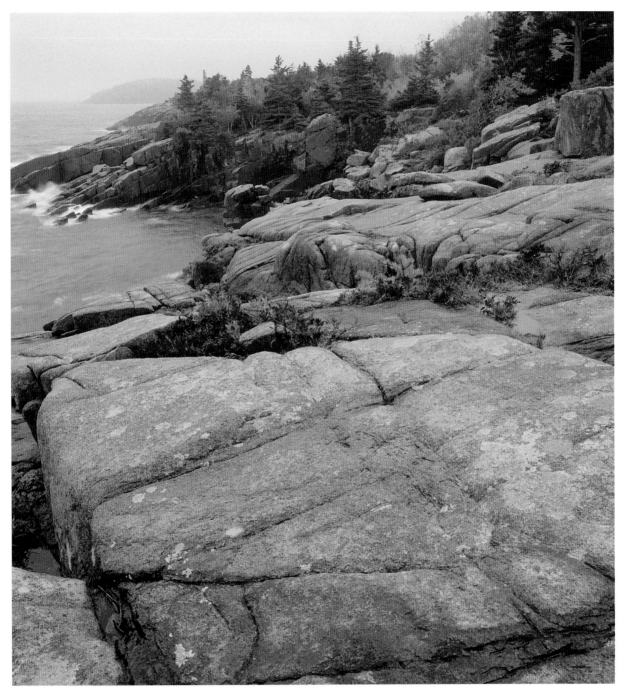

Photographing seascapes on either bright, cloudless days or completely overcast days can leave you with uninspiring images. On these days, look for interesting shoreline features and eliminate most of the sea and sky, leaving just enough so you know it is a seascape, as I did here in this shot at Acadia National Park.

As I was photographing atop Cadillac Mountain in Acadia on an overcast morning, the sun suddenly broke through, leaving a glistening sheen to the ocean waters. Unfortunately, the water was too bright for the film to handle, so I cropped it to just a small portion of the upper part of the image, which still captured the essence of that sweet moment of light.

If there is an attractive color in the sky, I may emphasize the sky and keep the foreground a secondary feature. Very seldom is the ocean calm. It is always moving, from waves and from wind. Because of this, there are not as many opportunities to have great reflections of the sky colors onto the water. This again is a situation where I'll emphasize the sky, keep just enough of the water in the scene to show it is a seascape, and find whatever is appropriate for a foreground feature, which may be a boat, dock, or distinctive land feature.

Deserts

The desert landscape presents its own set of unique challenges. For half of the year, it is too hot to photograph except during the early and late hours of the day. This is fine since the sun is usually too bright anyway, leaving the landscape without texture and shadow.

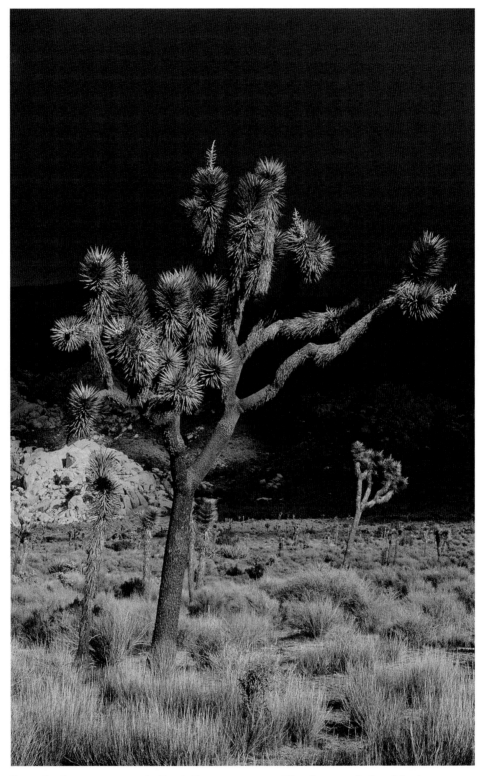

Desert landscapes present a similar challenge as seascapes. How do you make broad, boring expanses of a single color or surface come alive? Shooting early and late in the day with low-angle light helps to give highlight and shadow texture to this harsh environment.

In the deserts of the Southwest, sunrises and sunsets can be awe-inspiring events. Sometimes the desert sky is so intense it's hard to believe it's real. Make the effort to be ready for these early and late day miracles.

The desert is similar to a seascape. The sky can be the predominate feature in your desert photos. Atmospheric conditions often lend dramatic color to the first and last light of the day and you can fill up the frame with the sky at these times. But during most of the day, the desert sky is evenly blue and cloudless and adds nothing to your photograph. Keep it at a minimum or take it out altogether. In some areas, huge, billowy cumulus clouds develop on the horizon in the afternoon, setting the stage for potentially dramatic lighting. Storms in the desert generate spectacular lighting situations, even though no moisture may actually fall.

Compositional technique and your personal vision play important roles in how a stark environment such as the desert is portrayed. Find strong foregrounds to balance your images. Wait for the low-angled light of early and late day, and look for textures and forms that were not readily visible at midday. Sand and stone also reflect light more strongly than you would expect, so use a polarizing filter.

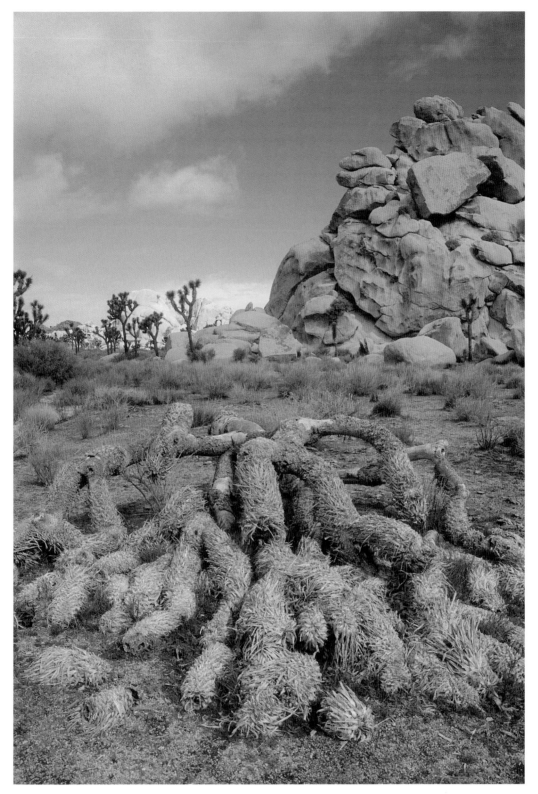

A strong foreground feature will also help to improve a stark desert landscape. Look for compositional elements during midday that you can feature when photographing during first or last light of the day.

Overcoming the physical and mechanical challenges of dry, hot conditions are explored further in Chapter 5.

The Seasons

Each season offers something special. But without question, my two favorite seasons are spring and fall. Spring is a time of renewal, bursting with fresh energy, new fragrances, and the delicate colors of new leaves and blossoms. In the part of the country where I live, the spring season lasts for three full months. I start photographing in the Great Smokies in March and can continue up the spine of the Blue Ridge Mountains until the end of May before all the blossoms are finished.

Springtime lighting and colors are almost on the opposite end of the spectrum from fall lighting and colors. Everything is subtle in the

Don't overlook the wonderful array of delicate green reflections on streams and rivers in the spring. They offer a soothing antidote to the rush of raucous color found in fall reflections.

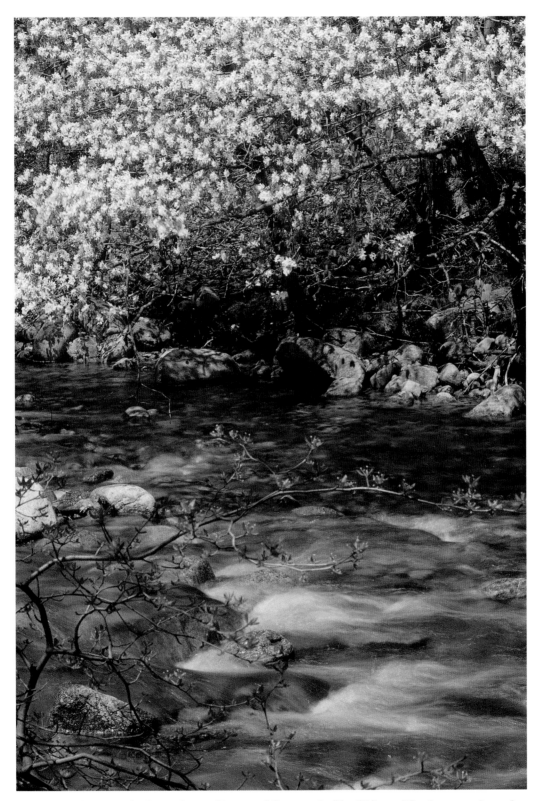

Spring is all about pastel colors and sweet blossoms. I live near the Blue Ridge and Smoky mountains and can follow the spring for three months from March to May, capturing the subtle colors of a fresh new year.

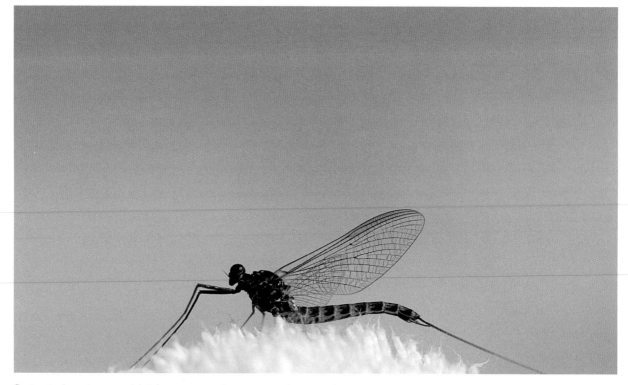

Spring is the quintessential time to capture the essence and magic of the sport of fly fishing. More often than not, I'm looking for intimate photos like this delicate mayfly.

spring, so I go out with that in mind. I plan shots based on the conditions I anticipate finding. Fly fishing is a big part of my life, and spring is the quintessential time to capture the essence and magic of this sport. Newborn fawns, nesting birds, and moose calves are also great subjects to look for. They always evoke the tender emotions of viewers.

More often than not, I am looking for intimate photographs of mayflies, fresh moss, or new wildflowers, all of which can be found along the banks of my favorite rivers and streams. Pastel shades of green reflect off the surface of the moving water. For the outdoor photographer, spring is very exciting. Seeing and interpreting these soft colors on film is a more subtle art than capturing bright fall reflections. But the final images are equally compelling.

Fall lacks the subtlety of spring. It is bright and loud. Even though the sun angle is similar to that of spring, it just feels different. In the height of the fall season in New England, with all the colorful deciduous trees, or states like Colorado that have large stands of golden aspens, the colors are flamboyant and showy. They scream, "Notice me!" It's hard not to be overwhelmed at times, especially when trying

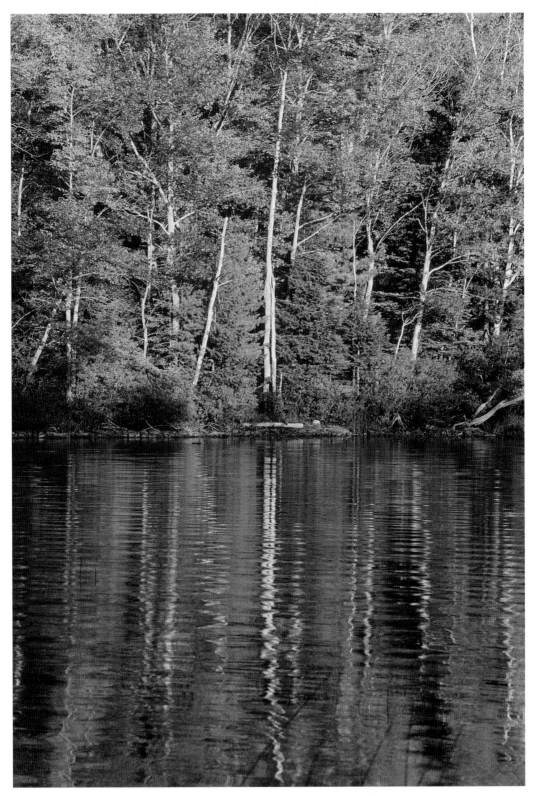

Fall is still my favorite time to chase reflected light. This scene of birches and maples reflecting onto a New England lake is amazing in its depth of color.

Winter light is subtler for sure, but sunrise and sunset colors can transform cold and bleak subjects into warm and inviting photos.

to compose photographs. It's tempting to make that riot of fall color your main focus or main subject. Just point, shoot, and you'll get a fantastic photograph. Well, . . . not exactly. Just as in the spring, you need to slow down and find the potentially stunning images locked into the puzzle of so-so pictures. Composition is critical in these circumstances.

Fall is an excellent time of the year to combine lines, textures, and colors. There are so many possibilities. The sensuous curve of a mountain stream sparkling with reflected light, a slanted hillside of scarlet maple, the white reflected boles of birch trees in a small lake—all pull these elements together to create images that are just not available other times of the year.

Winter seems to present fewer great shots to the photographer than does spring or fall. Winter photography can be intensely frustrating one day, and excessively rewarding the next. The light is difficult, the conditions are uncomfortable, and the vista is all the same color!

Shooting at midday can be especially difficult on sunny days. The snow reflects light even more strongly than desert sand and stone. A polarizing filter is essential in snow conditions. It will reduce glare and reflections and give you more defined textures. Vast expanses of snow can be very boring. Skies that are all one color combined with large snow-covered areas often make less-than-appealing images. Shooting sunrises and sunsets on a snowy winter day can be fun, however. The snow reflects the colors of the sky and gives you a warm reflection not found naturally.

Once you've found the perfect winter landscape image, exposure is critical. If you have no choice but to take a reading off the snow, you'll have to manually adjust your exposure depending on how you want to render it. The camera meter is designed to give you an exposure for an 18-percent middle-tone gray. If you follow the meter reading, the snow will be a middle-tone gray, but most of the other subjects will be too dark. To keep snow white, but not so white that you lose all texture and definition, open up one and a half to two stops.

I would rather try to find an object around me that offers a middle-tone color and meter from that. If I don't have something easy to meter from in mid-range, I take out my gray card and meter from it by positioning it in front of the camera at the same light angle as the most important subject in my photograph. Then I lock that exposure in, recompose, and refocus.

Few photographers spend a lot of time shooting in winter. If this is the time of year you like to be outdoors, there are great opportunities to be published. There are never enough quality winter shots for many publications.

Teaching Yourself to Take
Great Landscape Photographs

Truly great photographs take time and effort to compose. You have to be able to bring everything together at one time to create magic. Follow these rules.

- Start with a subject or an area that brings out your passion.

- Study the professionals. How would they interpret this subject?

- Understand your film and how it sees images.

- Be able to make any light work for you.

- Know your subject area.

- Be there for the early and late light.

- Have a plan on what you want to accomplish.

- Work through your stable of lenses.

- Experiment! Try different perspectives, shutter speeds, and apertures.

- When you find a potentially great image, work it hard from different perspectives. Shoot in-camera dupes.

The Wonders of Natural Phenomena

Some of the world's most famous photographers are best known for shooting in one particular area of the world. Why is that? How can they go back to the same places over and over again, and always seem to find something fresh?

The answer is that they never know what the natural world is going to throw at them next. Any location can provide a creative photographer with thousands of choices that are determined by season, by weather, and by light. The job of a photographer is to try to exploit the beauty of these many moods.

There's hardly anything more miraculous to the outdoor photographer than a sky full of light, texture, and color. Whether it's a vivid sunset, a brooding cloud bank, or even the perfect blue backdrop, the sky provides our potential image with a palette of light and color to help us capture the mood of a place. Violent lightning storms give us dramatic images, soft fog adds mystery, and sunset fireworks fuel our imagination. Capturing these moments requires a basic understanding of exposure and composition, a little technical know-how, and, oh yes, luck.

The Atmosphere

Getting that miraculous sky to translate accurately to the film can be tricky. Here is a rundown of some of the most interesting effects occurring in the atmosphere, and how to capture them.

There are many places around the globe that offer dramatic light because of the unique weather that is created around them. One of my favorite places to photograph is Baxter State Park in Maine. Several lakes and ponds present great vantage points to capture the daily drama of the magnificent cloud and light displays around Mount Katahdin.

What can be more miraculous to the outdoor photographer than a sky full of light? Be prepared to capture these sky scenes—they may never be repeated.

Virga, Rainbows, and Clouds

Virga are streaks of precipitation, such as water or ice particles, that fall from clouds but evaporate before reaching the ground. From a distance, they are sometimes mistaken for funnel clouds. Rainbows are formed in a similar way. The sun's light is reflected on raindrops or mist. From the photographer's viewpoint, virga and rainbows are comparable events. They only appear if conditions are right, and are often fleeting.

Both virga and rainbows can be shot successfully with the help of a polarizing filter. Rotate the filter until you capture the image to your satisfaction. You'll find that if your polarizer is turned the wrong way, the virga or rainbow will actually disappear from your viewfinder.

Rainbows may be more common than virga, but they are still a delight to see and to photograph. A polarizing filter will enhance the colors, but be careful as you rotate the filter—you might virtually eliminate the rainbow if you rotate too far.

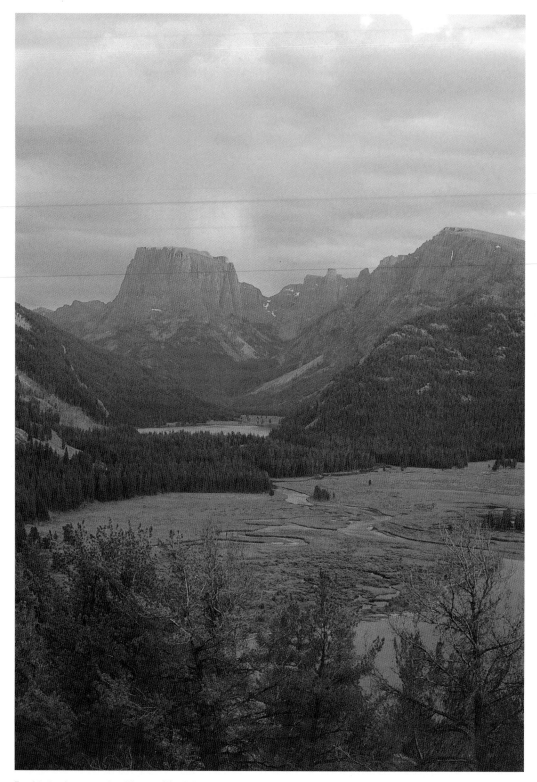

In this is photograph of Square Top Mountain in the Wind River Range, I was fortunate to catch the elusive phenomena called "virga." Virga are streaks of precipitation, such as water or ice particles, that fall from clouds but evaporate before reaching the ground.

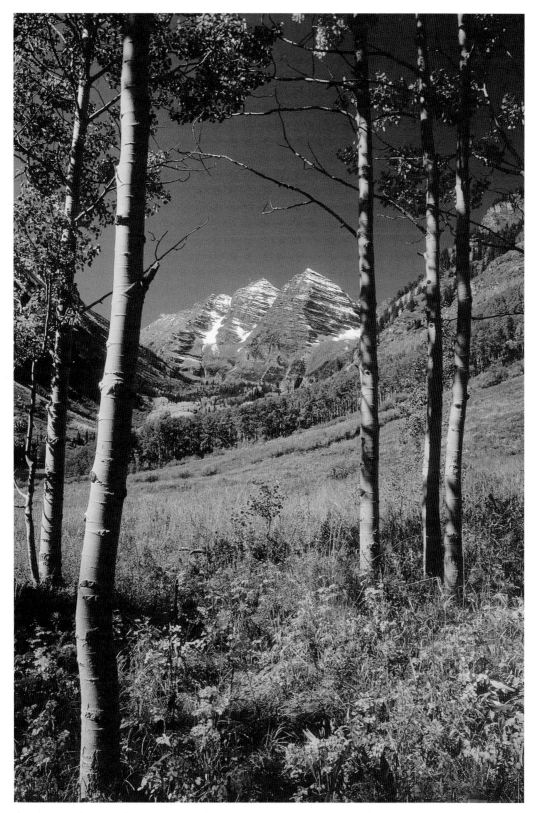

A polarizing filter will darken a bright blue cloudless sky to give it a more dramatic effect.

I am constantly drawn to the sky, to clouds, and to the colors in the sky. I used to just admire the cloud colors if I didn't have a subject on the ground to connect to them. Now I photograph them any time I see exciting formations and later incorporate them into images that I put together in Photoshop.

A polarizing filter is also great for enhancing clouds. The filter will darken the blue of the sky, emphasizing the brilliance and texture of the white clouds. To maximize the drama of the clouds, try a graduated neutral density filter. This will darken the upper part of your image without affecting the lower portion that features the landscape.

Sunrises and Sunsets

Sunrises and sunsets are those magical moments that turn ordinary people into photographers. The colors challenge you to grab a camera and start shooting.

You'll only have a few minutes to work with the rapidly changing light of a sunset. And the quality and intensity changes moment to

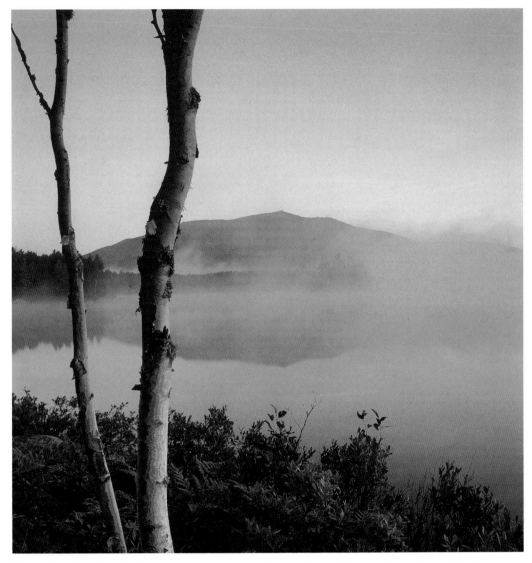

Many of my friends think I'm crazy for getting up so often at 3:30 or 4:00 a.m. just to chase the light—but it's almost always worth the effort. I was bathed in this morning light surrounding Mount Katahdin for about three to four minutes before it eased away.

moment. To make the most of your sunset opportunity, meter carefully. Take your meter reading on either side of the sun, never with the sun in the viewfinder. Frame your sunset with an eye-catching foreground. Whenever I'm in a new place, I quickly note where east and west are. Then I keep an eye out for likely shots. That way, I have composed the shot before I ever see the actual sunrise or sunset. When color starts to show in the sky, I know exactly where to head. A warming filter (81B) intensifies the redness of the sky, but I prefer those moments that don't require any help to be spectacular.

Both of these images were taken in late summer when the atmosphere was full of dust particles and smoke from nearby forest fires. Being there is often the most important thing to do if you want to capture these simple but effective images.

Lightning

Lightning is not an easy image to capture—and it can be a little scary. Timing and safety are critical. But if you want to do a little amateur storm chasing, do a bit of preliminary work.

Scope out the area around your home during clement weather. Ideally, start in a place with readily available shelter. Are there windows from which you've observed storms in the past? Check those windows to see if you can shoot from them. Next, walk around your yard to evaluate your sky views. If there aren't any likely choices, try a nearby park. Look for a location that has a wide-open vista of the sky and make certain that there aren't any bright lights in the area from buildings, headlights, or distant streetlights. These will ruin your image. Avoid places that tend to flood, and never use trees for shelter. I usually try this type of photography at night, when it is possible to capture lightning bolts that are four to five miles away.

To capture the images, select film with a low ISO. This will allow you to keep the shutter open for a long period without worrying about the effects of stray light. Mount your camera on a tripod and attach your cable release. Set your shutter-speed at B and your aperture at about f11. Then simply open the shutter and wait. If the lightning bolts are in the distance, try to shoot more than one lightning strike before advancing your film and starting again. If it's a very bright, nearby flash, advance film after each strike.

Warning: Stop shooting if the lightning storm is nearby.

The Moon and Stars

Any 35mm camera with a time-exposure setting can be used to take pictures of the moon and stars. A normal lens can capture star trails or place the moon in a landscape setting. If you want to record images of stellar objects, you can even attach your camera body to a telescope. Many manufacturers offer these adapters.

The Moon

The most common problem with moonlit landscapes that seemed perfect on location is that, on film, the moon appears smaller than it looked in the viewfinder. In order to get the moon to appear on film as large as it did in real life, use the following calculation.

I could have increased the size of the moon in this shot by using a longer telephoto lens, but I would have lost the great mountain foreground as a result. My other option was to shoot the moon as seen in this photo, but make a double exposure using a long telephoto lens with the second image to increase its size.

Focal length (in millimeters) = approximate size of moon on film

For example, a 100mm lens will produce an image of the moon on film that is only 1 millimeter, or about 1/25 of an inch. By using a 400mm lens, you can increase the moon size to almost 1/6 inch.

Serious night photographers often create double exposures. They do this for a couple of reasons. A landscape image at night requires a relatively long exposure time. If you shoot the moon at the same time, it will move on its evening trajectory, and will make an oblong shape on the film. Also, the moon's size will be very small in relation to the landscape.

This double-exposure technique solves these problems. First, shoot a landscape that appeals to you. Leave an area at the top of the film, preferably filled with nothing but black sky. Next, take a second exposure on the same film, this time of just the moon. Use a telephoto lens to enhance its size.

You can shoot great nighttime landscapes using moonlight as your light source. Don't include the moon in the actual image, though. Use the chart below to determine your exposure setting. These times will produce images with heavy shadow areas. To get the shadow detail that is more like a daylight shot, multiply the exposure times by four. Note that the times in this table are starting points only, and the angle of the moon will also impact exposure. Be sure to bracket additional exposures to ensure a good image.

Shooting in Moonlight

Lunar Phase	ISO	Exposure time (in seconds)	Aperture
Crescent moon	50	1/15	f5.6
Half moon	50	1/60	f8
Full moon	50	1/250	f8

Star Trails

Star trails make fascinating and dramatic images. And they're pretty easy to capture.

Try to find an interesting silhouette or skyline for the foreground. As with any night photography, avoid stray light from buildings or cars that may fog your film. The best time to photograph star trails is on a moonless night, early in the morning, or at a location away from the city. I like to photograph star trails when I'm on wilderness trips, far away from any stray light.

Use a 35mm camera that has a time exposure setting with a normal or wide-angle lens. Medium- to high-speed film (ISO 100 to 400) will give you the best results.

Your aperture setting will determine the width of the trails. A large aperture produces thicker trails, but you may not like the softness of the edges. Stopping down your lens to a small aperture opening requires a longer exposure, but will produce thinner, sharper streaks. Experiment to determine the kind of image you like best.

Due to the earth's rotation, stars appear to revolve around a point directly above the earth's axis, marked by the North Star. To record circular star trails, mount your camera to a tripod and aim it toward the axis point. Open your shutter for fifteen minutes up to four hours; the length of time you record will determine the length of the star trail.

If you're looking for a precise trail length, use the following calculation to determine the length of the star trail versus the time needed for a given lens.

Length of trail = focal length of lens (in inches) x time on film (in minutes)

For example, if you want to record a star trail of 1/10 of an inch on film, you'll need to shoot with a 5-inch lens for 4.5 minutes.

The Sun and Solar Eclipses

Warning: Shooting images of the sun is dangerous, both to the photographer and to the equipment.

I recommend that you avoid shooting any image that includes the sun. Never look at the sun directly through any kind of optical instrument with the naked eye. Ultraviolet and infrared rays can cause permanent eye damage before you even realize what's happening. The sun's rays can burn through your camera's cloth focal plane shutter and the film's emulsion.

There are methods for recording solar eclipses; if you want to pursue this sort of photography, your best information will come from books on astronomy. There are filters available for protecting eyes and equipment, but this type of photography has very specific requirements. Never attempt it unless you're fully prepared.

Aerial Photography

One of my favorite photographs is a shot of my home, taken from an airplane. That image shows me the setting of rocks and forest, fields and rivers that I live amidst, and reminds me of my place in the world. Landscapes photographed from the air provide a fascinating perspective on our world.

A commercial flight, however, is not the place to get aerial photographs. Yet, sometimes I just can't help myself; I snap an image from the window of an airliner. And though it may record what I saw, the result is always disappointing. There are simply too many obstacles in the way to achieve a quality image.

How many times have you been pinned in an airplane seat for hours, when suddenly, out the window, a fabulous scene screams at you to get your camera out and photograph it? Well, sometimes it is worth the effort. To capture these images correctly, refer to the chart on page 190 to help ensure clear, vibration-free photos.

To get great aerial shots, schedule an excursion for the sole purpose of shooting from the air.

To get great aerial shots, schedule an excursion for the sole purpose of shooting from the air. Hire a pilot with a small plane and explain your goals. Ask for scheduling flexibility to accommodate weather and lighting conditions, and plan on passing over the area you wish to shoot several times.

A filter is essential to compensate for the haze caused by UV rays. You could probably get by with a haze filter, but with color film, a polarizer will probably handle the haze well enough and give you the added advantage of helping you cope with reflected glare.

The following chart offers the slowest recommended shutter speeds for aerial photographs. Bracket your exposures to achieve the best results. These numbers don't take into account compensation for helicopter vibration, long lenses, or film size. All these conditions may require faster shutter speeds than those listed.

Shutter Speeds for Aerial Photographs

Altitude (in feet)	Ground speed (mph)						
	75	100	150	200	250	300	350
4000+	–	1/60	1/60	1/125	1/125	1/250	1/250
3000	–	1/60	1/125	1/125	1/250	1/250	1/500
2000	–	1/125	1/125	1/250	1/250	1/500	1/500
1000	–	1/25	1/250	1/500	1/500	1/500	1/500
500	1/250	1/500	1/500	1/500	1/500	1/1000	1/1000

Fish and Wildlife

Images of wildlife in their natural habitat are among the most fascinating shots we can get as outdoor photographers. That's because these images give us a chance to peek into another world, to learn more about the way wild animals live in their natural environment.

This is a skill that requires patience. A wildlife photographer may get up at 4:00 a.m. to be in place before the animals begin to stir, and then sit for hours in cold, wet weather waiting for a chance to snap a deer venturing out to graze or an elk feeding along the edge of a stream.

Of course, I'm assuming that you've done your research, and have an idea where and when animals will appear. Even then, there are other issues to consider. Is the animal in adequate light? Is the composition interesting, or does he insist on staying in darkened areas or in front of unattractive backgrounds? Can you capture him moving quickly?

Every wildlife photographer shares that incredible sense of wonder that comes from sharing a wild animal's world for even a little while. Unfortunately, most inexperienced wildlife enthusiasts only have piles of worthless animal shots to show for all their hard work. It's not enough to catch the animal on film. The composition, lighting, and pose have to also be right to make the image worthwhile.

Learning to take wildlife photos is one of the most rewarding aspects of outdoor photography, but it requires skill, patience, the right equipment, and quite a bit of luck.

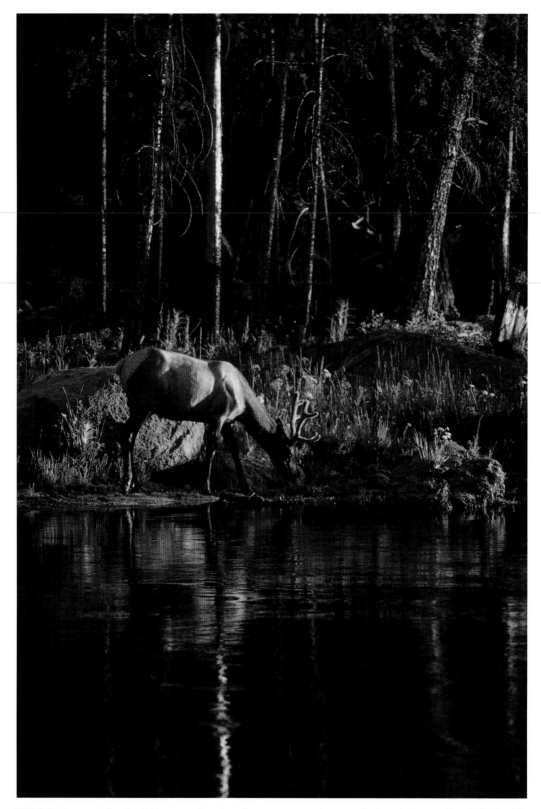

Wildlife photography should be more than just documentary—aim to make it artistic as well, as I did in this shot of an elk reflection in evening light.

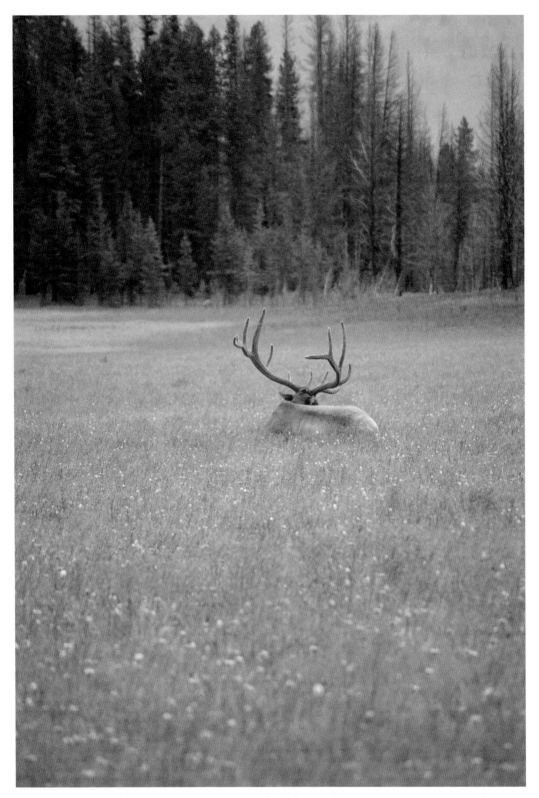

Because my first love is landscape photography, I'm always looking for ways to incorporate wildlife into strong compositional images within the landscape. By combining light, texture, and colors, I try to create something with a unique perspective.

Wildlife

The most critical factor in getting winning photos of wild animals is to learn as much as possible about them ahead of time. Wild animals inhabit a world that has little to do with ours, and they can be dangerous, particularly if you don't know what to expect from them.

Check with a local field guide to learn what species are found in the region in which you want to shoot. Scope out your subject's favorite territories. Find out the animals' feeding habits and other patterns of behavior. What do they like to eat and where do they find it? Are they nocturnal? Do they move in groups or are they solitary? How do they react in various types of weather? Take note of their mating season as well as when females will be giving birth, because they are unpredictable at these times.

One of the real pleasures I glean from photographing animals is simply observing them in their natural habitat. I always learn more from the animal himself than from any book. Watch his actions and try to figure out what he is doing and why. Animals rarely act randomly. Almost everything they do has a purpose. A male elk pawing the ground and bugling during mating season is acting out a ritual for attracting the attention of a local female. Chances are good he'll repeat that behavior throughout the season, and that he'll return to one spot often. Tomorrow you can be there, waiting for him.

Don't let the docile nature of a grazing moose fool you, however. While most animals are happy to ignore you or even avoid your presence altogether, few will stand for a rapid approach and none will willingly allow you near their offspring. Signs of displeasure on the animal's part may be as subtle as twitching his tail, stamping a foot, or pinning his ears back. These are all signs that he's not happy with your presence. That's the time to retreat and leave him to his territory.

When I first became interested in wildlife photography, I happened to be working in Yellowstone National Park. (It's easy to become enthusiastic about wildlife in a place that boasts so many opportunities to observe animals.) I was thrilled to come upon a lone elk standing picturesquely on a hill. I had an elk call with me, so I used it. Initially, I was excited when the elk noticed and headed slowly in my direction. It didn't take long, however, to realize my blunder when he began advancing with alarming speed. It was mating season! I didn't know

Understand your photographic prey before venturing out to capture them on film—know when they herd together, how they will react to you, and make sure you give them a respectful distance.

This female moose was surprisingly docile on this winter day. I was able to approach close enough to capture her on a 300mm lens. I would not have been so lucky in the spring and early summer when she likely would have had a newborn calf nearby.

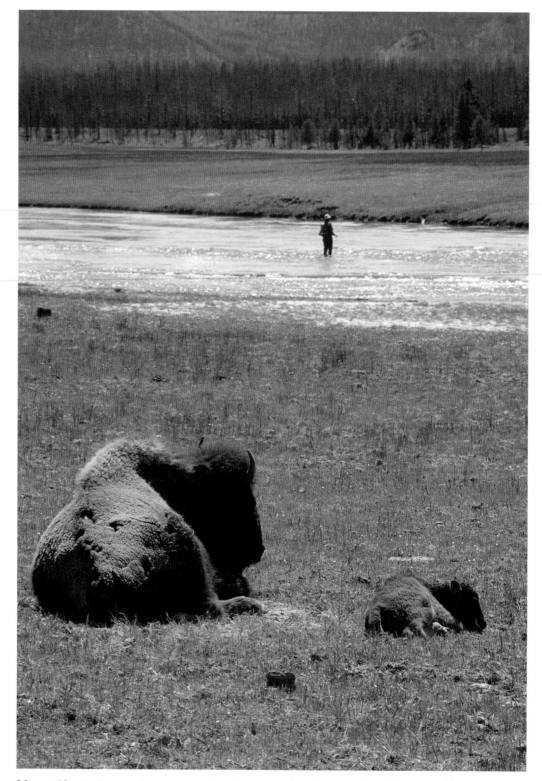

Many wild animals seem almost tame at times, but remember, they are truly wild creatures. I've seen several accidents involving tourists and bison in Yellowstone National Park because of people's ignorance about wild animals.

This bull moose in Baxter State Park in Maine was a particular grouch—it was mating season, and he was ready to fight anyone and everyone. I was able to get a few photos before he hustled us along. The bottom line? Offer wild animals respect. When it's clear they're getting annoyed, leave them alone.

enough at the time to determine whether I sounded like a female that he wanted to meet or a male that was challenging his territory. I didn't stick around to find out; I was back in my car before we got to meet face to face.

In my years in Yellowstone, I saw many such mistakes, some far more serious than mine. I saw people try to goad complacent moose into action by kicking dirt in their faces. I saw tourists with cameras approach baby elk while their mothers stood nearby. I even saw someone try to put a child onto the back of a bison! Unfortunately, one of these incidents proved deadly for the tourist. In another, the animal was caught and transported away from its home area.

The bottom line when photographing an animal is respect. If it's moving away from you or doing other things that make it clear that it feels threatened, back off. A 300mm lens should provide enough distance to get clear shots while maintaining its privacy. I prefer a 400mm

as a minimum; most of my wildlife photographer peers prefer 500mm and 600mm lenses. As a wildlife photographer, you can help to guard the delicate balance between our world and theirs.

Birds

Birds make fascinating subjects for the wildlife photographer. Because they're plentiful, you may be able to make a hobby of shooting them without ever leaving your backyard. But while they may not require the strenuous effort that's needed when shooting large mammals, they do require patience.

If you feed birds, you'll have plenty of opportunities for pictures. It's hard to get great shots at the feeder, but there are a couple of tricks that can make it appear as if the birds are in a more natural setting. I mount branches near the feeders so birds can hop off the perches and "pose" for me.

Luckily, backyard birds get used to your presence. After all, they associate you with filling those feeders! I can sometimes even use a

Birds make lively photographic subjects. Occasionally, I will set up on one of the lake shorelines near our home to do self-assignments. Along with practicing metering and composition techniques, it's a great way to understand the habits and behavior of different bird species.

flash for close-ups at the feeder without causing too much upset. Try this if the background is not too close. The light will fall off quickly, illuminating only the subject. Use a fast shutter speed and a relatively small f-stop to get a nice, even background. A setting of 250 at f16 should produce good results.

Birds with youngsters also make great subjects because you'll be able to easily predict their daily habits. You may even be able to set up a small blind in your backyard for recording their routines. Start out a good distance away, and then day by day, move a little closer as they become accustomed to your presence. But stay away from the nest during and right after the eggs are laid. If you frighten a bird then, it may abandon the nest.

Fish

Capturing fish on film is not easy. I spend a lot of time fly fishing, for trout in streams and rivers, and for bonefish, tarpon, and permit in the tropics. Each environment presents a unique set of problems to solve.

Wherever I photograph fish, I follow a few set rules. I make sure I have film that is fast enough to handle varying lighting conditions—usually 100 or 200 ISO. This will also ensure I get good color and fine grain. I preselect my exposure based on what I think I will need for shutter speed and aperture. In most cases, I set my shutter speed between 60 and 125. This will stop most movement by the fish and the person landing it. But sometimes 125 will not give me enough light; therefore, I also need a shutter speed that allows me to use an aperture that is in the f8 to f11 range to get some depth of field. I use this range of aperture to compensate for the movement in and out of the frame of focus by the fish or fisherman.

If your camera is equipped with auto-focus, this is the time to use it. If your fisherman is wearing a hat (and that's usually the case), use your flash and set it for fill lighting. For instance, if you set your shutter speed at 125, set your flash to give somewhere between one quarter and one half the normal full flash. You want just enough light to take out the shadows and still look natural. With too much flash, the shining fish will be blown out.

Predetermine where you will end up shooting this fish being landed. What will the background be? Will the water be dirty and silted from

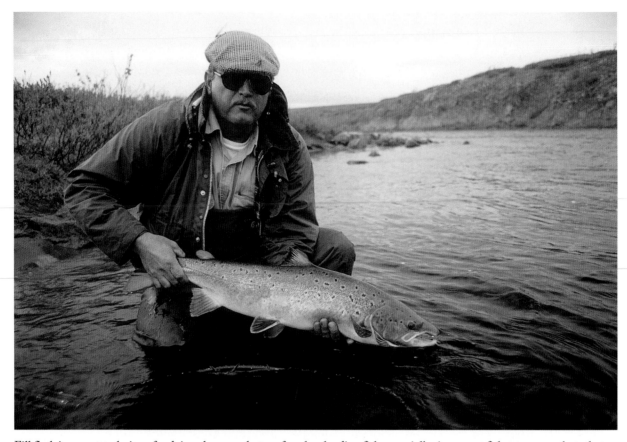

Fill flash is a great technique for doing close-up photos of anglers landing fish, especially since most fishermen wear hats that cast shadows onto their faces. Set your flash for either one quarter or one half power if using manual settings to remove the shadows without blowing out the fish or the fisherman.

the fisherman turning up the mucky bottom? Is there a sandy area to ensure the fish has a good backdrop? What will the background be for the fisherman? Do you want to include sky or eliminate it altogether? All of these factors should be analyzed beforehand to ensure you get a great shot.

Another tip: When the fisherman is finally holding the fish and smiling, make sure he keeps his thumb behind the fish. This will highlight the fish and will lessen the distraction of the hand.

In a freshwater stream scenario, you'll be working with dark, cola-colored waters in most eastern states. The fish will also be on the darker side of the color spectrum. Meter off a neutral shade of clothing or green grass nearby, set your exposure, and be ready to shoot when the action starts.

When shooting in clear western streams and rivers or in the sunny tropics, everything will be a shade or two brighter. Even the fish are

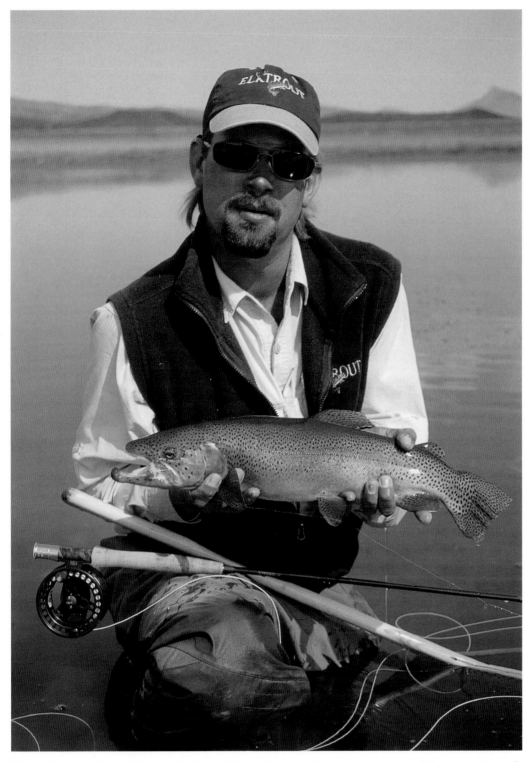

When photographing a fisherman landing a fish, predetermine the camera settings and the composition of the shot. Make sure the background is not too cluttered, find an area that's not muddy, and try to keep rods, reels, and lines either out of the photo altogether or integrate them into the composition. This image is too cluttered—the rod, line, and net detract from the beautiful fish.

A great catch, but the thumb over the back of the fish and the bright watchband are distracting. Always ask your anglers to keep their thumbs behind their fish, and try to eliminate watches to keep the emphasis on the fish.

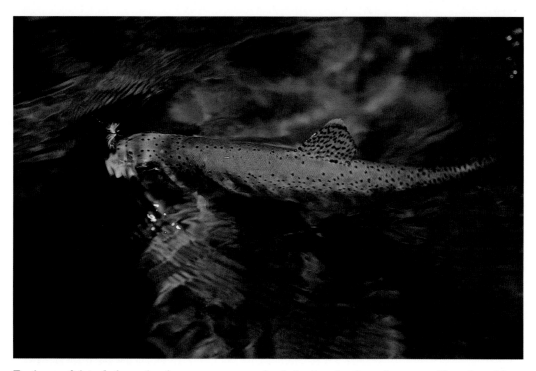

Freshwater fish in darker-colored eastern waters are also darker in color. Sometimes you will need to add a stop of light to open up the shadow areas and to bring out the full colors of the fish.

lighter in color, and usually very shiny. Tropical fish will flash some iridescence when turned at different angles. You can shoot at higher shutter speeds in these conditions. I will often set up at 250, but try to stay with an aperture of around f8 to maintain depth of field. I also use a polarizing filter to cut down on the reflection and glare from the water, the fish, and any metal objects, such as reels.

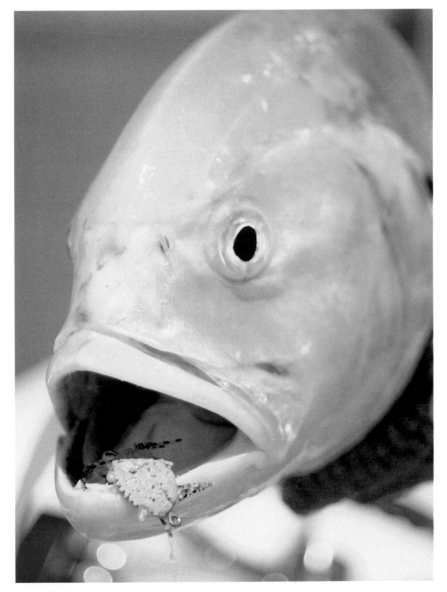

Be careful not to wash out the brilliant, often iridescent colors of tropical saltwater fish, as happened in this photo. Also, never meter directly off the fish or it will be too dark. Your meter always wants to make everything a medium tone. Meter off the back of your hand or the angler's face and close down a half stop to get the right exposure.

To eliminate glare, use a polarizing filter when photographing bright western or saltwater fish .

One of the prime reasons we catch fish is to get a glimpse into their world and to capture a moment of their splendid beauty. They are wild jewels!

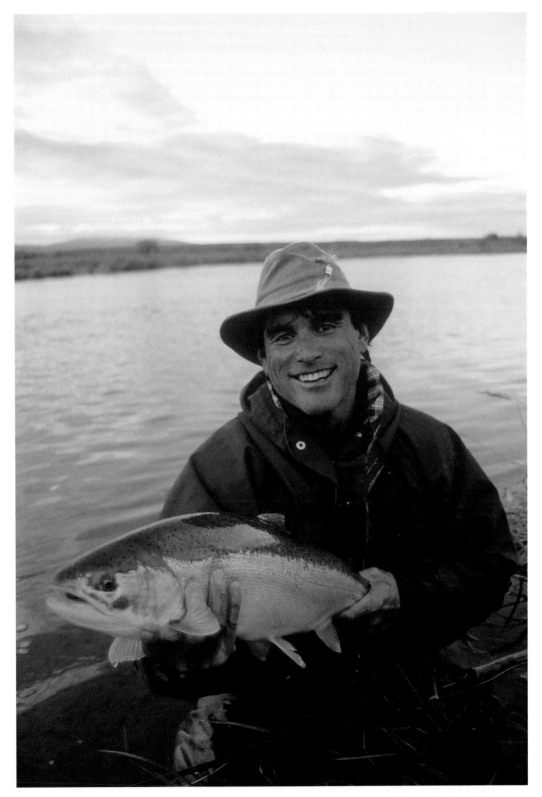

In this shot, the angler removed his sunglasses and pushed his hat back from his face so that I could eliminate the shadows that would have obscured his smile.

Emphasize the fish by having the fisherman hold it at angle coming slightly toward the camera. Remove sunglasses from the angler, and push hats up on the forehead a little to get even lighting on the face, even if using fill flash. Either move rods, reels, and lines out of the photo or place them in such a way that they are integrated into the composition. Too often, you'll notice a rod poking straight out of an ear or the back of the angler's head in the final print. Before you press the shutter release, make sure that you've removed any of these distractions.

Take several different photos, even close-ups of just the fish as it is being released. They are beautiful creatures and half the reason we pursue them is just to hold them for a moment to share their splendor.

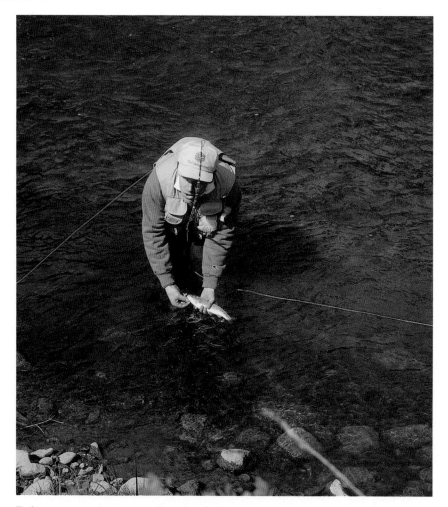

Before snapping the shutter, take a close look at your composition. Make sure there isn't a rod sticking out of the top of the angler's head (as in this photo) or other unintentionally funny things going on in the picture.

Composing the Great Shot

Don't forget everything you know about composition during the excitement of the chase. Everything that is important to your landscape shot is important here. These basic tips can help turn ordinary shots into extraordinary ones.

Whenever possible, get your camera at the animal's level or lower. This enhances the animal's appearance and creates a more impressive image.

Pay particular attention to your subject's eyes when you're focusing. If the eyes are out of focus, the photo will never look right, and the entire composition will seem out of focus. If you have a choice of compositions with or without the face and eyes showing, you'll find that the shot with the eyes will almost always be better.

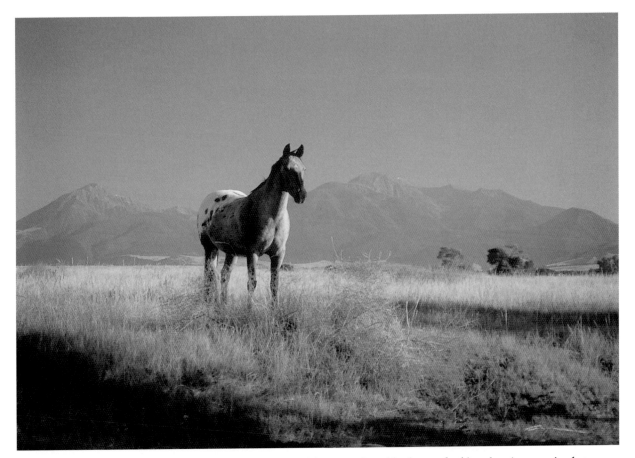

To keep the focus on your subject, always look for uncluttered foregrounds and backgrounds. Also, shooting an animal at eye level will help to enhance its appearance and often creates a more impressive result.

Shoot both horizontal and vertical images when possible. It will open up new avenues for potential sales.

Keep the background and foreground clean. It's very easy to forget your surroundings when you have an animal in your viewfinder. If you have time, look around the area and preplan your shot. Patience is required. I once sat for hours waiting for a moose to cross a stream, which I was certain he would eventually do. The rocks and grass made the perfect foreground. I had already surveyed the area and determined that this was the shot I really wanted to get. When he finally crossed, I was ready.

There are many good wild-animal shots that capture the animal standing still or grazing. It takes patience to capture your subject at just the right moment, but it's well worth the wait. You'll be rewarded with trophies that you will definitely want to hang on your walls.

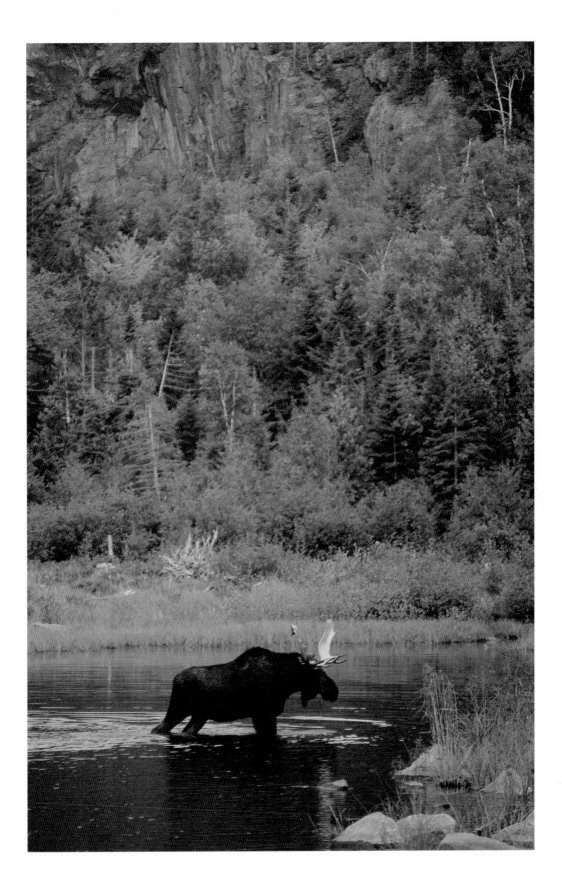

Equipment

The wildlife photographer rarely works under ideal conditions. The best opportunities are early in the morning or late in the day. Lighting conditions are difficult. Weather is often uncooperative. Subjects are shy and skittish and often require a great deal of distance between themselves and humans. They often move very quickly. And you often have to travel into remote places to pursue them.

There are many equipment options to help you become a successful wildlife photographer. But be aware: A serviceable outfit for wildlife photography can get expensive. Before you get started, make sure that you'll do enough of this type of photography to warrant the high costs.

A lens with a long focal length is an absolute must for pursuing wildlife, but they tend to be expensive. It's important to know what you need to achieve the results you're after. More often than not, the beginner starts with a lens that is too short.

When photographing dark-colored animals such as bison and moose, take an exposure reading off the animal and open up one and a half to two stops to get the proper exposure. You can also meter off a medium-toned object near the animal, set the exposure, recompose, and take the shot.

Because of the distances involved, you need to start your outfit with at least a 300mm lens, but I would recommend a 400mm because it will be more versatile with different species. The 300mm is the smallest of the long focal length lenses, which range from 300mm to 1000mm or more. Buy the highest quality lens you can afford. It is hardly worth going through all the effort of stalking and photographing your subjects only to find that your images are not sharp because you have a lens that was not up to the job.

There are some good zoom lenses on the market also, but high-quality zooms are often expensive. They're also heavier than prime lenses so they're harder to hand-hold. Hand-holding any lens over 300mm is not practical anyway, because you can't stabilize the lens well enough to ensure sharp pictures. Both Nikon and Canon offer vibration reduction lenses that allow you to hand-hold at lower shutter speeds. These are excellent, fast lenses. They come with hefty price tags, but are worth the extra cost to serious wildlife or sports photographers.

Begin shopping for lenses made by your camera's manufacturer. Most of the top-end manufacturers can be trusted to produce good-quality lenses. And if you're lucky, the telephoto you choose may be compatible with the other lens in your outfit. Lenses from the same manufacturer often take the same filters. This can save you a lot of money.

You'll also need something to anchor these long lenses while tracking your subject. A tripod is essential, of course, for mounting your camera when you won't be moving around a lot. Get the sturdiest you can carry. I paint the legs and upper post flat black, green, or brown to camouflage it. This will prevent the shiny surface from catching the attention of your subjects. You can also use the same kind of camouflage tape that bow hunters use. I wrap hard-cell foam insulating material on my tripod legs; it's flat gray, and provides a little cushioning to protect my shoulders when I haul it around.

You can get away with a simple monopod if you're going to be working in good lighting conditions. This one-legged stand helps stabilize your camera when you stop for a shot, and it's a little easier to walk with. I don't use a monopod often—only if I'm shooting at fast shutter speeds, usually 250 or higher.

For photographing birds in flight or stalking animals on the move, a shoulder stock is very useful, especially to photographers who have had some experience with guns. There are lightweight aluminum supports

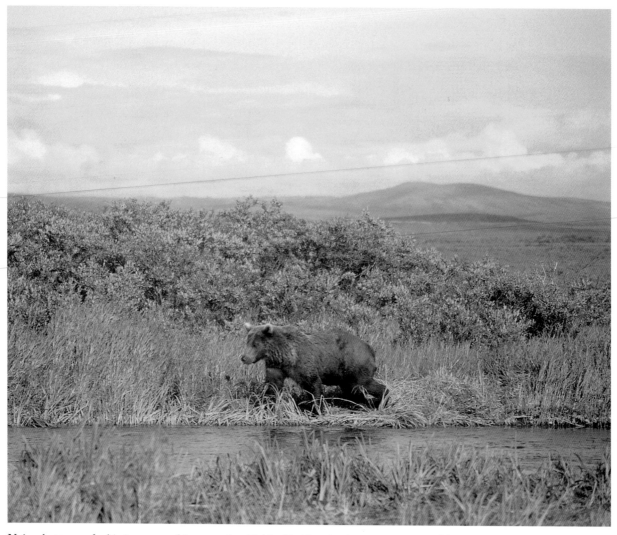

Noisy shutters and whirring motor drives can alert highly skittish animals to your presence. If you have a mirror lock-up feature on your camera, use it when around noise-sensitive wildlife.

that balance on your chest and shoulder, or the more traditional wooden gunstock styles. Your stock should be comfortable, provide reliable stability, and allow you to move quickly. After trying a number of styles, I have still not found the perfect stock. Many photographers buy stocks and then adapt them to their particular preferences.

A motor drive is essential for photographing moving wildlife. Even the slowest motor drive is faster and less distracting than having to thumb-crank after every shot. You also don't run the risk of missing a shot because you forgot to advance the film. But to really capture animals on the run, you'll need an auto-focus camera that can adjust focus at lightning speed, as well as a motor drive that shoots off frames at a

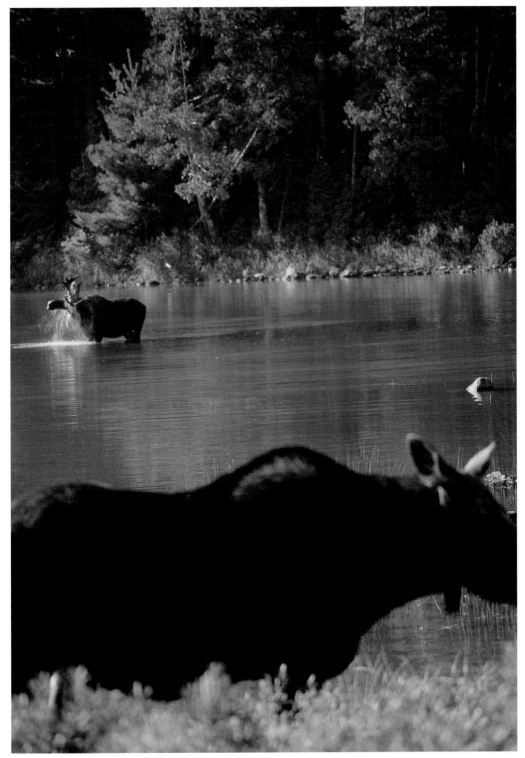

What's wrong with this photo? Well . . . everything. It should have been a horizontal format to capture the entire front moose. He also happens to be out of focus, along with the bushes at the bottom of the image. The moose in the background is moving, which is distracting, there is no compositional design, and the exposure is off. I'm not sure why I even snapped the shutter on this one! At least it will always be good for a laugh or two.

very high rate. It's easy to waste a lot of film this way, though. A run of twenty shots may produce only one that's worthwhile.

Noisy shutters and whirring motor drives are always an issue when you are around noise-sensitive subjects. While shooting birds nesting near my home, I have actually tried insulating the camera with foam and rubber bands to muffle the sound. But the best thing to do when your camera distracts the subject is to take a break and give your subject a chance to settle before beginning again.

If your camera gives you the choice of interchangeable focusing screens, you may find that a clear matte focusing screen is best for shooting wildlife. Most camera outfits come with a split-image screen. These are fine for general photography, but I find it easier to focus wildlife with a flat focus screen.

If you know where your subject is going to be, or if you expect to remain in one position for a long time, blinds are a great way to stay concealed. Marsh birds, for example, often live in exposed areas where you simply can't conceal yourself any other way. Some photographers build blinds out of materials handy in the field. That requires too much reliance on luck, however, as well as a whole bag of tools for assembly. It can also be disruptive to the environment.

If you're going to do much of this kind of photography, it may be worthwhile to invest in a portable blind. A good blind is lightweight and easy to transport, and should assemble quickly, and allow you to shoot from a number of heights. Don't forget that you're setting up this blind because you plan to stay awhile. Comfort is important, so make certain the blind is big enough for you to sit without crouching—a blind is rendered ineffective if you bump against the fabric and cause the whole thing to ripple. Bring along a comfortable seat too; folding stools can work, but on soft ground, they make sink. Try to find something with a wide base.

Stalking Your Prey

Many wildlife photographers used to be hunters. They may have traded their guns for cameras, but the skills they learned in years of stalking prey serve them in good stead. Here are some of the things they know that will help you become a better wildlife photographer.

- Camouflaging your gear will help you to keep your profile low. Wear dull clothes and try to dull your shiniest gear. But don't fool yourself into thinking this will prevent you from being noticed by your subject. Chances are very good the animal picked up your scent long before you knew he was there.

- Stay downwind from your subject. This can help you stay concealed a little longer. Some photographers keep a length of yarn on their tripods to help them track wind direction.

- Move slowly around your subject. Be aware of every move you make. It's not enough to walk slowly. Watch your hands. They are often moving quickly to adjust focus and exposure settings. Set a pace with which the animal can be comfortable.

- Stay nonthreatening. Approach the animal from an angle and don't pay any attention to him. The moment he shows signs of tension, stop what you're doing and direct your attention elsewhere. Stay still and let the tension pass. Approaching him straight on, sneaking up from behind, or staring directly at him are all acts that he may associate with aggression, so be subtle.

- Use a blind. If you know where your subject is going to be, or if you expect to remain in one position for a long time, this is a great way to stay concealed.

Close-up Photography

You don't need grand vistas and soaring peaks to find compelling subjects for outdoor photography. There are literally thousands of subjects to be found on the ground, in the forest canopy, or along lakeshores and streams. Close-up photography allows you to explore worlds that you might normally overlook on hikes through a forest or meadow. Wildflowers, of course, are one of the most common subjects for close-up photography. But insects, tree bark, leaves, and pebbles become wonderful subjects for those open to the opportunities.

The special appeal of close-up photography is its potential to amaze and delight viewers. A raindrop on a leaf becomes an entire universe. The intricacy of a butterfly's wing captures the complexity of the natural world. The delicate petals of a flower filtering sunlight illustrates how fragile and exquisite the ecosystem really is.

Equipment

If you already have a camera with interchangeable lenses, you can get started by adding just a couple of accessories.

To get up close and personal with your subject, you need the help of an extension tube, which is a hollow, fixed-length accessory that fits between your camera body and your lens. Different lengths provide varying amounts of magnification. A normal 50mm lens will shoot a subject at about half of life-size. (Life-size refers to the relationship

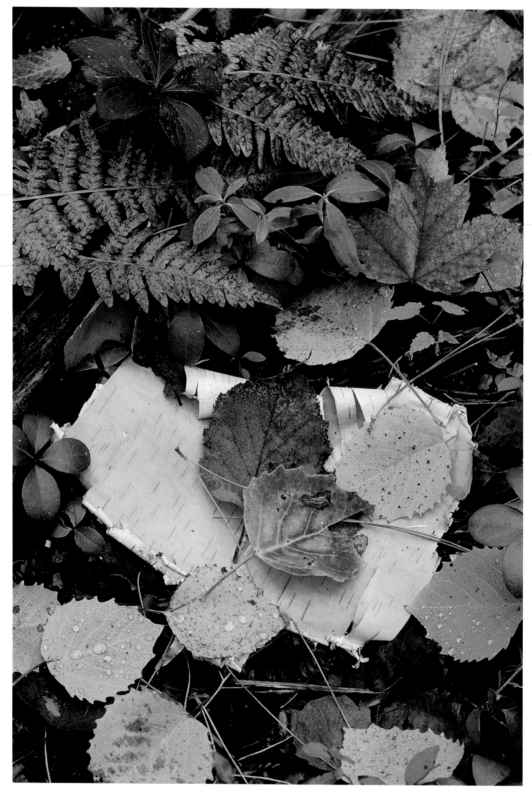

Close-up photography opens up whole new worlds to explore. There are endless possibilities throughout the seasons in virtually any weather condition.

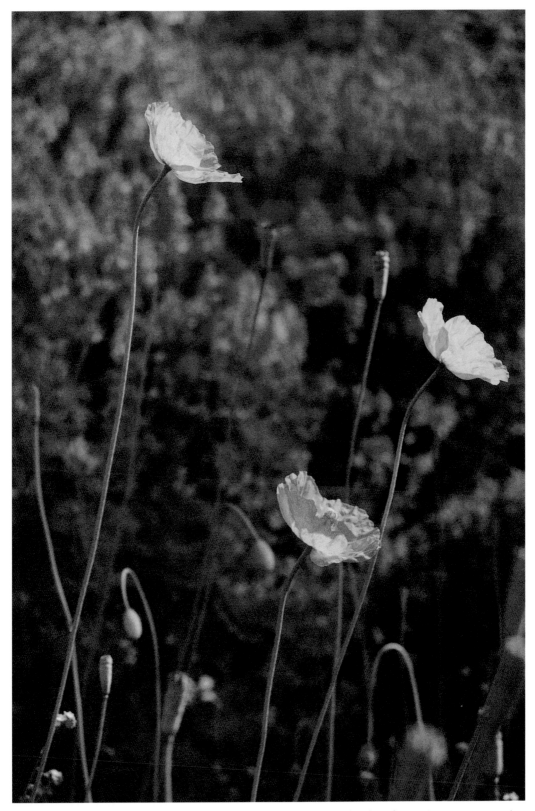

Sunlight filtering through the delicate petals of a flower illustrates how fragile and exquisite our ecosystem is.

To get life-size, one-to-one ratios in your close-up photos use an extension tube approximately half the length of your lens. For example, add a 25mm extension tube to a 50mm lens.

between the area that you're photographing and the size of the film format.) To get the subject to life-size, add an extension tube approximately half the length of the 50mm lens—a 25mm tube. For most field photography, the extension tube is a less expensive and equally appropriate choice. You will lose a stop of light with the use of the extension, so you need to factor this in.

A bellows extension is also available for 35mm cameras and takes the place of an extension tube. Its length adjusts so you can increase or decrease magnification without changing accessories. The bellows should be designed to link up with your lens, or you could lose your ability to use through-the-lens metering.

Macro lenses are essentially normal lenses that have a built-in extension tube. They're great for close-up work. Their main advantage is for extreme close-ups that require virtually no distortion, such as photographing postage stamps or other flat specimens.

Screw-on close-up filters are an inexpensive alternative to both extension tubes and macro lenses. They function like little magnifying glasses, bringing small images up close for better viewing. They are fun to play with, but I don't recommend shooting with them because they are rarely of the same optical quality as your lens.

A tripod is essential if you do a great deal of close-up photography. Camera shake is a major problem with this delicate work, and a tripod is usually needed to provide stability. Mini-tripods are designed specifically to get you as close to the ground as possible. They are lightweight, easy to pack, and give you that extra bit of stability. Some full-size tripods also have legs that can be spread out to bring you to ground level, or reversible center posts that let you place your camera upside down and near the ground. As I stated earlier in the equipment chapter I have a carbon fiber tripod made by Gitzo. The legs can be adjusted to fold nearly flat out sideways and the short center post can be unscrewed to allow me to bring the camera to nearly ground level. It is a great tripod for close-up work.

Once your camera is on the tripod, another handy gadget is the cable shutter release. It prevents you from causing camera movement that might occur if you used your finger to press the shutter release. You can also use a built-in self-timer for stationary subjects.

Your camera may come with a mirror lock-up option. If you are shooting subjects that aren't going to move, you can use this to prevent any camera shake. First, view the image and get it in focus. Then, just before you shoot, lock the mirror out of the way. This helps to prevent the slight jarring of the camera caused by the mirror snapping up and down.

Composition

Close-up photography calls for a "less-is-more" approach. Uneven lighting, cluttered backgrounds, and competing subject matter easily overwhelm small subjects. When you find an interesting subject, take a few minutes to decide exactly what you want your photograph to include.

I always put my camera on a tripod. Setting up my shot with the help of a tripod allows me to slow down and really evaluate the subject and its environment. I can walk away, view the subject from another angle,

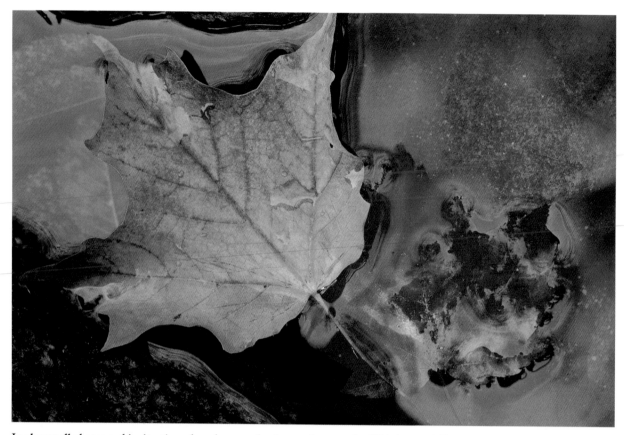

In almost all photographic situations, less clutter makes better photographs. This is especially true in close-up or macro photography. Keep your image simple and clean.

and stand back to see the surroundings. Being free to stand away provides me more time to think through what I'm trying to accomplish.

Evaluate the backgrounds available to your subject. A light object will have more impact against a dark background, and a dark object will be enhanced if you can frame it against a light background. Often, a change in camera position will help you achieve a strikingly different effect.

Uniform clutter, such as a bed of leaves, may make an acceptable background, but a branch running through the shot may be very distracting. Similarly, out-of-focus greenery may be just the right backdrop, but a sliver of blue sky peeking through the leaves can draw the eye away from your subject.

Often a shot is almost perfect, except for some small distracting detail. Though I usually like to work with things exactly as I find them, I sometimes manipulate the landscape just a bit to get a good shot. I occasionally use tweezers to eliminate pine needles from an otherwise

Just because you are in close-up mode doesn't mean you should abandon compositional rules. Look for angles and lines that add a little extra edge to these simple photo designs.

Look for background contrast to turn ordinary subjects into stunning photographs.

pristine bed of moss, or hold branches aside to get an unobstructed view of a mushroom. These are reasonable ways to enhance your photograph. Some photographers, however, in their enthusiasm to capture a subject, can do serious damage to that subject's environment. Broken branches, upset birds' nests, and trampled flowerbeds are not the legacy you want to leave behind from a day of photography. Be aware of your impact on these tiny ecosystems.

Depth of Field

The only way to create a really good close-up photograph is to have your subject in crisp, sharp focus. But it's a little harder with these tiny subjects. As magnification increases, depth of field decreases. Small f-stops may be needed to increase the area of focus, but the light available in the field is often insufficient. The necessary lower shutter speed

Depth of field is a very important element in close-up photo design. Often you will be working with very limited depth of field—no matter what the lighting conditions. Make sure you keep the most important aspect of your subject in sharp focus.

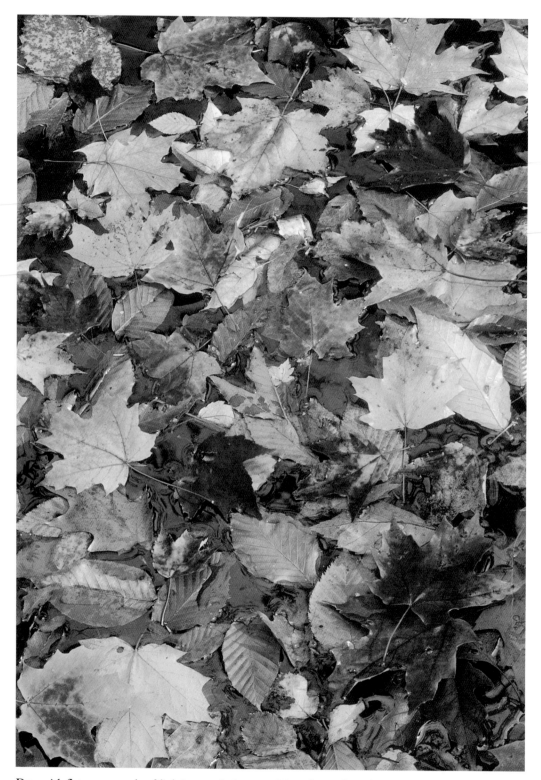

Days with flat, even, overhead lighting are the best conditions for outdoor close-up and macro work.
Exposure meter readings are more reliable since everything is evenly lit with few reflections.

may not be practical either, even for stationary subjects at the whim of breezes. That's why the set-up of your shot is so crucial to its success.

First, choose the plane of the subject that's most important to your composition. Is it the leaf's outside edge or the opening petals? Do you want to catch the top of the mushroom or its length? The cluster of berries or the thorns along its branch?

Using a tripod, line up your camera so that the film plane is precisely parallel to the most important part of the subject. This can be very frustrating; I have found my face in the mud on more than one occasion. But the results are worth the effort.

Center your subject to highlight the key element you wish to capture. Because your subject is so small, an angle of only a few inches can result in your subject's main feature being out of focus.

Extend your lens out to its closest focus length. Then move your camera back and forth until you find the optimum distance from the subject. Don't adjust your lens; adjust your distance. You can fine-tune the focus with your lens after you settle on your composition. This will save you valuable time and frustration, especially when working with subjects that move.

Lighting

Days with flat, even lighting are my favorites for photographing small subjects. Because this is often the wrong time for shooting dramatic landscapes, a cloudy day can offer a wealth of photographic material you might not have thought to shoot otherwise. Cloudy or wet weather allows you to take advantage of this even lighting and make your day in the field fun and productive.

Bright, sunny days can create harsh lighting and prevent your subject from taking center stage. Shadows or hot spots in the background confuse the eye and spoil the composition.

But what if you just found the perfect mushroom and the sun is shining brightly? Or a spectacular tree frog, hiding behind a fallen log? There are a number of tricks that can help you achieve a great photo, even in poor lighting conditions.

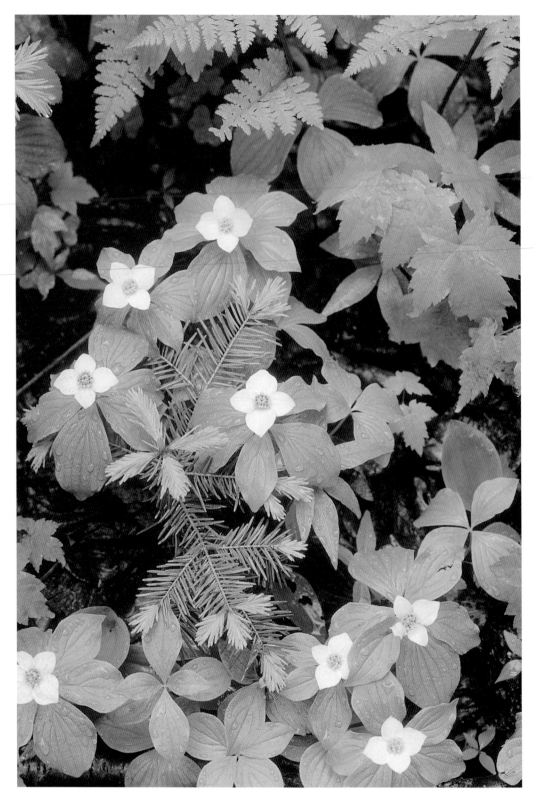

Wet, overcast days are great for close-up work because broad, dramatic landscapes are not available. Make the most of the lighting. When the weather closes in, go with the flow and capture subjects that are more intimate.

Bright, sunny light is often hard to work with. Use a polarizing filter to cut down on glare and reflections and be careful to keep highlights within the image toned down enough for the film to record accurately.

Natural Light

Low-light conditions are common on deep forest floors or under branches where many of the best subjects hide. It will be necessary to capture as much available light as possible and direct it at your subject.

To do this, I use a reflector. You can make a simple, inexpensive reflector from a square of cardboard and a little aluminum foil or silver Mylar paper. Just cover an 8-x-10-inch cardboard rectangle with the reflective material, using a little glue to keep it from slipping. Shiny smooth foil will give off a lot of reflection, creating a spotlight effect. Crumpling the foil slightly and then re-smoothing it will provide a softer, more subdued reflection. Position the reflector a slight distance from your subject and experiment with the effect it creates by changing the angle at which it's placed. This is often enough to provide the extra boost of light you need to bring the subject to life in your camera lens.

In low, overcast lighting situations, a reflector will bounce extra light onto macro subjects. Use a portable reflector, tin foil, or any other easy-to-pack reflective surface to pump in an extra stop of light or two.

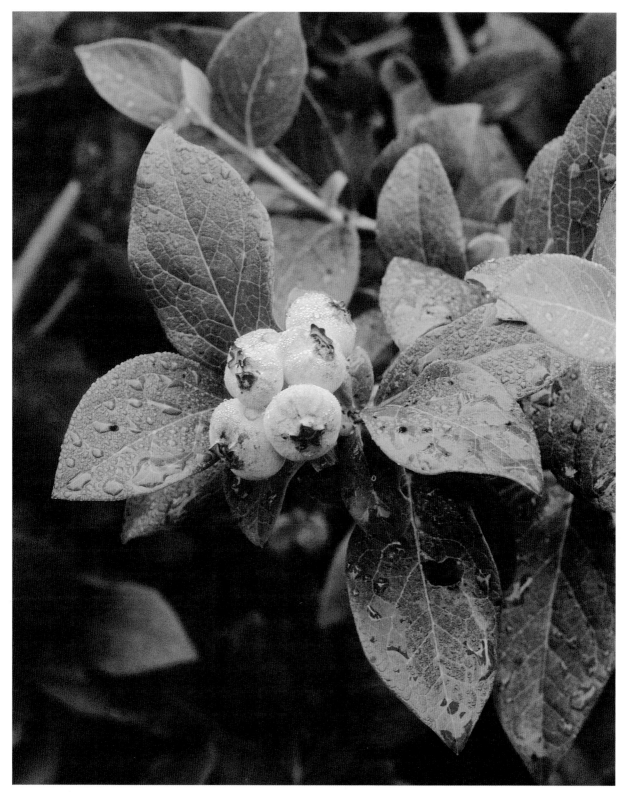

Reflected light made all the difference in this shot of dew-covered blueberries. Without the extra light, these berries were dark and dull with deep shadows around them.

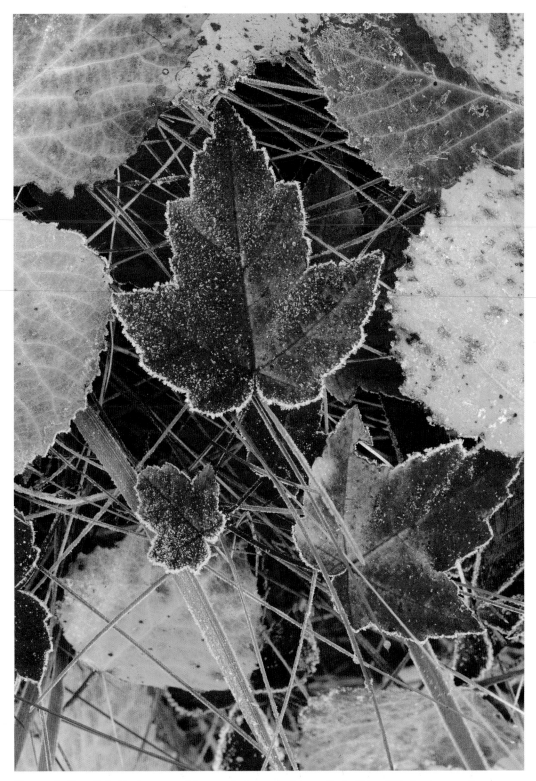

Too much direct light hitting your subject can be just as bad as too little. Use a diffusing screen of some sort to diffuse the light on your subject while keeping it natural. You can purchase fold-up diffusers, or use cheesecloth or light mesh for the same effect.

Diffusers help soften the effects of direct sunlight. Small, pocket-size diffusers made specifically for fieldwork are available at photo shops that cater to nature photographers. Or make your own diffuser by stretching some light mesh or cheesecloth between two frames. I made my first one using my wife's small embroidery hoop and fine window screen. The choice of material will dictate the amount of diffusion, so experiment with materials. A few years ago I was able to find a small portable set of reflectors and diffusing screens that zip into a 12-inch diameter flat bag. It has a combination of three different reflectors, one diffusing screen, and one black screen. It's easy to bring along on all of my trips.

Always take along a small piece of dull cardboard when going out to shoot small subjects. I always carry a standard gray card. This works perfectly for blocking sun that's shining directly on the subject and throwing the background totally into shadow. This eliminates the mottled light that sometimes causes a small subject to get lost. To shade larger areas, I use whatever is around; a jacket, a blanket, or even another person can cast a larger shadow than my card.

A combination of reflecting, diffusing, and blocking techniques gives you the greatest degree of control over your lighting. Block harsh light with your gray card, then use your reflector to bounce a little soft light back onto the subject. Such techniques cover most of the situations you'll find in the field.

Artificial Light

There are a few situations that require a little extra patience and additional equipment. Sometimes, you just have to bring in a little extra light. Constantly moving bugs don't allow you the luxury of using low shutter speeds or elaborate reflecting techniques. This is when flash photography is your best option.

You need a very small flash output for this type of work. A manufacturer's guide number of 30 or 40 at ISO 25 is best. This guide number appears on the back of the flash. You should be able to choose between mounting it on the camera's flash mount or hand-holding it with the help of a flash cable. In some cases, the flash angle provided by the camera's hot shoe will be just right, but sometimes the light needs to come from other angles. If you can take your flash off the hot shoe and

attach a flash cord, you will have greater freedom to experiment with various angles.

Automatic flashes are fine, but I prefer to have a setting for manual use. A large flash held at a distance will create a harsh light source similar to extremely bright sunlight. Conversely, a small flash held quite close to the subject will create nice even lighting.

The best way to understand the effects of flash strengths and angles is to experiment. Shoot your subject using a variety of angles and exposure settings. Bracket the same composition in a number of ways. I always keep a journal with me, so I can jot down the methods I used. Later, when you sit down with your processed film, you can review your methods and results. This is the best way I know to learn.

People

What makes a pleasing "people" photograph? We've all seen great shots, but do you know why they worked so well? Was it the funny face he made? Or the way the sun caught her hair just right? Or that fisherman's proud grin as he brought in the catch of the day?

All of these photos have one thing in common: They were captured at the perfect moment. In fact, taking pictures of people is not all that different from wildlife photography. Your subjects may be a bit more cooperative—at least in the short term. Yet, a moment's delay in pressing the shutter release can create that "deer-in-the-headlights" look that turns a spontaneous moment into a stiff one.

The problem with off-the-cuff snapshots is that those photos are rare indeed. Taking the time to learn a few tricks will make your people photograph time outdoors more productive and reward you with a larger gallery of great shots.

Faces

Faces represent a special challenge for the photographer. Because portraits are such personal things, you'll be subject to more opinions about them than any of your landscapes.

Remember that the lens represents your camera's eye. Since you generally view other people at eye level, you will get the most natural effect

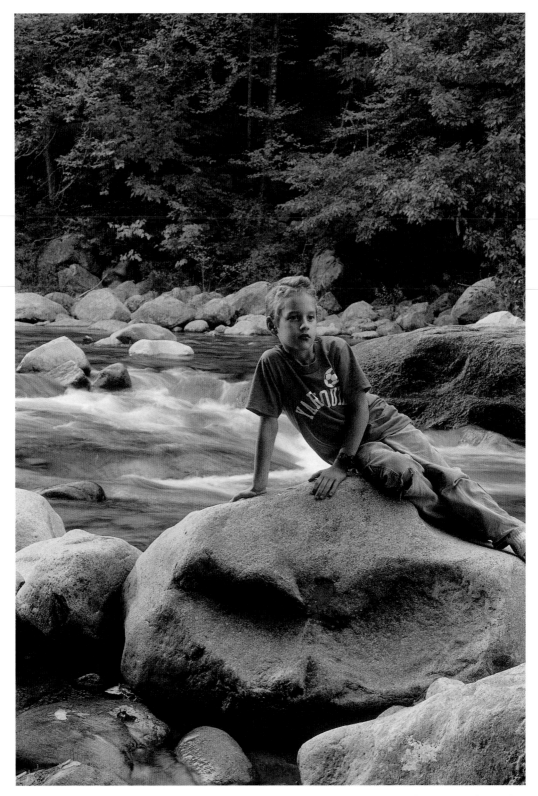

Capture those elusive moments when the light is perfect and everything comes together for a brief second in time. Preset your exposure and lighting so all you have to think about is the composition.

Faces are the most important element in photographs of people. The best photos of faces are usually shot at eye level, as I did here.

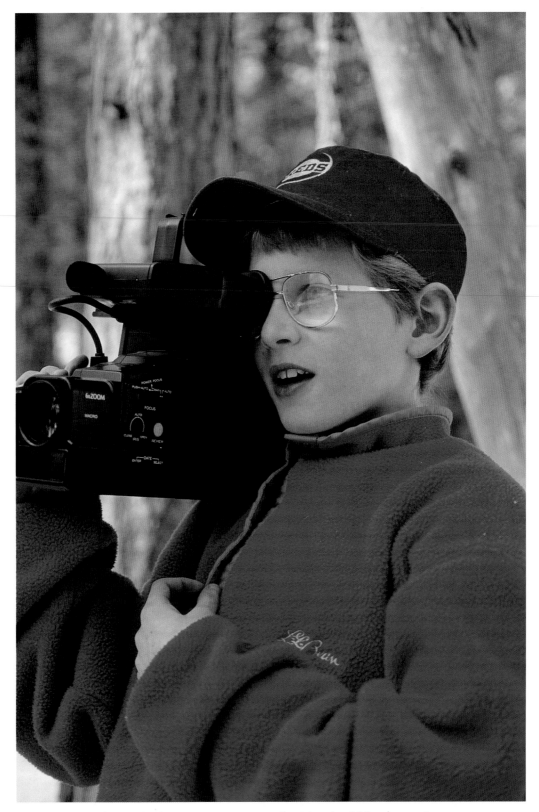

Photographing kids at eye level creates a stronger image by giving the child more prominent stature.

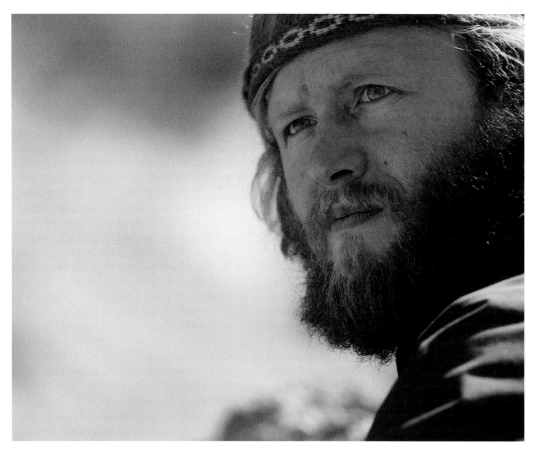

Use a low-angled position to minimize a wide forehead or bald head.

by shooting your subject straight on. There are times, however, when shifting the camera angle slightly may help put your subject in a more flattering position. If your subject wears glasses, make sure the frame doesn't cut through her eyes. The perfect frame will follow the angle of the eyebrows. Position your camera at a slightly higher or lower angle to remove any glare.

Children usually benefit from being shot at a lower angle. Shooting down at them will produce a distorted, often unflattering shot. Get down to their level, or even a little below them.

Strong features can be minimized in a number of ways. A large nose can be de-emphasized by shooting the face straight on. Shooting from a lower angle can minimize a prominent forehead or a bald head. A broad face or double chin may be slimmed or hidden with a slightly higher angle. If your subject is sensitive about wrinkles or skin blemishes, try using a soft-focus filter, designed specifically for portrait photography. These do a nice job of easing out deep lines or shadows.

Lighting

In general, the optimum time to take outdoor pictures of people is midmorning or late afternoon, preferably when there's a light cloud cover. These conditions produce lighting that's flattering to almost anyone. There's just enough direction to the shadows to produce definition, but not so much as to cause your subject to squint. These conditions are transient though, and often you'll have to work with lighting that's less than perfect.

You'll also find that you can get great shots from lighting that's completely flat, such as a bright, high, overcast sky. The advantage to this type of light is that it casts your subject in a soft, flattering light and allows the eyes to relax. Contrast is low, and colors are saturated. The drawback is that the light has no direction, which results in little definition on the face. This problem can be easily remedied: Simply using a soft reflector to bounce a little light toward the face is usually enough to give you exactly the effect you want.

Never shoot at high noon! This overhead lighting causes nose and eye shadows that are very unflattering. If lighting conditions are bright, turn your subject away from the sun so that his face is protected from the sun's glare. Take your meter reading up close to your subject's face, and then step back to take the photo. Open up a half stop so the skin tone is natural, otherwise the meter will make the face a mid-tone that will be just slightly too dark.

Compose your subject so that the scene is either completely in sunlight or in shade. While you might find a backlit scene pleasing, your film will have a hard time handling the extreme contrast of light and dark. There are certainly times, though, when a backlit effect can be used to advantage—highlighting hair or setting a romantic scene in silhouette. Just remember that these situations call for careful attention to detail. Your meter can be confused by the variation of light in the frame, so know what you're metering for to achieve the best effect. If your camera does not allow you to adjust or set exposure levels you'll have a difficult time getting these photos exposed as creatively as you might want.

Fishermen are notorious for refusing to remove their hats, and the brims cast deep shadows that make a shot very difficult. If your subject's face is in deep shadow, you can use a weak flash to fill in the dark

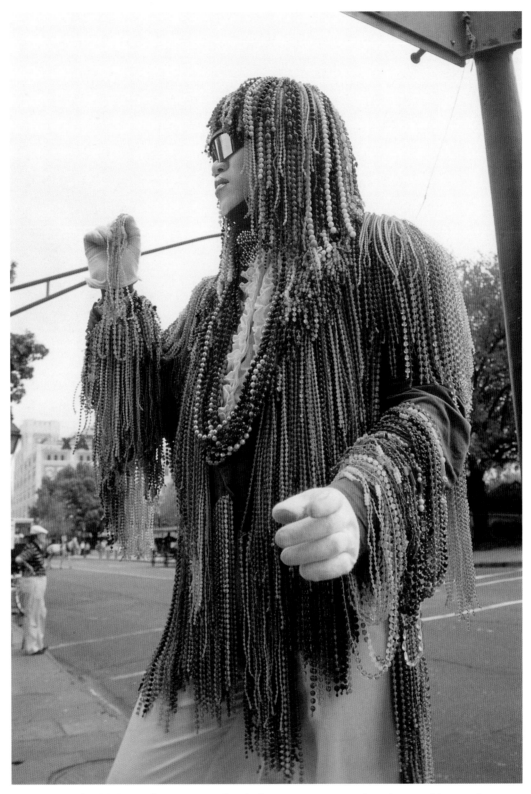

Flat, even overhead lighting allows you to easily calculate correct exposure when photographing people out-doors. This worked nicely for this shot of a street vendor in New Orleans because it eliminated harsh shadows.

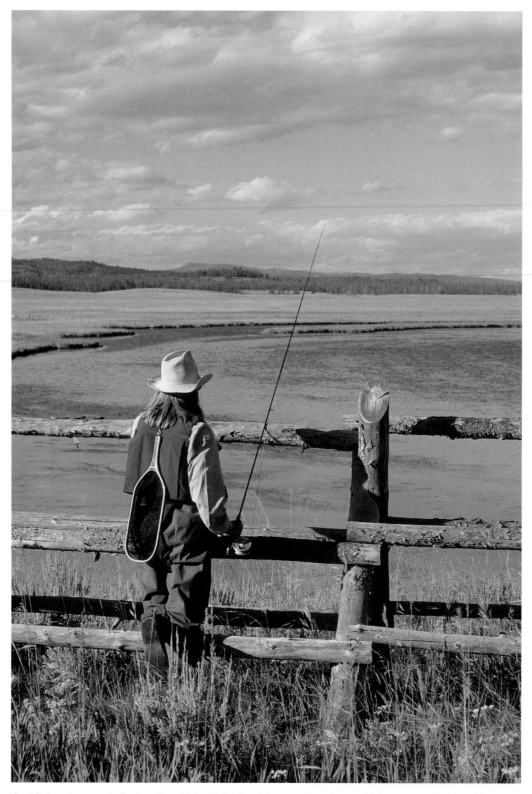

Avoid shooting people during the middle of the day. If you need to shoot midday, use a polarizing filter, keep your subject's face out of direct light, and find strong compositional designs that work with the light.

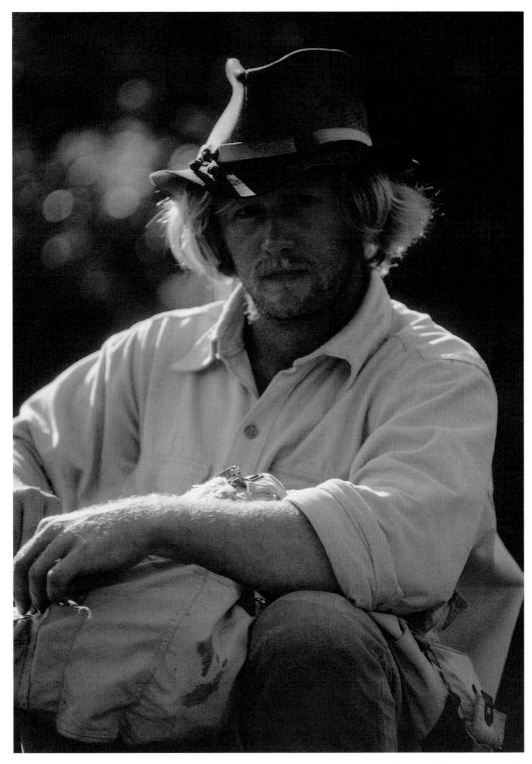

Backlighting for people shots can be either frustrating or exciting, depending on how well they are exposed. To keep your subjects exposed correctly, take readings directly from their faces or a piece of clothing that will render a neutral tone. Set the exposure, recompose, and shoot. This will usually give you rim-light highlights. Practice this using different exposure settings to get a variety of rim lighting effects.

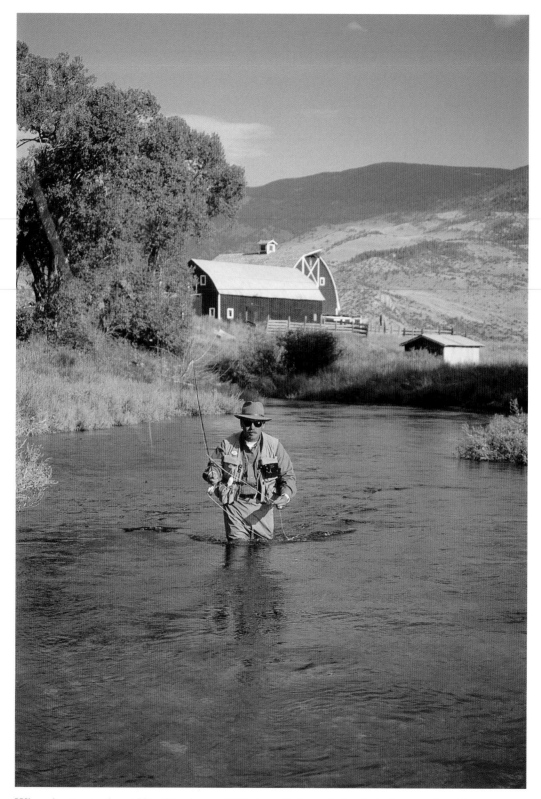

When shooting in the middle of the day, use fill flash to eliminate the harsh shadows produced by strong, direct light. This shot of a fly caster illustrates this nicely.

spaces while leaving just a bit of shadow. There are many complicated formulas for calculating the amount of flash to use, but I use a basic rule-of-thumb for fill flash: First meter the face for perfect exposure, and then turn on your flash and adjust your meter setting down one stop. If the shot is important, always bracket—take one shot at the recommended exposure, the next a half stop down, the next a full stop down. This will ensure that at least one shot will be perfectly exposed.

Composition

Truly candid shots take place without the subject being aware of your presence. You may occasionally get an exquisite shot, but this technique offers only limited opportunities. It's really better to have your subject be an active participant in your shot.

Generally, if you want to take pictures of any subject, whether they are family members or tribal natives you meet on safari, it's best to ask their permission. It may seem obvious, but getting their verbal agreement is the first step in the right direction. Relax them by telling them what you're hoping to achieve. Engage them in light conversation while your mind is racing with exposures, angles, and perspectives. If they don't speak your language, use hand signals and plenty of smiles to communicate your wishes.

A certain amount of posing is a necessary evil. Saying "Stop right there!" when you see something you want will probably result in a stiff pose and an uncomfortable smile. A relaxed, natural pose is the aim, so it's nice if you can have your subject engaged in an activity. Props make a photo more interesting and give your subject a focus that will help ease the awkwardness of posing. You might shoot your father leaning on his golf clubs or your daughter on her mountain bike. That happy glow of confidence reflected by your subject's pleasant association with their favorite activity makes all the difference.

Of course, you'll get complaints from your subjects if you spend a lot of time fussing with propping and composing. Don't be surprised if you end up with stiff smiles and unnatural poses if you make them wait for the perfect angle, light, and exposure. Watch for signs of tension. Hands should be gently curved, and neither wide open nor clenched.

Work with your subject to help find a pleasing composition, but be careful you don't fuss too long or you will lose that natural feeling you are trying to capture.

The Rule of Thirds is just as important in people images as in any other subject. In this image, the subject is positioned in one of the power points in the frame, looking into the scene.

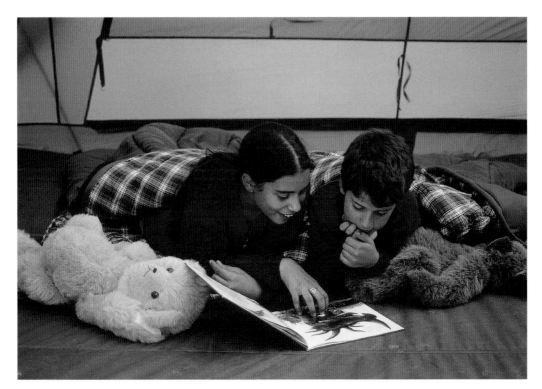

Catching your subjects when they are engaged in an activity and relaxed brings out their best.

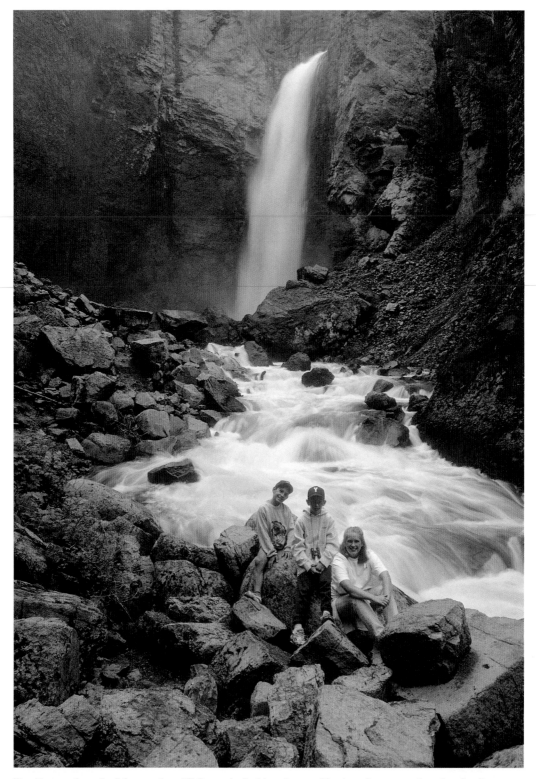

Family snapshots don't have to be stiff. Instead of taking the usual boring photos, try shooting family por-
traits in unique settings, such as parks and scenic areas. These will bring back much fonder memories as the
years go by.

Elbows should not be bent stiffly, but dropped slightly to form a graceful curve. One foot should be ahead of the other, with the back foot taking most of the weight, which gives the body a sense of ease. If necessary, have subjects cross their knees or ankles to put them in a more relaxed position.

Train with a willing victim who will let you practice in the backyard. Take multiple shots at various exposures and study them after they're developed. Try to make some of these tips second nature, so you don't have to fuss with your subjects when you're outdoors with them.

Action

Since what they do for fun expresses so much of people's personalities, it's not surprising that some of the best photos of them are taken when they're on the move and deeply engaged. Self-consciousness evaporates. As the photographer, you must be on your toes. Action photography requires a quick command of the requirements of exposure, composition, and environment. Plan ahead as many factors as possible to allow yourself to concentrate on the action as it occurs.

Start with the setting. If possible, scope out the place where the action will occur. Visit it ahead of time to locate vantage points, and calculate the exposure requirements. Preset your exposure, determine how much of the scene you want to take in, and choose your lens.

Action photos call for a fast shutter. Some cameras have shutter speeds as high as 1/4000th of a second. The table below gives you the minimum shutter speed required to stop action when subject is in full frame. (If your subject is farther away, a slower speed can usually be used.)

Shutter Speeds to Freeze Action

Activity	Shutter Speed
Running	250
Fly Casting	250
Ice Skating	500
Cycling	500
Tennis Serve	1000
Downhill Skiing	1000

Prefocus and have your exposure settings in place before moving in close to photograph your subjects. That way you can shoot quickly to capture them in a relaxed and comfortable mood.

Fast shutter speeds that freeze action may not provide you with enough light to get the proper exposure. That's where faster film comes in. A shot that requires an f1.8 setting with ISO 200 film will only need an f2 setting if you choose ISO 400 film. ISO speeds reach as high as 3200; so if you're going to do a lot of action photography, experiment with various films.

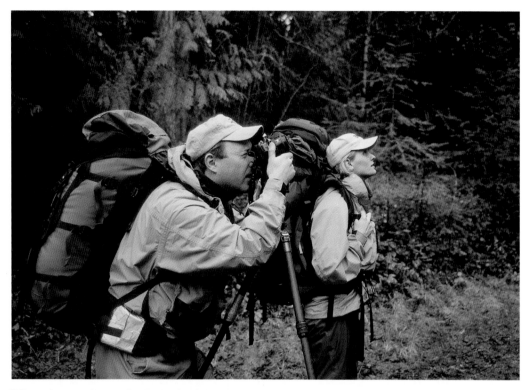

When photographing individuals who feel self-conscious, get them involved in one of their favorite activities. You will get a relaxed mood in your photo.

To stop a pitched baseball, you will need to shoot at 1/1000th of a second.

Prefocus so that you are ready when the action begins. Even if you have an auto-focus camera, the delay caused while the camera evaluates sharpness may lose you precious microseconds. You can eliminate delays by determining where the action is going to occur, then focusing on that spot, and releasing the shutter when the subject enters the frame. Timing is crucial—pressing the shutter a fraction of a second too early or too late will result in a blurry photo.

Panning is a technique that you can use to stop movement, even while using a relatively slow shutter speed. By following a moving subject across the frame with your camera during exposure, you can reduce the rate of movement while creating a blurred background that accentuates the sense of motion in the foreground.

This technique takes practice. Start by choosing a location in the desired proximity of where the action will take place. Set your shutter speed at 125, prefocus, and stand squarely facing this spot. As your

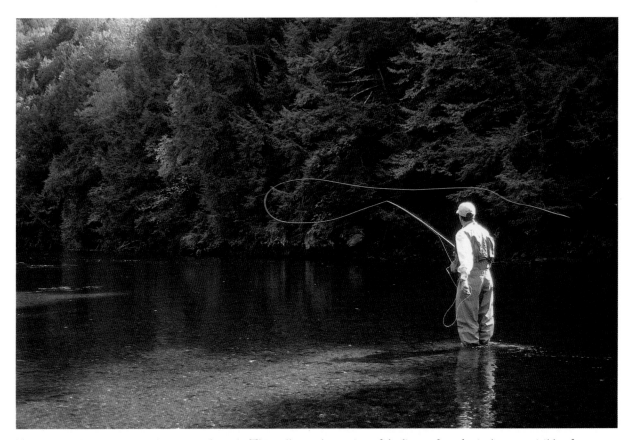

To capture a fly line set your shutter speed at 250. This will stop the motion of the line and render it the most visible of any shutter speed.

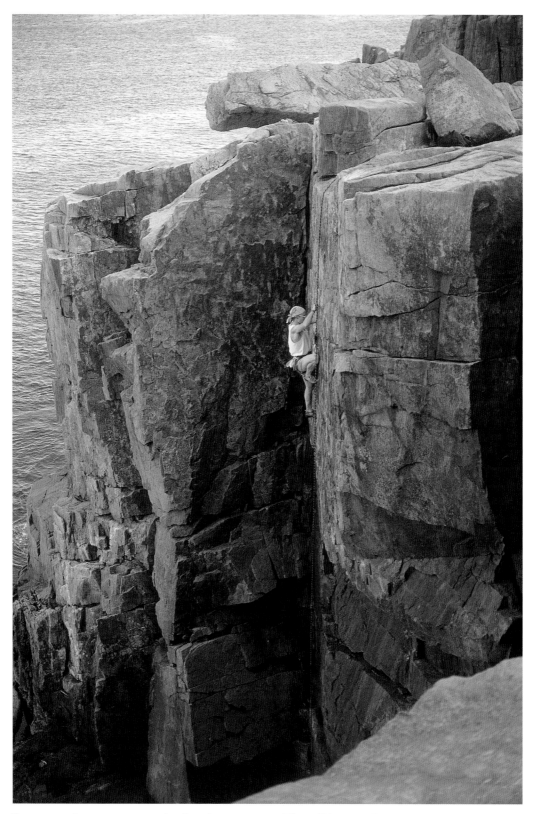

Learn to prefocus so you are ready when the action starts. This will keep you from missing that special shot.

subject approaches, swivel your body to pick it up in the viewfinder. Keep the subject in the center of the frame until it is almost directly in front of you and press the shutter. Follow through smoothly after the exposure to avoid any distortion. Your shutter speed will change with different distances from your moving subject. The farther you are away and the smaller your subject is in your viewfinder, the slower shutter speed you can use. The closer and larger your subject is in your viewfinder, the faster shutter speed you will need. The closer subject fills up more of your frame and even though it is moving at the same speed as the farther-away subject, it will move through your frame much faster. With these closer subjects, you will have to move your shutter speed up to 250 or 500 while panning.

At Play in the Outdoors

Catching people at play often results in dynamic outdoor photographs. Since your subjects are focused on an activity, you have a better chance of getting a relaxed, natural shot. Be aware that certain outdoor conditions, such as shooting in winter or on the water, present particular sets of challenges.

Winter

Winter is a wonderful time to capture people at play. Cross-country skiers, downhill skiers, skaters, and sledders are all worthy subjects. But the combination of bright snow and brilliant sunshine creates special problems.

If you take a meter reading of your brilliant snowscape, the meter will indicate a lower exposure to compensate for the large expanse of brightness. To capture the whiteness of the scene, open the lens about one and a half to two f-stops or decrease shutter speed one and a half to two stops to compensate. To properly expose people on the snow, meter off their faces if possible. If this is impractical, use a gray card to get a neutral reading and use that exposure. As with other types of people photos, a late-afternoon sun will give you a pleasing range of shadows and light.

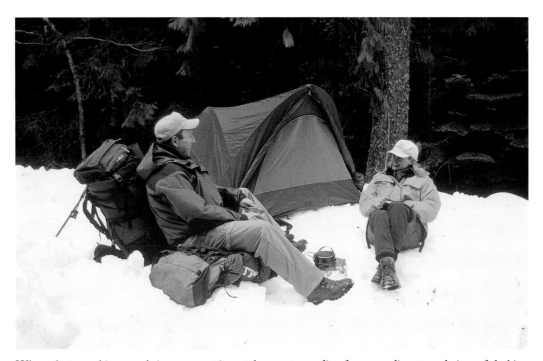

When photographing people in snowy settings, take a meter reading from a medium-toned piece of clothing or their faces. Set the exposure, recompose, and shoot. If you let your meter take an average reading, your subjects will be too dark.

A polarizing filter will sharpen the blue sky and remove the reflected highlights on the snow's surface. Your shot will benefit from enhanced definition and color saturation. A polarizing filter will reduce the light reaching your film by one or two stops, so factor that in if you're not metering through the lens.

Water

Like snow, water reflects a great deal of light, and the camera's normal metering of a water scene will result in an image that is underexposed. Adjust your meter setting a half stop to a full stop down to compensate for this reflection. Use a polarizing filter to reduce the glare and enhance the color saturation. And consider the angle of the light: Water can sparkle, reflect, or become dull and lifeless, depending on how the sun is hitting it. If you can comfortably look at the water, you can probably photograph it. If, on the other hand, you have to squint to look at the surface, even a polarizing filter may not be able to help you achieve a good shot. Change your angle to better balance light and shadow.

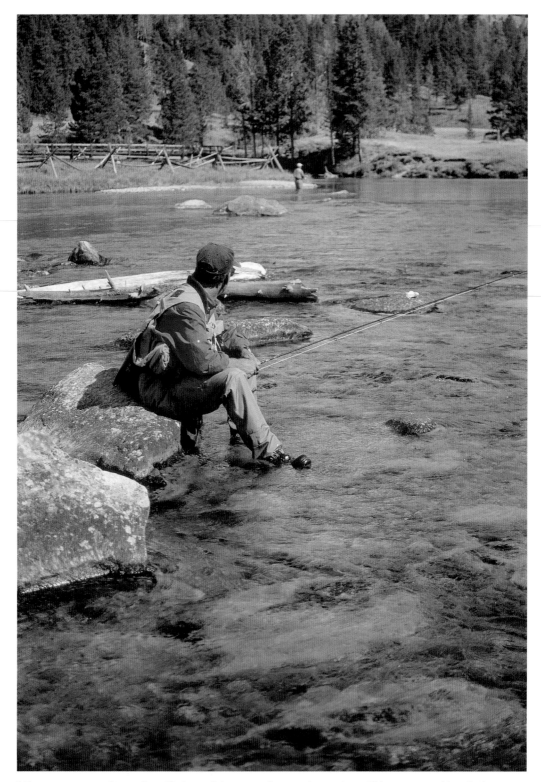

Like snow, water reflects a lot of light, and the camera's normal metering will leave your subject dark or underexposed. Move in and take a reading off medium-color clothing or use a gray card to get a meter reading that overcomes the reflected light from the water.

This was a deceptively tough meter reading. The reflected light off the water is three full stops brighter than the subject. Find something medium toned to meter from to get an exposure similar to your subject's reading. Otherwise, open up two, two and a half, and three stops to ensure you get the right exposure.

Film

Your choice of film also makes a difference in people photography, portraiture in particular. The film I use most often for general people shots is Fuji Reala print film. Reala renders the best skin tones, yet picks up color nuances very well. It will also give solid vibrant clothing colors. Most of the Kodak print films are also designed primarily for shooting people. Their Royal Gold is more vivid, while Portra renders subtle, neutral tones. Agfa's Optima and Portrait are both designed to give soft neutral skin tones.

In slide films, Kodak's Elite Chrome works well for natural skin tones. Fuji's Superia, with the fourth-color emulsion layer, gives excellent color tone and balance. And Agfa's CT Precision gives nice, natural skin tones.

The best thing to do is experiment. You'll find films that work well for the situations you shoot in most often. Get to know one or two films well so you can feel confident in what you will get each time you are photographing people.

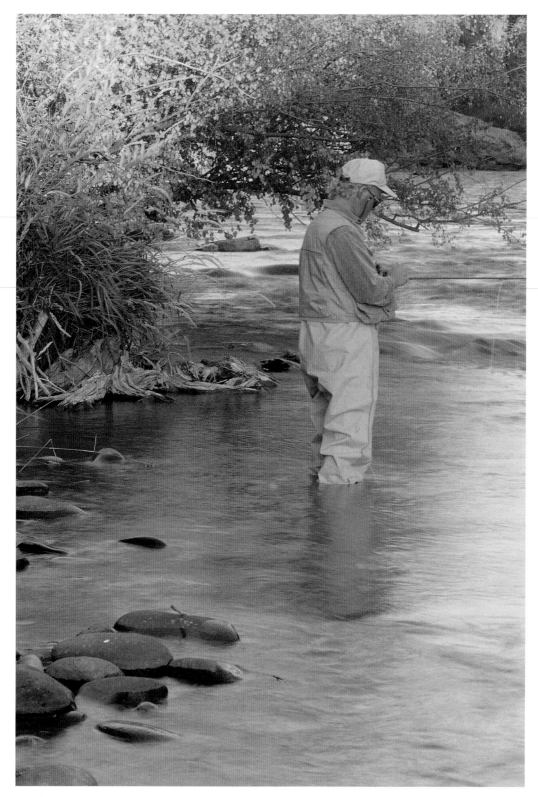

Before choosing film, research which ones render the most natural skin tones. In most cases, these films will also produce evenly balanced color tones.

Agfa has a whole series of films that are designed to render skin tones properly. My favorite is Agfa Portrait.

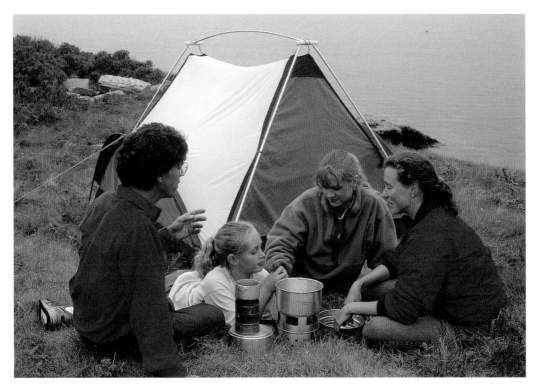

Kodak Royal Gold is a print film that offers bright, vivid colors for outdoor action photos.

Getting a Great Portrait

Why do professional portrait photographers get such good shots? Because they know a few secrets about the camera's relationship with the human face. Keep these things in mind when shooting people.

- Relax your subject by telling them what you're hoping to achieve.

- Midmorning or late-day light, with a light cloud cover, produces lighting that's flattering to almost anyone.

- Shoot at eye level. The lens represents your camera's eye. You'll generally get the most natural effect by shooting your subject straight on. (But there are exceptions.)

- Children usually benefit from being shot at a lower angle. Get down to their level, or even a little below them.

- If your subjects wear glasses, try to make sure the frame follows the angle of their eyebrows. Position your camera at a slightly higher or lower angle to remove any glare.

- Minimize strong facial features. De-emphasize a large nose by shooting the face straight on. Shooting from a lower angle can minimize a prominent forehead or a bald head. A broad face or double chin may be slimmed or hidden with a slightly higher angle.

- If your subject is sensitive about wrinkles or skin blemishes, try using a soft-focus filter, designed specifically for portrait photography. These help to ease out deep lines or shadows.

- Watch for signs of tension. Clamped jaws or clenched hands are signs that it's time to take a break.

Digital Photography

The greatest advancement in the history of photography is the technical explosion in the digital world. Digital cameras provide instant gratification, easily capturing images and making them available on the spot. And the computer has become an almost indispensable piece of equipment, also. All you need is a scanner to turn your existing film images into digital files that you can manipulate and print yourself. Every photographer can now have their own digital darkroom in their home, office, or even on the road. The digital darkroom gives us more freedom to be creative than we could have imagined a few years ago. Film darkroom processing is already beginning to look like ancient history.

One of the hardest things about digital today is the fact that the rapidly improving technology is bringing an ever-changing parade of new and improved products to the market. Current, cutting-edge products will be dated before this book is a year old. Fortunately for us, photography is still photography and most of what we know can be readily applied to the latest technologies.

What is Digital?

To really understand what a digital image is and why it is so important to the future, you have to go back to the roots of photography.

On a piece of conventional film, there are millions of silver halide grains that upon exposure to light form invisible dots. When developed in the darkroom, these silver halide dots combine on the film to form an image. Once this silver halide grain is developed, its nature is fixed. The information held on that little piece of film is now set in stone.

A digital speck of information, on the other hand, is formed when a bit of light is measured as an electrical charge and is formed into a pixel. This tiny bit of information can be processed mathematically, so you can change it, transmit it, and use it to manipulate the entire image. This is the key to its versatility.

Digital technology is really just a logical extension of the original photographic technology. That's why most of what we know about photography still applies.

Elements of a Digital Image

A number of terms are used to describe the amount of detail a digital image contains. While most photographers are primarily concerned with resolution, there are a number of other factors that have to be considered and managed as well.

Resolution is crucial to the quality of any image. It dictates the level of detail that the image will hold. Resolution is referred to by the number of pixels in a given area of the image. This is expressed as "pixels per inch" (ppi). Resolution ranges from low (640 pixels per inch x 480 pixels per inch) to very high (3008 pixels per inch x 2000 pixels per inch).

Dynamic range is the ability of the image device to capture the brightest highlights and the deepest shadows that you can see with your eyes. The brightness scale begins with 0, which reads as pure white, and ends at 4.0, which reads as pure black. The brightest level at which your system can detect detail is called the "DMin." The darkest level at which your system can detect detail is referred to as the "DMax." Dynamic range is measured as the difference between its DMin and its DMax. Example: If your camera has a DMin of 0.3 and a DMax of 3.6, the dynamic range would be 3.3D.

Bit depth controls the accuracy of color. It is a measurement of the number of bits per pixel that determine how many different colors it

can display. Photo-quality images usually require 8 bits per channel, often referred to as 256 color, and this is what most software provides. Some cameras and scanners work as high as 10-bit and 12-bit.

Noise refers to unwanted information that causes random fuzziness in the image. It is caused by electrical signals that are not a part of the making of the image. Noise reduces the quality of a visual image in the same way static would reduce the quality of a sound broadcast. If not removed during the recording of the initial image, it can usually be cleaned up in the editing process.

The Digital Camera

Digital cameras allow you to capture your image as a digital file. There are a great many cameras on the market, and their numbers keep growing as the technology improves. So how do you know what to look for? First, it's a good idea to have an understanding of how a digital camera works.

Capturing Digital Light as a Photographic Image

Most digital cameras use a charged-coupled device (CCD). This is a silicon chip made up of elements called "silicon photo diodes" (SPD). The SPDs are light-measuring elements that accumulate light based on the exposure. The CCD is the heart of your camera. It is where light is captured and turned into an image. CCDs have been in existence since the late sixties and have been used in film cameras' through-the-lens metering systems for many years. In digital cameras, these devices are simply used more extensively.

Where film is made up of emulsion layers, CCDs (or more specifically the SPDs in them) are laid out in rows. Once the SPDs have been exposed to an image through the camera lens, the light charges are read a row at a time and digitized. A row is read, than deleted, and the next row is linked or coupled to the information on the preceding row. This information is than transferred to a memory card in the camera. These cards are removable. Once the information is downloaded onto a permanent storage device, the information is deleted and the card is ready to use again.

Less commonly used is a sensor system called "CMOS" (complementary metal-oxide semiconductor). This is a relatively conventional memory chip. It is easier and less expensive to manufacture than the CCD sensors. It also can process information right in the chip. It has light sensors built into each cell within the sensor.

Exposure

Digital cameras work on exactly the same principles for exposure as film cameras regarding the relationships between shutter speed and aperture. You can adjust each up and down to determine how much and how quickly light reaches the camera's sensor.

Interestingly, film's speed rating, which is referred to as the "ISO," is also used in equivalent terms in digital. In film, the slower the ISO, or film speed, the finer grain the film will produce. The higher the ISO, the grainier the final picture. When using film, you cannot change your ISO once you start shooting. All of the shots must use the same film speed or processing will be off.

A majority of digital cameras have a sensitivity that roughly corresponds to that of ISO 100 to ISO 1600 film. But unlike film, a digital camera allows you to change the ISO speed with every shot, if you wish. This gives you an additional way to adjust to lighting conditions in action situations. The ability to change ISO is a real advantage if you are willing to sacrifice a little sharpness in your final print. Lower ISO ratings will give you less noise (the equivalent of grain structure in film); a higher ISO will create a little more noise in the final picture. But this won't even show up in most applications unless you are trying to enlarge and print photos to 11 x 14 inches or larger.

Factors to Consider when Choosing a Digital Camera

You probably won't be surprised to see the same words popping up repeatedly when it comes to digital quality.

Pixels

The name of the game when it comes to digital photography is pixels. The higher the number of pixels, the higher the resolution, the

greater the detail, the sharper the image, and the better the ability to maintain high resolution when printing images.

Effective Pixels

The measurement known as "effective pixels" describes the level of detail that your digital camera can capture. This is one of the main factors in determining the quality of your image.

A camera's CCD is the heart of the digital camera. It captures light as millions of tiny pixels. But it does not use all these to capture the image. That's why you'll see the measurement referred to as "effective pixels." This is a count of the number of pixels that are actually used to capture the image. You can see what kind of capacity for detail your camera has by looking at the number of effective pixels it has. The higher this number, the finer the resolution. Resolution ranges from low to very high. High-resolution images are sharper, but require more memory to store.

Range of Resolution

Low resolution:	1 to 2 megapixels
Medium resolution:	3 to 6 megapixels
High resolution:	8 to 20 megapixels

Resolution

We often use the word *resolution* to describe the overall quality of an image. But we also use the word to describe the number of pixels in a given area of the image. Resolution is expressed as pixels per inch (ppi). A camera's specifications will often refer to its top resolution, that is, the highest resolution that the camera can offer.

So how much is enough? Remember that the higher the resolution, the more pixels are needed. And as more pixels are needed, the need for memory space increases. So how do you decide what is best for you?

If you send the majority of your photographs to friends and family via the Internet or you generally don't make prints larger than 5 x 7 inches, then you may be happy with a low-resolution camera. It will be excellent for this use. If you want to manipulate your photos, enlarge up to 8-x-10-inch prints, or design your own desktop publications, you

will need medium-resolution capabilities. For professional work, most publication purposes, and making prints 8 x 10 inches and larger, you will need a high-resolution camera.

You should buy the highest resolution quality you can afford. Because a majority of the digital cameras on the market today allow you the option of shooting at different resolution levels, you do not need to be concerned about having "too much quality" always at your disposal. You can drop down and shoot lower-resolution shots if you do not need the higher quality. Resolution takes up space because it is using more pixels. Shooting at lower resolution allows you to take more photos before your memory card fills up. Your camera can process these lower-resolution photos more quickly because they do not contain as much data. Therefore, they use up less recording space and time.

Even when using film cameras I take along a digital camera to record areas where I think I may want to shoot in the future. I shoot these images at low resolution so that I can bring home lots of reminders. Chances are I will download them into a file for future reference and never even bother to print them. Low-res is perfect for such occasions.

While the imaging capability of a good digital camera approaches the quality of a good film camera, it is not entirely there yet. For the most part, film is still capable of delivering higher-quality resolution than digital. If crisp fine art images are what you are looking for, the average digital camera is not quite up to the challenge.

The average linear pixels/millimeter for the standard 35mm film camera is about 60 to 75 lp/mm. In contrast, a 4-megapixel digital camera provides only 25 to 30 lp/mm. This is comparable to the quality you might expect from a point-and-shoot camera.

It probably won't be long, however, before digital surpasses film, at least when we compare it to 35mm film. Digital cameras that offer 5 to 6 megapixels are beginning to produce very good prints up to 8 x 10 inches. Canon's new introduction, the EOS-D1s, offers 11 megapixels, and Kodak's DCS Pro14n offers 14 megapixels. Both match the quality of 35mm film for virtually all uses. The only drawback of these cameras is the cost. The Canon comes in around $8,000 and the Kodak just under $5,000.

A growing number of professionals are using both mediums side by side. Digital works better in some situations, film in others. Many

landscape and outdoor sports photographers are shooting digital and backing it up with film, just to make sure they can use it in any market.

Lens Optics

Many digital cameras come equipped with built-in zoom lenses. The lens size advertised generally refers to the optical zoom. Many of the mid-range cameras have zoom lenses in the range of 35mm to 100mm. Most optical zooms will provide consistently clear, sharp images.

Sometimes you'll see a reference to the "digital zoom," often expressed as "1X–4X magnification." A digital zoom is actually a false zoom effect. This effect is created when the center of the CCD is enlarged through interpolation, a bit-mapping procedure that fills in the gaps in a resized area by comparing the values of nearby pixels. Digital zooms allow you to zero in on your subject further, but result in seriously degraded image quality. Don't be fooled by the promise of extreme focal lengths that the digital zoom seems to imply.

Digital lenses are labeled by focal lengths in the same way as 35mm cameras. This would be convenient, if they were accurate. Unfortunately, they are not. To understand the problem of comparing focal lengths, we need a quick review of how film cameras work. A lens for a 35mm camera is measured by its focal length. This is the distance within the lens where light entering the camera diverges to the focal plane, which is the film. The focal length of a lens is measured in millimeters based on this equation.

The 50mm lens is considered the standard 35mm camera lens because its perspective is the closest to the normal view of the human eye. Shorter lenses are considered wide-angle lenses and longer, telephoto lenses. The accuracy of this measurement is based on the size of the film plane. A conventional 35mm camera uses film that measures 24mm x 36mm in diameter.

In the case of digital, the camera's "film plane" is the CCD sensor. At present, the diagonal size of the CCD sensor in a digital camera is not standardized. Most are smaller than 24mm x 36mm, the size of 35mm film.

Because digital lenses are still designated in equivalents to 35mm lens focal lengths, you aren't really getting what you might be expecting. To understand how the focal length designated on your digital

camera compares to the focal length on your 35mm camera, you need to do a little math. Generally speaking, you can multiply a 35mm focal length by 1.5 to get the comparable lens value for your digital camera. For example: A 100mm lens for a 35mm film camera will be 150mm on a typical digital camera. (That's because the sensor is about one-third smaller diagonally than 35mm film).

If you often shoot wildlife or sports with telephoto lenses, this is a good thing. Your digital camera with a stated zoom lens of 35–100mm really gives you magnification more comparable to a 150mm lens. And that longer lens doesn't cost a cent more! If on the other hand, you shoot primarily with wide-angle lenses for landscape, this is a disadvantage. That stated 35mm is really more like 52mm—not wide at all.

I shoot many of my landscape photos using a 28mm lens. When I multiply that by 1.5, the 28mm lens becomes a 42mm lens and it gives me a very different perspective. In order for me to keep the 28mm perspective I am accustomed to, I would need an 18mm lens on my digital camera. Another of my favorite lenses is a zoom lens of 28–70mm. It is difficult to find an equivalent digital focal length zoom lens. I would need something like an 18–50mm lens to have a lens that corresponds equally to my film lens.

Canon and Kodak have come out with high-end digital SLR cameras with sensors the same diagonal size as 35mm film. If you already own a Canon or Kodak system (Pro-Kodak cameras use Nikon lens mounts, so all Nikon lenses work), this means the lenses you use for your film camera will give you the same angle of view and focal length distance on these digital cameras. This is a significant advancement, but still very expensive.

Shutter Lag

Shutter lag is one of the negative issues with digital cameras right now. With film cameras, the instant we press the shutter release our shot is recorded. With the exception of a few SLR pro digital cameras, on the average digital camera there is a delay after the shutter release is pressed. This delay varies from camera to camera. It is not a problem if you are shooting stationary subjects, but it can offer various degrees of difficulty when photographing action, sports, or any moving subjects. Unfortunately, right now all you can do is learn to compensate for this delay. It can be a frustrating thing to overcome, in particular with moving subjects that are fairly close.

Recently I was at a championship dog show. My assignment was to photograph several breeds as they worked their way through the ring. I was using my Nikon 35mm film camera, shooting slide film. Between one of the breed programs, I stopped by to watch friends show their dog. They proudly gave me their new 4-megapixel digital camera, which is currently considered the best in its class, and asked me to shoot their dog while they were in the ring. Great, no problem!

But, there was a problem. The camera had a long shutter delay. Time after time, as the dog and handler moved across the show ring, I set myself up to capture a particular angle as they came diagonally toward me. I pressed the shutter release at the appropriate time and . . . nothing. Then a moment later, the prime shot was gone, and the shutter went off. Too late!

After a while, I began to predetermine where they would be and pressed the release to compensate for the delay. This worked sometimes, but didn't give me the precise control I need in a real working assignment.

The reason for the delay is all the built-in intelligence of a digital camera. It takes the camera time to assess and calculate all the information it's taking in.

Even though the more RAM the camera has the faster it will process information and the shorter the shutter delay will be, for most people, the delay is an annoyance. It can be overcome with a little preplanning, but in important situations, it can be a big deal. It's no fun to spend a lot of money on a camera to "almost get the shot."

Storage Media

Image data is stored on memory cards, which are removable storage devices. There are several types of short-term memory cards used by camera manufacturers. The most common are Compact Flash I and II, SmartMedia, and Microdrive. Sony has its own memory card, the Memory Stick.

Compact Flash I and II. This is the most widely used format. Compact Flash II is just a thicker version. They come in a wide variety of file sizes and speeds from 16 megabytes up to 1 gigabyte.

Microdrive. This is really a very small, high-density hard drive. It's the same size as a Compact Flash card. The advantage is it can store up to 1 to 2 gigabytes. Wow!

SmartMedia. This is the thinnest card available. It's about a third of the size of a credit card. It comes in storage sizes from 8 to 256 megabytes.

Memory Stick. This Sony memory card, which resembles a narrow stick of gum, is different than any of the others. It is available from 8- to 512-megabyte storage capacity.

Short-term memory cards come in various storage capacities and storage speeds. Storage capacity is measured in megabytes. An average memory card holds 32 megabytes.

What does this storage capacity number really mean in practical terms? How many photos can you store on a storage memory device? What is the difference between 32 megabytes and 128 megabytes of memory? There are several answers to these questions. Let's look at the following chart:

Image Storage Capacity*

Camera Type	Image Size	Quality	Card Memory Size			
			16MB	32MB	64MB	128MB
			Number of Images			
1.3 Megapixel	640 x 460	Fair	114	228	468	919
	1280 x 960	Good	38	78	115	311
2.2 Megapixel	640 x 460	Fair	100	200	402	805
	1024 x 768	Good	38	76	153	306
	1280 x 960	High	16	32	64	129
3.3 Megapixel	640 x 480	Fair	66	132	266	530
	1600 x 1200	Good	12	25	51	100

* These are approximations and will vary with different camera units.

Latency

Latency, the lag in time between snapping the shutter and the recording of your image on the memory card within your camera, is a quirk of digital that takes a little getting used to.

Your digital camera goes through two stages in storing your image. It must first capture the image, and then it has to record the image that it receives. With many digital cameras, this process prevents you from shooting consecutive shots very quickly. Other cameras have a built-in memory that will allow you to continue shooting. These cameras actu-

ally store information temporarily while recording information from previous shots.

Yet, even with built-in memory, some cameras won't be able to store information quickly enough at higher resolutions. The higher the resolution, the greater amount of information is recorded onto your memory card. You may have to decide if you want to keep shooting using a lower resolution or stop shooting momentarily until the camera has finished recording your image information.

You can improve latency by having a memory card that accepts information more quickly. Not all memory cards are created equal! In general, Compact Flash cards record faster than Microdrives. Even within Compact Flash cards there are differences. Compact Flash cards have speed marked as "4X," "8X," and "12X," up to "32X." The larger the number the faster the card can record and file information.

USB Interface

Your camera should come with a USB interface cable as a piece of standard equipment. This cable allows you to connect your camera to a compatible computer or printer for a direct transfer of JPEG images. This is a handy feature, particularly if you are downloading only a few images. But for multiple image transfer, I strongly recommend a card reader.

Rechargeable Batteries

Check out the average battery life of your digital camera. Most digitals eat alkaline batteries very rapidly, although the newer ones are better than they used to be. Nonetheless, it's important to buy a digital camera with rechargeable batteries. It will save you lots of money in the long run.

Types of Digital Cameras

Now that you understand many of the factors that go into digital technology, how do you go about choosing your camera?

Digital cameras come in a surprising range of sizes and shapes. That's because digital technology doesn't require all the mechanical elements that go along with film cassettes. There is no film to load, wind, or position into place. This has allowed designers to experiment

with a variety of sizes and ergonomic shapes. You'll find sleek, slim-line cameras, as well as boxy cameras that seem to be dominated almost entirely by the lens. The size and shape won't tell you much about the features that are inside. The smallest camera may have the greatest number of features or the least.

Entry Level Compact Digitals

It might be tempting to categorize this group of cameras as "point-and-shoot" cameras, in the style of the 35mm category. It would be a mistake to do so, however. While there is certainly a lower end to the digital market, it is difficult to make a direct comparison to conventional entry-level film cameras. Many conventional film point-and-shoot cameras are inexpensive, have low-quality optics, and very few features. On the other hand, entry-level digital cameras are pretty well built, and have many of the same electronic and processing features as their more expensive counterparts. You'll generally find a zoom feature on most digital cameras in this category, plus auto-focus, built-in flash, and center-weighted or spot metering.

What you probably won't see is a high degree of resolution provided by the sensor. Entry-level digital cameras will generally have a lower "effective pixels" rating than their more expensive counterparts, probably in the range of 1.3 to 2 megapixels.

The other difference among cameras in this category is in the size and quality of the lens and few, if any, in-camera image editing options.

Mid-Range Cameras

This category of digital cameras is the most widely available. Cameras in this category generally offer 2 to 4 megapixels of resolution, an optical zoom in the range of 3:1, and at least a few options, such as a choice of exposure modes and manual override of exposure settings.

Advanced Cameras

Digital cameras that fall into the category of "advanced" generally offer high-resolution options (up to 6 megapixels) and longer zoom lenses. What really differentiates them from others is the range of options available in add-on accessories, including external flash units, wide-angle and telephoto attachments, and customizable exposure set-

tings. These cameras require extensive study of their instruction manuals to fully optimize their capabilities.

Many of these advanced cameras have through-the-lens viewfinders and, in some cases, even interchangeable lenses.

Professional SLRs

When it comes to this category of digital cameras, you can throw out all the issues and inconveniences I have mentioned regarding digital to this point. Cameras in this range are virtually equal to their film cousins in every way. Pixel resolution is huge, ranging from 5 to 14 megapixels. Lenses are interchangeable and, due to the smaller sensor size, more powerful than standard 35mm lenses. Because of their enormous storage capacity, you can shoot as quickly as you like with no discernable lag time. All of the auto-exposure and auto-focus features can be overridden or customized to meet your needs. These cameras are truly amazing and, of course, they come with amazing price tags, too. Cameras in this category run into the thousands of dollars, from $1,500 to as high as $30,000, but prices are tumbling rapidly.

Computers

In order to fully realize digital photography's potential, you'll need a computer system—to edit and store your images, to share them with others, and to make prints. Following are some basics you need to think about when purchasing a computer for your digital photography needs.

The Platform

The most important consideration when choosing a computer specifically to be used to manipulate and send your images is the platform, or operating system. The two most common are the various versions of Microsoft Windows and Apple Macintosh. Windows represents over 95 percent of the computer market; but most graphic designers and professional photographers use Apple Macintosh.

Macintosh is by far the easier to use for graphic design and image

manipulation. The primary reason is that it uses a single video driver. The advantages are easier and more accurate monitor and color calibration. It also makes image-editing programs like Adobe Photoshop work more easily and more quickly. For example, when changing levels and curves in Mac, they show up immediately. Windows is slow and cumbersome at these tasks.

Windows can certainly handle the task of image editing, and all of the software is available. But the real strengths of the Windows platform are its wide usage, higher speed in multi-tasking, and the wider selection of software available at lower costs. Windows has had the advantage in speed over Macintosh, but the race is heating up over megahertz (MHz), or the speed at which the programs run. Macintosh just introduced the Apple G5 to compete with Windows XP.

The advantages of Apple Macintosh for an image-editing platform are its ease of use, better graphic interfaces, ability to easily attach and configure peripherals, and the fact that it uses a single video driver.

So what is so important about a video driver? This is the software that the monitor uses to control and calibrate the color, brightness, contrast, and tone of the display screen. The Macintosh system does this simply and accurately. This is very difficult to do within the Windows system especially for nonprofessionals.

Hard Drive

So what are the most important things to look for when purchasing a computer system to do image editing, image storage, and all the other tasks required in digital photography? You'll need to make basic decisions on the size of the hard drive for active memory or RAM (storage), the speed of the processor, and the kind of video card. You'll also need to decide which software programs will work for your needs.

Monitors

Monitors are actually more important to photographers and graphic designers than almost all other computer users. We need the largest monitor, the highest resolution, and the best color depth we can afford. Why? If you are going to manipulate your images on the computer for printing or publication you want the image on your monitor to be as precise and close to your final output as possible.

It is also important that your camera, computer monitor, scanner, and printer are compatible in resolution and color depth capabilities. They all need to be in sync to get maximum final output. All these devices are measured in lines or pixels per inch. The standard for monitors today is around 96 ppi. Monitors work in RGB (red, green, blue) mode and display colors in a way that is acceptable to the human eye. Monitors can be adjusted to different angles that will cause the display to change in brightness. This can be very deceptive for actual final color and brightness output. You'll need to experiment with prints to adjust to this factor. You can adjust your monitor bit depth by going into Control Panel and display settings. Monitor resolution will vary with model and screen size. When purchasing a monitor, look for 24- or 32-bit color depth, the highest resolution you can afford, the largest screen you can afford, and calibration software so you can tune the monitor to match your output for prints.

Monitor Bit Depth

Index	Bit	Depth # of colors
Grayscale	8	256
Indexed color	8	256
High color	16	65,000
True color	32	16.7 million

Long-Term Storage Devices

Digital photos take up huge amounts of space. Whether they're located on your memory card, your computer's hard drive, or on long-term storage devices, you will need a lot of space to store your images. For example, a 6-megapixel image from a Canon EOS 10D SLR camera will take up 15 to 16 megabytes in "RAW" or "TIFF" mode on your computer. If you manipulate your image in Photoshop or another software program, with several layers or copies, you may find yourself with a 25-megapixel image.

If you want to send this image by e-mail, it will take forever to send it and forever to open it. A better solution is to send it to a removable storage device. There are several options and all have their pros and cons.

Issues to consider when choosing a storage device are speed, cost, memory, and security. Speed is a major consideration when moving

huge files. Everyone is going to be frustrated if it takes too long to open a file for just one image. Cost is broken down into a number of factors. First, there's the cost of the drive to use the device and the media itself.

Zip drives are currently the most common media and easy to use. These are removable hard discs that look just like thick floppy disks. They are essentially magnetic drives. They work well and are inexpensive, but cannot be exposed to a magnetic force or everything could be lost. But they are the most accessible at this point in time. They have storage capacities up to 250 MB.

CDs are also popular. They are excellent for long-term storage, are easy to use, and are universally accepted. They are more stable than zip drives. CDs come in CD-R and CD-RW, which are rewriteable. They also have more storage capacity than zip discs, up to 750 megabytes. CD-R and CD-RW disks are very inexpensive, durable, large capacity, and long lasting, but the recorder to copy to or to open is relatively expensive.

DVDs are the future. Pricing for the drive is high right now, but coming down rapidly. This media is likely to soon take over as the prime media for removable storage. DVDs also come in rewriteable versions: DVD-R and DVD-RW. They offer the same stability as CDs but offer the highest storage capability, up to nearly 10 gigabytes.

Average Number of Images Stored

	JPEG (840 KB)	Tiff (11 MB)
Zip Drive (250 MB)	250	20
CD-R7 (750 MB)	625	55
DVD-R (5.2 GB)	9000	1500

File formats

Most cameras offer different file formats on which to save your photographs. The most common format is called "JPEG," short for Joint Photographic Experts Group, which is derived from the International Organization for Standardization. It is a format that compresses your image data to various degrees. This is the most widely recognized process used to save recording space for your images.

JPEGs compress image information and file size, which saves recording space and reduces in-camera-processing time. But anytime you compress image data, it degrades the final image. This is known as a "lossy" system, meaning that you lose information in this process. It is still a very good system and gives you choices for the file size or resolution quality to record your images.

The format and amount of compression you choose will determine the final output quality of your image. The JPEG format you choose determines how high the resolution will be.

JPEG Formats

JPEG Low or Basic:	640 X 480 pixels	1 megapixel
JPEG Medium or Normal:	1024 X 768 pixels	2 megapixels
JPEG High or Fine:	1280 X 960 pixels	3 megapixels
JPEG Super High or Super Fine:	1600 X 1200 pixels	4 megapixels
JPEG Full:	2048 X 1536 pixels	5 megapixels

Most digital cameras allow you to shoot in formats that do not compress the image data. The most commonly used format is called TIFF (tagged image file format). It is universally readable. When using the TIFF format, you will not lose any image information, but it will take up more space in your memory card and take longer for your sensor to process.

Many digital cameras also offer a RAW format. This is also uncompressed—meaning it captures 100 percent of the image data. The advantage it has over TIFF is that it takes up about 60 percent less space. The disadvantage is you can only use your camera manufacturer's software to read it. It is not universally readable.

Card Readers

Card readers allow you to take your memory card from your camera, pop it into your reader, and work with your photos quickly. This frees up your camera for other uses and limits the enormous battery drain that direct downloads can cause.

Card readers are plug-in attachments to your computer or printer. They also work well as short-term storage units for your digital images.

Image-Editing Programs

After you've downloaded your images into your computer, there are many choices available in software programs that you can use to edit your images. These run the gamut from extremely simple to very complex.

Image-editing programs allow you to fix color problems, adjust shadows and highlights that may have been too harsh in the original shot, and even adjust sharpness to some degree. You can remove unwanted image content in big ways or small, from tiny blemishes to large ones (like an ex-girlfriend!) Painting, blending, and correction tools allow you to unleash your creativity in myriad ways.

Simplified programs, such as Adobe Photodeluxe, are often bundled with digital cameras and scanners. These software programs tend to have limited features, but do allow you to do some basic manipulation of your images.

If, however, you want to have real control over your images, shop around for an image-editing program that gives you complete flexibility over your digital files. It's really important to do your homework on this purchase. These programs run into the hundreds of dollars, so be sure that you're not only comfortable with the different features of the program, but also with the approach the program takes in manipulating the images.

The best way to learn whether a program is right for you is to use it before you buy it. Consider enrolling in an image-editing class through continuing education or your local community college to learn how to unleash the power of various programs. Many classes are given specifically for a certain type of program; so if you are inexperienced in this area, look around. I learned on Adobe Photoshop, so it's my favorite, but it does require a steep learning curve to really master its features.

Features

You don't need to choose an image-editing program based on the number of features it has. You'll be much farther ahead if you know what features are most important to you, and then seek out the program that performs those task best. Here is a summary of some of the useful—and common—tools that you may encounter. The fact is that,

unless you are a professional graphic designer, most programs will offer many features that you are unlikely to ever use.

Levels. A contrast and brightness tool that lets you adjust light, dark, and middle tones separately. It uses a histogram graph of tonal values in the image file.

Histogram. A diagram of tonal values that ranges from black to white. It helps to evaluate a photo's brightness and contrast needs.

Hue/saturation tool. This lets you manipulate color in two different ways. You can change the actual color (hue) or you can adjust its richness or intensity (saturation).

Magic wand. This tool allows you to select an area of similar tonal values by simply clicking on it.

Color balance control. A simple sliding scale that allows you to show different levels of color balance.

Clone tool. A selection tool that allows you to select a piece of the image, copy it, and move it from one place to the other. Handy for fixing problem areas.

Layers. A method of separating parts of an image by isolating them into stacks. This tool comes with masks and other adjustments that let you manipulate how each of the layers is seen.

Stitch tool. Automates the connection of several photos to make a panoramic image.

Your Program's Personality

Mastering an image-editing program is a key step toward having a home-based digital darkroom at your disposal. As much fun as taking the pictures was, you'll find that the ability to work with your images all the way through to the final outcome will be extremely rewarding.

Even more important than the number of features your program uses is how it functions. Is it friendly and self-explanatory, or complex and mysterious? Does an easy-to-understand manual and third party support come with it, or are you on your own after the purchase?

The first thing to look at is how the program is navigated. There are basically two different approaches to operating one of these programs.

Buttons or Menus?

The first method of navigating an image editing system is button, or

icon, based. These programs offer simple user interfaces and logical graphics buttons or icons for each step. These programs don't have as much raw power as some of the more complex programs, but for the most part, you can teach yourself how to use them without too much trouble. They tend to follow step-by-step programs to get you where you want to go.

The second approach is menu-based. Menu-based programs tend to have a greater number of features and options, but they can be a little harder to learn initially. You have to know how to get to and navigate through all the available tools on your own.

Wizards and Friendly Advice

Some programs use "wizards" to help guide you along. A wizard helps by stringing together a series of operations for you. Dialog boxes can guide you through the process, too. And if you get really stuck, some software programs offer third-party support by phone or on the web.

Templates

A few lower-end programs offer a range of templates that let you create everything from greeting cards to calendars. These can be handy if you have no graphic design background, but take a look at them before you buy to make sure you like their look and style.

Converting Existing Images to Digital

Does all this talk of pixels and bits mean that all the beautiful images you have taken over the years are obsolete? Fortunately, the answer is no.

You don't need a digital camera to break into the world of digital imaging. By converting your existing film images to digital files, you can create an entire digital library of work that can be stored on CDs or DVDs for future use. Once your images are stored in this manner, there is very little difference between them and images that are created in a digital camera. Of course, to maximize the benefits of this image bank, you'll want a good computer and software that will allow you to manage your library, as well as manipulate and print your images.

To convert your existing photos to into useable digital files, you'll

need a scanner. Because film holds an extremely dense amount of information, the trick is to capture as much of it as possible. All of the elements of a good digital image must be re-created during the process of scanning the image. This is where a high quality scanner comes in.

When choosing a scanner, consider the following factors.

Resolution. A scan must have fairly high resolution to be useful. In order to produce a high-quality 8-x-10-inch image from a file scanned from 35mm film, it would have to have a resolution of at least 2100ppi. Good high-end scanners are capable of capturing this higher resolution and the quality of their optics and accuracy help to ensure a truly sharp image.

Bit depth. The dynamic range and color accuracy of your scan are completely dependent on your bit depth. Good scanners work at bit depths of 10 or 12, which provides 30-bit or 36-bit color. This is important, because most image-editing programs only work at 8, or 24-bit color, so when your file is converted downward in the editing process, your digital image has better dynamic range and finer color gradation.

Noise. Like a good digital camera, a good scanner will automatically suppress extraneous electrical signals, preventing your image from degradation by random patterns of unwanted information.

Does all this sound like a lot of work? It can be if you want to store a lot of images as digital files. Fortunately, there are services that will digitize your images and store them on photo CDs for you. Even better, many photo-finishing houses will produce prints from your film, and allow you to order a CD file at the same time.

If you decide to purchase a home scanner, there are a number of things to look for.

Choosing a Scanner

The scanner you choose needs to be able to handle the type of original images that you are going to work with most often. There are four primary scanner types.

Flatbed Scanner

A popular and relatively inexpensive choice for the home digital darkroom, a flatbed scanner has a glass bed upon which you lay your photo or artwork face down. This scanner is great for prints or large transparencies. Most flatbed scanners can handle images as large as 11 x 14 inches.

They do not work well for transparencies as small as 35mm, but many do offer an optional transparency accessory for handling these images. Most flatbed scanners offer optical resolution of 1200ppi. Many manufacturers give a higher resolution along the length, such as 1200 x 2400dpi. Ignore this. It only reflects that the array is being stepped in increments half the width of the sensors, and does not represent actual optical improvement. Density ranges can be as high as 3.7 to 3.9.

Printer/Scanner Combination

This scanner works like a conventional flatbed scanner, but many printer/scanner combinations have fairly low scan resolution. This makes them more appropriate for low-resolution documents or simple line art rather than photographs.

Film Scanner

This type of scanner is a great choice for photographers who work primarily with slide film. You can get a film scanner that accepts variable film sizes, or one that is designed exclusively for 35mm film. Good film scanners can give optical resolution as high as 4000ppi with a density range approaching 4.0. They are a bit more expensive, but with their corresponding increase in quality, they are ideal for most photographers using slide film.

Drum Scanner

This is the highest-quality scanner on the market. The film is taped to the outside of a transparent drum that then spins. Readings are taken as the drum spins, providing an extremely detailed and high-quality scan. Optical resolutions are as high as 8000 to 14000ppi. Density range often approaches the maximum of 4.0. The drum scanner provides the best possible scan, but does require a little more skill to use. Unfortunately, the steep prices of these scanners make them impractical for home use.

Resolution

All scanners allow you to do low-resolution scans if you wish, but high-resolution capability is crucial to getting good photographic scans

at home. Above, you saw the ranges that the different scanner types generally provide. Choose the highest quality scan resolution you can afford.

Dynamic Range and Bit Depth

Again, look for the highest quality dynamic range densities and bit depth you can afford. This is key to getting a scan that captures all the depth in shadow, highlight, and color that is in your original.

Software

Most scanning and editing programs use a set of standards called "TWAIN." This set of standards help to ensure that various products will be compatible with one another and allow you to open and share files. Make certain that the scanner you choose is TWAIN-compliant.

How to Choose a Home Scanner

- Select a scanner type that is best for the type of images you will work with most often.

- A flatbed scanner may be a bargain, but if most of your work will be with film transparencies, you'll get much higher quality with a film scanner.

- Buy the highest resolution scanner you can. Most scanners will provide at least 1200ppi, but if you want to make a high-quality 8-x-10-inch image, you'll need a scan of at least 2100ppi.

- Dynamic range contributes greatly to the overall quality of the image. Make certain that the scanner you choose has a high-density range of at least 3.7.

- Choose a scanner that can work at bit depths of 10 or 12, which provides 30-bit or 36-bit color.

- Make certain the scanner you choose is TWAIN-compliant.

Printers

There are printers on the market that accommodate almost any use you may have for them. But to maximize the quality of your digital photographic images, you really need to choose one that can make the most of your image's color and clarity. The best choice in printers for photographic reproduction at home is the inkjet printer. Nearly any inkjet printer on the market, even the most inexpensive, can make a decent print. As prices go up, higher end printers offer greater resolution, better color control, speed, and paper handling.

Resolution. When talking about printers, resolution refers to the number of dots of ink that the printer can lay down per inch. You'll see that on the manufacturer's specs as "dpi." It is usually measured in two directions, such as 2400 x 1200dpi.

Dot size. Another factor that affects the quality of the print is the size of the dots that the printer lays down. These ink droplets are measured in picoliters—one-trillionth of a liter. A typical inkjet printer uses 3-, 4-, or 5-picoliter droplets. The more droplets per square inch, the higher the resolution.

Print method. The way that the ink is laid down on the paper is another factor in determining print quality. The way that the ink is delivered makes the ink droplets flow together better. Different companies use different methods to achieve this. Try to compare prints that come from different machines to determine which is the most appealing to you.

Speed. The highest-quality prints come from a printer that is set to deliver the "best" mode, which requires the greatest amount of ink and tends to take a long time to print. When reading manufacturer's specs, be aware that the speed they claim is probably for a low-quality "draftmode" print, and not a high-quality photo print. The best prints take up to five or ten minutes to print. If you make few prints, that's probably okay. But if you often print in the highest-quality mode, check to find out the print time for a full-color photo-quality 8x10.

Connectivity. Most new printers offer two types of connection. USB ports are faster and easier to connect than the older style parallel ports. Just make sure that your computer can accept a USB interface. USB 2.0 is the latest version, and is significantly faster than USB1.0.

Another connection option being offered on printers is a direct one.

Some printers now have built-in card readers and LCD screens that allow you to plug your camera directly into the printer, bypassing the computer altogether. This is a great option if you want to make a quick print or take your printer on the road without having to lug around your computer. Of course, you don't have the ability to manipulate or crop the image beforehand, but in many cases that's not a necessary option.

Paper size. Most printers are designed to handle standard 8½-x-11-inch paper. If you want a printer that will handle larger sizes, plan to spend more money. Some printers will handle roll paper, which is great for printing panoramics or multiple prints at once. There is also a wide-format printer that can handle up to 13-x-19-inch prints.

Paper path. The way the paper feeds into the printer makes a difference, too. You can choose a top-loading or front-loading printer. A front-loading printer forces the paper to bend as it feeds into the machine. This can be difficult for heavy paper stock and some of the new specialized canvas and watercolor papers. A top-loading printer feeds directly, allowing the paper to go in unbent.

Noise level. This should be a simple decision: How much noise are you willing to put up with while your printer makes your print? Especially when you are running a high-quality print, this can make a big difference to your enjoyment of the process. If you try out your printer at a store, you can listen for yourself to the difference between printers, but if you are ordering by catalog or Internet, you may need to do a bit of research to get an accurate comparable noise specification for the printer you are considering.

Archival quality. Most printer inks are not designed to last much longer than ten or twenty years. While that's fine for the short term, many photographers prefer archival inks that will last much longer. Manufacturers now offer printers that use inks that are designed to last as long as 200 years. The printer you are considering will make it clear if this is one of its features.

Types of Printers

As I mentioned at the beginning of this section, inkjet printers are really the best choice for home printing. But if you are curious about other options, here is a rundown.

Inkjet Printers

An inkjet printer is generally the lowest-priced option in the printer world, and surprisingly, is often the best choice for printing photographs. A color inkjet printer can create near photo-quality prints, especially when paired with high-quality photo paper. Prices start as low as $99 and go up as you add higher resolution and speed.

Laser Printers

Laser printers work like big photocopiers, and may be handy for producing a large quantity of color prints because they print much faster. But they are more expensive than inkjet printers and, generally, their print quality is inferior to them.

Dye-Sub Printers

Priced much higher than other printer options, dye-sub (short for "dye-sublimation") printers really do make the highest quality photographic prints. They create prints using a process that transfers dyes from a roll onto the paper in a way that allows the amount of dye to be varied. This method creates a truly continuous tone image. Unfortunately, they tend to be priced out of reach for the average home user.

Sharing Your Photos by E-Mail

Sending photos by e-mail is a great way to share your favorite images with friends and family, but it's also a great way to quickly get important information to a business associate.

Image files tend to be really large however, and that can cause problems. Big files take a lot of time to download, especially for someone with an average phone line modem. There are a few tricks you need to know to send your images quickly and easily in a way that will be enjoyable both to you and your recipients.

Always send image files as attachments. Don't paste them into the e-mail directly. Sending it this way preserves it in its original file format so it will get there in one piece. Send small files. By this, I mean less than 300K. You don't need high resolution for displaying an image

on a computer. Save a small (5 x 7 inches or smaller) copy or your image file at a resolution of 72dpi for e-mailing.

Save your image using a compressed file format such as a JPEG. JPEG allows variable compression, so you can choose the balance between image quality and file size. And it's a universal file format, so most users can readily open it.

If you want to share several pictures, send them a few at a time. A small file will open more quickly. A file that's too large can even crash your recipient's computer.

How to Use This Book for Digital Photography

Virtually every chapter on film also applies to digital. All of the rules about composition and exposure are still needed to make great photographs. The chapters on exposure, aperture, shutter speed, and ISO speed also apply to digital. A firm understanding of these basic concepts is still required.

Of course, there are issues that are specific to digital. A more tech-savvy approach is required to fully utilize the power of digital technology. But having a firm understanding of the film side of photography will help you transfer virtually all of the knowledge and techniques you've learned with your regular camera into the world of digital photography.

Glossary

AE. Automatic exposure. The automatic adjustment of the lens aperture and shutter speed by a control mechanism. There are three different types of AE available: aperture-priority; shutter-priority; and programmed.

aerial photography. Photographing of terrain on the ground and objects in the air from an aircraft.

angle of view. The angle at which the lens views the subject. A wide-angle lens, such as a 28mm, has a wide angle of view, and the subject appears smaller. A telephoto lens, such as a 300mm, has a narrower angle of view, and the subject is magnified and appears larger.

aperture. The opening in a lens that controls the amount of light passing through the lens to the film. The size of the aperture-opening adjustment is variable and is referred to as the "f-stop."

aperture-priority auto exposure. The shutter speed is automatically selected by the camera to match the photographer's manually set aperture for a correct exposure. This is used when the photographer wants to control depth of field.

APS. Advanced Photo System. A new standard in consumer photography produced by several manufacturers based on a new film format, camera, and photofinishing technologies. Generally, APS cameras are more compact in size and weight. APS offers several print-size options and even provides thumbnail prints (contact sheets) for you to select or preview prior to printing.

archival quality. The ability of a material, including some printing papers and compact discs, to last for many years.

ASA. American Standards Association. Film speed designation, today replaced by "ISO."

auto-focus. A feature found on many SLR and fully automatic cameras that automatically keeps subject in sharp focus. Auto-focus usually focuses more quickly than the photographer can manually.

automatic camera. A camera with a built-in exposure meter that automatically adjusts the lens opening, shutter speed, or both, for proper exposure.

B. Bulb. A shutter-speed setting on an adjustable camera that allows for time exposures. When set on B, the shutter remains open as long as the shutter release button remains depressed. Used for long time exposures.

background. The part of the scene that appears behind the principal subject of the photo. The background's degree of sharpness can be controlled by the aperture setting and shutter speed.

backlighting. Illuminating the subject from a position opposite the position of the camera, or lighting from behind the subject. Backlighting brightens the dark edges of a subject to outline the subject.

balance. Placement of colors, light and dark masses, or large and small objects in a picture to create harmony and equilibrium.

ball and socket head. A tripod head with one handle that moves the attached camera in all directions. It tends to be lighter, more compact, and a little faster to use than a pan/tilt heads. Also called a "ball head."

bellows extension. A camera accessory that, when inserted between lens and camera body, extends the lens-to-film distance for close focusing or macro photography.

bit depth. The number of bits per pixel, which determines the number of colors it can display.

bracketing. Shooting the same subject at different exposures to ensure the best shot possible. Usually means shooting from a half to one stop under and over the camera meter's recommended exposure.

built-in memory. A feature in some digital cameras that allows you to shoot consecutive shots at the same time as the camera is recording information from the previous ones.

C41 process. One of two types of slide-processing systems. Kodak's

Kodachrome films use a C41 process and must be processed by a Kodak facility.

cable shutter release. A small push-lever cable that screws into your shutter release and allows you to squeeze off a shot without touching the camera.

camera shake. The movement of a camera caused by unsteady hold or support, vibration, etc., leading, particularly at slower shutter speeds or with long-focus lenses, to a blurred image.

candids. Unposed pictures of people, often taken without the subjects' knowledge. These usually appear more natural and relaxed than posed pictures.

card reader. A USB device that reads image files from a digital camera into a computer

CCD. Charge-coupled device. A tiny photocell sensor that records light. A recording medium in many cameras and scanners.

CD. Compact disc. An optical storage medium.

CD-R. Compact disc-recordable. A rewriteable CD-ROM.

CD-ROM. Compact disc-read-only memory. Storage medium that can be only be read, but not altered.

center-weighted metering. Meter sensitivity based on the center of the camera viewfinder.

clone tool. A selection tool featured in many image-editing programs that allows you to select a piece of the image, copy it, and move it from one place to the other.

close-up. A picture taken with the subject close to the camera— usually less than two or three feet away, but it can be as close as a few inches.

CMOS. Complementary metal-oxide semiconductor. A less common, but relatively conventional memory chip that is easier and less expensive to manufacture than CCD sensors. CMOSs have light sensors built into each cell within the sensor and can process information right in the chip.

coated lens. A lens covered with a very thin layer of transparent material that reduces the amount of light reflected by the surface of the lens. A coated lens is faster than an uncoated.

color balance control. A simple sliding scale, which is included in many image-editing programs, that allows you to show different levels of color balance.

color sensitivity. Refers to film's reaction to different colors. Some films produce softer, more pastel colors; others generally produce colors that are more vibrant.

color temperature. A scale used for rating the color quality of illumination. Measured in degrees Kelvin (K). The temperature of daylight on a sunny day, for example, is expressed as 5500K; that of light from a tungsten lamp is expressed as 3200K to 3400K.

Compact Flash card. One of two widely used types of removable digital camera memory cards. There are two types of cards, Type I and Type II, with Type I being slightly thinner.

composition. The pleasing arrangement of the elements within a scene.

compression. Method for reducing the amount of space that a digital file occupies.

contact sheet. A sheet of images made from direct contact between paper and negatives, which allows you to identify and evaluate specific images without having to print an entire roll of film.

contrast. The range of difference in the light to dark areas of a negative, print, or slide.

daylight. For outdoor photography on a bright day, direct sunlight and light reflected from the sky combine to produce a natural ambient light with a color temperature of around 5500K. Color films for daytime use are called "daylight-type films."

daylight-type film. A film balanced for proper color rendition when exposed in daylight. With this kind of film, shooting under a cloudy sky or in shade results in a bluish color cast; shooting at dawn or dusk results in a reddish cast.

definition. The clarity of detail in a photograph.

depth of field. The area of sharpness in front of and behind the subject on which the lens is focused. Depth of field will vary according to other factors such as focal length of the lens, aperture, and shooting distance.

depth-of-field preview. Some SLR cameras include a feature that allows the lens to be closed to the aperture setting you've chosen. This gives you a preview of the photo's depth of field.

diaphragm. The device, usually found inside the lens, which uses a set of interleaving blades to control the size of the aperture.

diffuse lighting. Lighting that is low or moderate in contrast, such as on an overcast day.

diffuser. Translucent material placed between the light source and the subject to give more even illumination to the subject and soften the shadows. When using a flash with a diffuser, the greater the flash-to-diffuser distance, the more diffuse the light becomes and the softer the shadows.

digital. A way of organizing data as a number of distinct units.

digital camera. A camera that captures the photo in an electronic imaging sensor that takes the place of film.

digital zoom. A false zoom effect that enlarges objects for closer observation, but results in a seriously degraded image

disposable camera. A basic, affordable, plastic-body camera used to take one roll of pictures. After you shoot the film within the camera, you return the whole camera for developing and recycling.

DMax. The darkest tone that can be recorded by a camera or scanner.

DMin. The brightest tone that can be recorded by a camera or scanner.

double exposure. Two pictures taken on one frame of film, or two images printed on one piece of photographic paper.

download. Sending a data file from the computer to another device.

dpi. Dots per inch. A measurement of the resolution of a digital photo or digital device, including digital cameras and printers. The higher the number, the greater the resolution.

drum scanner. A scanner with a spinning transparent drum upon which film is taped. Readings are taken as the drum spins, providing an extremely detailed and high-quality scan with optical resolution as high as 8000 to 14000ppi and density ranges that often approach the maximum of 4.0.

DVD. Digital video disc or digital versatile disc. DVDs are high-capacity optical discs that are similar in size and appearance to CDs but have increased storage—up to 4.7GB for single-sided DVDs to 17GB or for double-sided.

DVD-R. A write-once recordable DVD format.

DVD-RW. A rewritable and recordable DVD format.

dye-sub printers. Short for "dye-sublimation" printer, which is a printer that works by transferring dye images to a substrate by heat to give photo-quality images.

dynamic range. The ability of the image device to capture the brightest highlights and the deepest shadows that you can see with your eyes.

E6 process. Kodak's standard chemical process for developing Ektachrome or compatible slide films from other film manufacturers.

effective pixels. This is a count of the number of pixels that are actually used to capture the image; describes the level of detail that a digital camera can capture.

81B filter. A warming filter with a slight amber cast that is useful on overcast days, in shady areas, or at high altitudes where more blue light is present. It works by neutralizing the cooler bluest cast that can throw off the balance of your photo.

emulsion. Micro-thin layers of gelatin on film in which light-sensitive ingredients are suspended; triggered by light to create a chemical reaction resulting in a photographic image.

enlargement. A print that is larger than the negative or slide.

existing light. The available light that is already on the scene.

exposure. The effect of the light that reaches the film, expressed by the formula: *Exposure = intensity of light x duration.* Intensity is controlled by lens aperture, and duration by shutter speed.

extension tube. A hollow, fixed-length accessory that fits between your camera body and your lens; different lengths provide varying amounts of magnification.

fast film. Film with an emulsion that is very sensitive to light. Such films have high ISO ratings (for example.: ISO 1600). They are all, however, more grainy than their slower counterparts.

file format. A method of writing or storing a digital image. TIFF and JPEG are common formats.

fill flash. A method of flash photography that combines flash illumination and existing light.

film. A photographic emulsion coated on a flexible, transparent base that records images or scenes.

film scanner. A scanner that accepts variable film sizes or one that is designed exclusively for 35mm film. Good film scanners can give optical resolution as high as 4000ppi with a density range approaching 4.0.

film speed. The rating that indicates film's sensitivity to light. Film speeds are designated by the film's assigned ISO number set by the International Standards Organization. The higher the ISO film speed number, the more sensitive it is to light and the faster it is considered.

filter. Glass or plastic disks that attach to the lens to absorb or modify the transmitted light as it enters the camera.

fish-eye lens. An extremely wide-angle lens with a photo angle of 180 degrees or more.

flare. An overall decrease in contrast caused by light being reflected off, instead of transmitted through, a lens surface; aggravated by unclean lens surfaces on front and rear lens elements or filters.

flash. An artificial light source that is either built into the camera or is attached to the camera. Flash is an intense burst of light used as a supplement to natural light sources.

flatbed scanner. A relatively inexpensive scanner choice, a flatbed scanner has a glass bed upon which you lay your photo or artwork face down. This scanner is great for prints or large transparencies. Most flatbed scanners can handle images as large as 11 x 14 inches, but does not work well for transparencies as small as 35mm.

flat light. Lighting that produces very little contrast or modeling on the subject with a minimum of shadows.

f-number. The numerical expression of the relative aperture of a lens. This is equal to the focal length divided by the aperture of the lens opening. Each f-number is 1.4 times larger than the preceding one—f4 to f5.6 to f8, etc. Each number is a halving or doubling of the amount of light that passes through the lens and available to strike the film. The next-higher f-number always allows one-half as much light; the next lower f-number allows double the amount of light. The most common apertures found on cameras: f1.4, f2.0, f2.8, f4, f5.6, f8, f11, f16, f22, f32. The aperture number represents the diameter of the diaphragm through which light passes to reach the film and controls the depth of field in your photo.

focal length. The distance between the optical center of the lens and the film plane when the lens is focused on infinity.

focus. Adjustment of the distance setting on a lens to define the subject sharply. In a camera, this is effected by moving the lens bodily towards or away from the film or by moving the front part of the lens towards or away from the rear part, thus altering its focal length.

focusing screen. Located in a position that is equivalent to the film plane, and used to focus and compose the subject. In some SLR cameras, the focusing screen can be changed to suit the needs of the photographer, such as a flat focus screen or a split-image screen.

focus-priority. Auto focus setting on auto-focus cameras that prevents the shutter from being released until the subject is in focus.

foreground. The area between the camera and the principal subject.

fps. Frames per second. Used to describe how many frames the motor drive or winder can handle automatically on winding per second consequently.

frame. One individual picture on a roll of film. Also can apply to a object that can be utilized to frame a subject in composition.

front lighting. Illuminates the subject from the position of the camera. Illumination falls evenly upon the subject, so a front-lit subject may look flat and less three-dimensional.

f-stop. Number that equals the focal length of the lens divided by the diameter of the aperture.

GB. Gigabyte. One billion bytes.

gelatin filter. Filter cut from dyed gelatin sheets.

graduated neutral density filter. A filter that is neutral gray on the top and graduates to clear on the bottom; used to bring balance to a picture that has a wide range of exposures within the same frame.

grain. The sand-like, granular appearance of a negative, print or slide. Graininess becomes more noticeable with fast films and increased size of enlargement.

gray card. A piece of cardboard that is an 18-percent reflectance middle-tone gray color. A gray card will allow you to find the proper mid-tone exposure for your subject.

grayscale. A sequential series of tones between black and white.

hand-hold. To shoot a photograph holding the camera in your hand. When shooting at low speeds, can lead to blurred images.

histogram. A graphic representation of the range of tones from dark

to light in a photo featured in many image-editing software programs.

hot shoe. The electrical fitting on a camera that holds a small portable flash and links to the camera shutter mechanism.

hue/saturation tool. A control featured in many image-editing programs that lets you manipulate color by changing its actual color (hue) or adjusting its richness or intensity (saturation).

image editor. A computer program that enables you to adjust a photo to improve its appearance. With image editing software, you can darken or lighten a photo, rotate it, adjust its contrast, crop out extraneous detail, remove red-eye, and more.

image resolution. The number of pixels in a digital photo.

incident light. Light falling on a surface as opposed to the light reflected by it.

incident-light exposure meter. A handheld meter that measures the light falling on a subject. Not affected by a subject's reflective properties. Should be positioned near the subject.

infinity. Infinite distance. In practice, a distance so great that any object at that distance will be reproduced sharply if the lens is set at its infinity position.

inkjet printer. A printer that places ink on the paper by spraying droplets through tiny nozzles.

interchangeable lens. Lens designed to be readily attached to and detached from a camera.

ISO. International Organization for Standardization. The international standard for representing film sensitivity. The higher the number, the greater the sensitivity, and vice versa. A film speed of ISO 200 is twice as sensitive as ISO 100, and half that of ISO 400 film.

JPEG. Joint Photographic Experts Group. JPEG is a file compression method used in digital photography that shrinks a file's storage size, but which can also cause image degradation as a result of data loss.

landscape format. Composition of an image in a horizontal direction.

large-format camera. The largest of modern film formats (the most popular being 5 x 4 and 10 x 8 inches), large-format cameras are especially suitable for high-quality commercial work.

laser printer. A laser printer uses a laser to imprint the page content onto a drum. The drum then passes over the toner cartridge and the toner adheres to the drum where the imprints were previously made by the laser beam. In the final step, the toner is transferred onto paper using heat and pressure.

latency. The lag in time between snapping the shutter of a digital camera and the recording of the image.

layers. Included in many image-editing programs, this is a method of separating parts of an image by isolating them into stacks. This tool comes with masks and other adjustments that let you manipulate how each of the layers is seen.

lens. One or more pieces of optical glass or similar material designed to collect and focus rays of light to form a sharp image on the film, paper, or projection screen.

lens coating. A layer or multiple layers of thin antireflective materials applied to the surface of lens elements to reduce light reflection and increase the amount of transmitted light reaching the film. Most lenses today have an integrated multilayer coating.

lens speed. The largest lens opening (smallest f-number) at which a lens can be set. A fast lens transmits more light and has a larger opening than a slow lens.

levels. A contrast and brightness tool in many image-editing programs that lets you adjust light, dark, and middle tones separately.

light speed. How receptive film is to light. This is a carefully designated variable that is indicated by its ISO number.

long telephoto lenses. Lenses that range from 300mm to 600mm or higher. They are designed to reach out and pull in distant subjects.

lossless compression format. A digital file format that is capable of compressing a file without losing image quality.

lossy compression format. A digital file format where some quality is lost in achieving high compression rates, which results in a degraded image.

low-angled light. A soft, warm light that develops within an hour or so around both sunrise and sunset.

macro lens. Lenses that have built-in extension tubes. They are specifically designed for close-up photography with virtually no distortion.

magic wand. A feature in many image-editing programs that allows you to select an area of similar tonal values by simply clicking on it.

manual exposure. A camera mode in which both the aperture and shutter speed are set manually. This mode allows the photographer total control to create photographs with any exposure.

matrix metering. An advanced camera light-metering system that uses a multi segment sensor and computer. The algorithm used is based on extensive shooting data. With matrix metering, you have a high likelihood of a correct exposure for most lighting situations, including scenes that incorporate the sun and backlit subjects.

medium-format camera. A larger format camera than the popular 35mm size, which can provide the image quality necessary for commercial reproduction, using 120mm, 220mm, or 70mm film.

megabyte (MB). A measurement of data storage equal to approximately one million bytes.

megahertz (MHz). The speed at which computer programs run.

megapixel. Equal to one million pixels.

Memory Stick. A memory card slightly smaller than a single stick of chewing gum. Like Compact Flash and SmartMedia, it is flash-based storage for your photos.

Microdrive. A very small, high-density hard drive that can store up to 1 to 2 gigabytes.

middle tone. The gray tone halfway between light and dark. The exposure meter chooses the correct exposure for recording your subject in the mid-range between light and dark. It is the same 18-percent gray tone reflectance of the standard gray card.

mirror lock-up. The mirror of many cameras can be locked up before the picture is taken to reduce camera shake when using a tripod during long exposures.

mode. Method of operation in a program.

modem. A device for transmitting data over a phone line.

monopod. A simple one-legged stand that helps stabilize your camera.

motor drive. A mechanism for advancing film automatically. Many new automatic cameras have built-in motor drives that can be adjusted to advance film from 1 frame per second to as many

as 8 frames per second. Popular for action-sequence photography and for recording images by remote control.

multiple exposure. Created by taking two or more pictures of different subjects, or successive pictures of the same subject on the same frame of film.

negative. The developed film that contains a reversed tone image of the original scene.

negative film. Represents the subject in reversed tones. Bright parts of the subject are reproduced in dark tones in the developing process. When reproduced with reversal processing on negative-type photographic paper, the image appears similar to that of the original subject. This is the negative/positive system.

neutral density filter (ND). A neutral gray lens filter that reduces the amount of transmitted light without affecting color balance. It is available in different densities that are used to reduce the amount of light striking the film.

noise. Random patterns of information on a digital image caused by nonimage forming electrical signals.

normal lens. For a 35mm camera, normal refers to a lens size of 50mm to 55mm, because this size provides an angle of view that's close to that of the human eye, about 45 degrees.

normal lighting. The same as front lighting. It illuminates only the parts of the subject that are facing the camera. Because it imparts few shadows, it tends to create a fairly flat effect.

overexposure. A condition in which too much light reaches the film, producing a dense negative or a very bright/light print or slide.

panning. A technique used to follow the motion of a subject by moving the camera with the subject. This is used to convey the image of speed or to freeze the moving subject using slower shutter speeds, leaving the background in a blurred state.

panorama. A broad wider-than-high view, usually scenic.

pan/tilt head. A tripod head that has separate handles for every direction of control. It provides precise movement of every camera direction, but tends to be heavier and more time-consuming to use then a ball-and-socket head.

perspective. The relative size, distance, and depth of a three-dimensional subject or scene within a two-dimensional, flat picture.

Photoshop. Best-known and well-used image-editing computer program by Adobe Systems.

picoliter. A miniscule unit (one-trillionth of a liter) of liquid measurement used in inkjet inks.

pixel. The smallest unit of a digitized image.

platform. A computer's operating system, such Apple Macintosh or Microsoft Windows.

point-and-shoot camera. Any camera that will focus and choose your exposure automatically, allowing you to shoot quickly. Many point-and-shoot cameras come as complete packages, with built-in zooms and flashes.

polarizing filter. A filter that eliminates glare or reflection from surfaces by reducing reflected light from objects. The true colors come through to the film, resulting in more saturated colors. Most polarizing filters are linear polarizing filters; circular polarizing filters convert linear polarized light waves to circular light waves. It can eliminate undesirable reflections from a subject such as water, glass, or other objects with shiny surfaces. This filter also darkens blue skies.

portrait format. Photographs that are formatted in a vertical orientation. So called, because they are often used for head and shoulder photographs of people.

positive film. Also called "reversal" film or "slide" film. Usually used for slide projection or printing purposes.

ppi. Pixels per inch. The number of pixels both horizontally and vertically in each square inch scanned or recorded by a digital camera.

prefocus. A useful technique for action photography in which you determine in advance where the action will occur, set up and focus your shot, and release the shutter when the subject enters the frame.

print. A positive picture, usually on paper, and usually produced from a negative.

print film. Film processed as a negative image (dark areas appear light in the negative and light areas appear dark), from which positive prints are made. Black-and white and color print film are the most common films used.

processing. Developing, fixing, and washing exposed photographic

film or paper to produce either a negative image or a positive image.

programmed auto exposure. The camera automatically selects the optimum combination of shutter speed and aperture. Available programs include auto multiprogram and vari-program, which allow the photographer to select the most suitable program for the desired results.

pushing film. Setting the ISO dial on the camera at a higher speed than the film is optimally designed for. This must be compensated for during development by having the film push-processed one extra stop for the entire roll of film.

RAW. The RAW image format is the data as it comes directly off the CCD of a digital camera, with no in-camera processing performed.

red-eye. The red glow from a subject's eyes caused by light from a flash reflecting off the blood vessels behind the retina in the eye. The effect is most common when light levels are low.

reflected-light exposure meter. Measures light reflected from the subject. The exposure meter built into SLR cameras is a type of reflected-light exposure meter, whose readings are affected by the amount of light and subject's reflective properties.

reflector. Accessory used to bounce reflected light toward the subject to fill in shadows.

resolution. In film photography, resolution refers to the ability of a lens to discern small detail. In digital photography, it refers to the detail that the image will hold. Digital resolution is referred to by the number of pixels in a given area of the image. This is expressed as "pixels per inch" (ppi).

reversal film. Also called "positive film" or "slide film." Usually used for slide projection or printing purposes.

RGB. The way that the colors are recorded in digital imaging. A large percentage of the visible spectrum can be represented by mixing red, green, and blue (RGB) colored light in various proportions and intensities.

rim lighting. A type of backlighting that casts a bright aura of light around the subject or portions of the subject.

rule of thirds. A guideline for composing images using a grid format. The intersections of the grid lines are strong areas in the photo

frame. Placing the subject at one or more of these intersections gives the photograph more tension and is often more appealing to the eye.

saturation. How rich the colors are in a photo. Saturated colors are called vivid, strong, or deep. Desaturated colors are called dull, weak, or washed out.

screw-on close-up filter. Inexpensive alternatives to both extension tubes and macro lenses for close-up photographs. They function like magnifying glasses, bringing small images up close.

self-timer. A feature found on many SLR cameras that is designed to delay the operation of the shutter by several seconds. Allows a 10-second delay after the shutter button is released before the shutter operates.

sensitivity. Photographic emulsion's response to light.

sharpness. The clarity of detail in a photo.

short telephoto lenses. Lenses in this category range in size from 85mm to 200mm. Focal lengths of 85mm, 105mm, and 135mm make excellent lenses for people or pet portraiture photos.

shoulder stock. Traditionally used by hunters to support their guns, these lightweight aluminum supports that balance on your chest or the more traditional wooden gunstock styles can be used with cameras to provide stability and allow you to move quickly.

shutter. Blades, a curtain, plate, or some other movable cover in a camera that controls the time during which light reaches the film.

shutter lag. With all but a few of the most advanced digital cameras, there is a delay after the shutter release is pressed, which varies from camera to camera. This delay can cause the photographer to miss shots, especially when shooting action.

shutter-priority auto exposure. The lens aperture is automatically selected by the camera to match the photographer's manually selected shutter speed for a correct exposure. This is used when the photographer wants to stop action or create motion effects using slow shutter speeds.

shutter speed. Measures how long the camera shutter will be open to let the light reach the film plane. Most camera shutter speeds range from B up to 1/4000 second. Shutter speeds are referred

to by only the denominator of the fraction: a speed of 1/125, for instance, is called 125, and this is how the speed appears on the shutter-speed dial. Therefore, the higher the number, the faster the shutter speed. Shutter speed is used to control how motion is recorded.

sidelighting. Illuminates the subject from either side, producing more shadows on the subject than front lighting. It is used to give the subject more definition or depth.

silhouette. A dramatic technique that leaves your subject in darkness and its outline framed by a lighter background; achieved by choosing an exposure setting based on the lighting behind your subject.

skylight filter. Corrects the excess bluish cast that results from taking pictures in the shade on clear bright days. It is often used as a protective lens filter, because it does not affect the exposure.

slide. A photographic transparency (positive) mounted for projection, which is the first-generation production of a image. Most agencies and photo editors prefer slides rather than prints.

slide film. Also called "positive" film or "reversal" film. Usually used for slide projection or printing purposes.

slow film. Film that has a limited light sensitivity. Such films have low ISO speeds (e.g. 25 or 50 ISO).

SLR. Single-lens-reflex camera. The SLR employs the same lens for viewing the scene, through the use of internal reflex mirrors, as it does for recording the image on film.

SmartMedia. A wafer-thin, matchbook-sized memory card. This is a flash-memory based storage medium.

soft focus filter. A filter that creates soft outlines. Useful when shooting portraits.

spot metering. Meter sensitivity concentrated within a small circle in the center of the viewfinder, usually 1 to 5 percent of the total area of the viewfinder. It is used for very precise metering.

SPD. Silicon photo diode. SPDs are light-measuring elements that accumulate light based on the exposure. CCDs (charge-coupled devices), where light is captured and turned into an image, are composed of SPDs.

stitch tool. A feature in many image-editing programs that automates the connection of several photos to form a panoramic image.

stop. A measure or increment of exposure. Shutter speeds and aperture

are each represented in increments called "stops." Each stop doubles or halves the amount of light that is allowed to reach the film during exposure.

stopping down. Changing the lens aperture to a smaller opening; for example, from f-8 to f-11.

teleconverter. An optical element that is placed between the lens and the camera to increase the focal length of the lens. The two most common teleconverters are 1.4X, which increases the focal length of a 400mm lens to 560mm and reduces the aperture by one f-stop, and 2X, which increases a 400mm length to 800mm and reduces the aperture by two f-stops.

telephoto lens. In 35mm photography, any lens over 85mm is considered "telephoto." Telephoto lenses have longer focal lengths, have a narrower angle of view, and magnify the image in proportion to the focal length. Short telephoto lenses are 85mm to 135mm; medium telephoto lenses are 150mm to 200mm; and long telephoto lenses are 300mm and above.

through-the-lens focusing (TTL). Viewing a scene to be photographed through the same lens that admits light to the film. TTL refers to exposure systems that read the light that passes through the lens to strike the film.

thumbnail. A small version of a photo. Image browsers commonly display thumbnails of photos several or even dozens at a time.

TIFF. Tagged Image File Format. TIFF is a common file format used in digital photography. This high-quality file can also contain color management profiles and be color separated.

time exposure. A comparatively long exposure made in seconds or minutes.

tone. The degree of lightness or darkness in any given area of a print; also referred to as value. Cold tones (bluish) and warm tones (reddish) refer to the color of the image in both black-and-white and color photographs.

transparency. A positive image viewed by transmitted light rather then reflected light. Once mounted they are called "slides."

tripod. A three-legged camera support with collapsible legs and a separate adjustable head mount to which the camera is attached. Especially useful when using slow shutter speeds and/or telephoto lenses.

tungsten light. Light from a photo lamp has a color temperature of 3200K to 3400K. Under a tungsten lamp, images on daylight-type film tend to take on a reddish cast.

tungsten-type film. A film balanced for proper color rendition when exposed under tungsten light. When a tungsten-type film is used in daylight or with illumination from a flash, use a color temperature conversion filter such as the A12 to prevent the appearance of a bluish cast.

TWAIN. A cross-platform interface developed as a standard for acquiring images from a scanner, digital camera, and computer software.

USB. Universal Serial Bus. A protocol for transferring data to and from digital devices. Many digital cameras and memory card readers connect to the USB port on a computer.

underexposure. A condition in which too little light reaches the film, producing a thin negative, a dark slide, or a muddy-looking print.

UV filter. A filter used to absorb ultraviolet light and to cut haze on overcast days and in high-mountain terrain. This filter has no effect on exposure.

variable focus lens. Lens of which the focal length can be continuously varied between set limits. The lens must be refocused with each change in focal length.

viewfinder. Device or system indicating the field of view encompassed by the camera lens.

video card. A board installed in a computer to control or enhance monitor display.

video driver. The software that a computer monitor uses to control and calibrate the color, brightness, contrast, and tone of the display screen.

warming filter. Usually an amber toned filter such as the 81A-EF series, which are used to amplify the warmer color spectrum of a photograph.

wide-angle lens. In 35mm photography, any lens smaller than 50mm in focal length. These lenses have shorter focal lengths and a wide angle of view. They make the image smaller in proportion to the shorter focal length. The most common are 24mm, 28mm, and 35mm.

wireless remote control. A handheld device that allows you to shoot without touching the camera.

wizard. A series of dialog boxes that guides you step by step through a procedure featured in many software programs.

zip disk. A portable storage medium that holds 100 megabytes.

zip drive. A drive used to access zip disks, which can be mounted on a computer internally or externally.

zoom lens. A lens of variable focal length, which can be adjusted from the lowest focal length to the upper focal length to change the scale of the image without throwing the image out of focus. Examples of common zoom lenses are 35–70mm and 70–200mm.

Index